S0-BRN-254

Wild Spaces and Unique Places

CELEBRATING THE NATURAL WONDERS OF UTAH

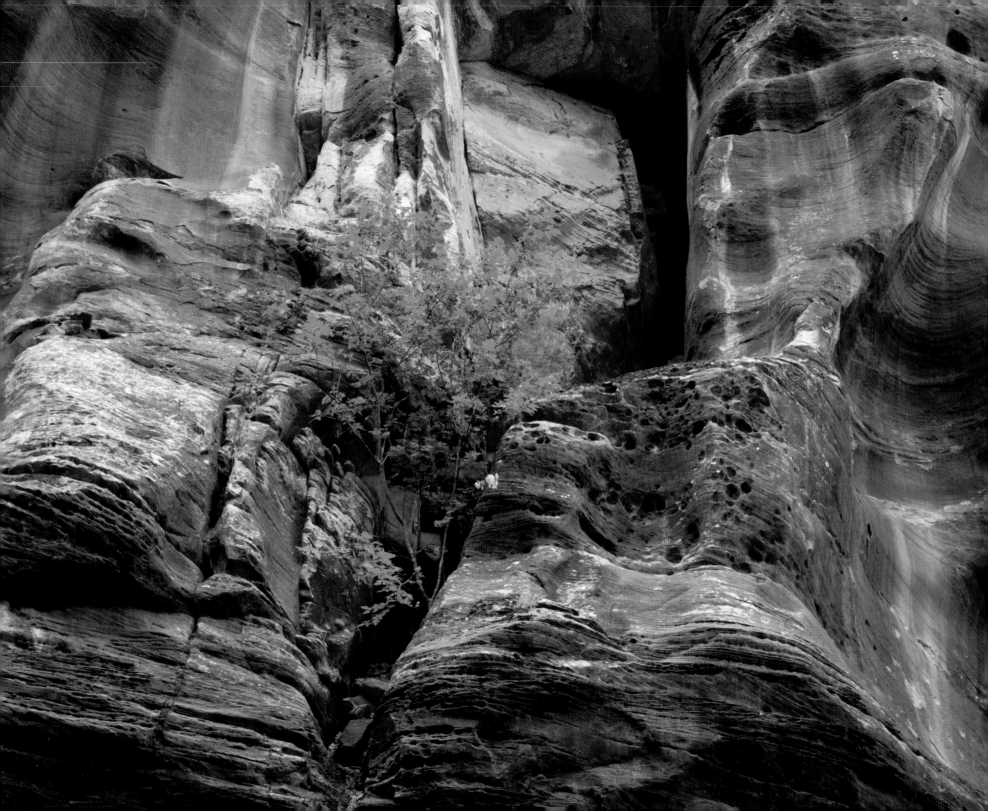

Wild Spaces and Unique Places

CELEBRATING THE NATURAL WONDERS OF UTAH

Ryan Jeffery

GIBBS SMITH

TO ENRICH AND INSPIRE HUMANKIND

First Edition
25 24 23 22 21 5 4 3 2 1

Text © 2021 Ryan Jeffery
Photographs © 2021 Ryan Jeffery

All rights reserved. No part of this book may be reproduced by any means
whatsoever without written permission from the publisher, except brief
portions quoted for purpose of review.

Published by
Gibbs Smith
P.O. Box 667
Layton, Utah 84041

1.800.835.4993 orders
www.gibbs-smith.com

Designed by Sheryl Dickert
Printed and bound in China

Gibbs Smith books are printed on either recycled, 100% post-consumer
waste, FSC-certified papers or on paper produced from sustainable PEFC-
certified forest/controlled wood source. Learn more at www.pefc.org.

Library of Congress Control Number: 2021931685

ISBN: 9781423658764

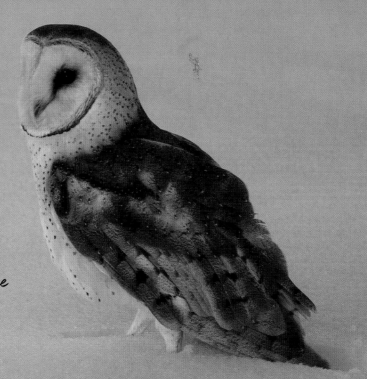

I would like to dedicate this book to my wife Nancy for all the love and support she has given me over the last thirty-one years. She has been a tremendous source of inspiration, a great traveling companion, and my best friend.

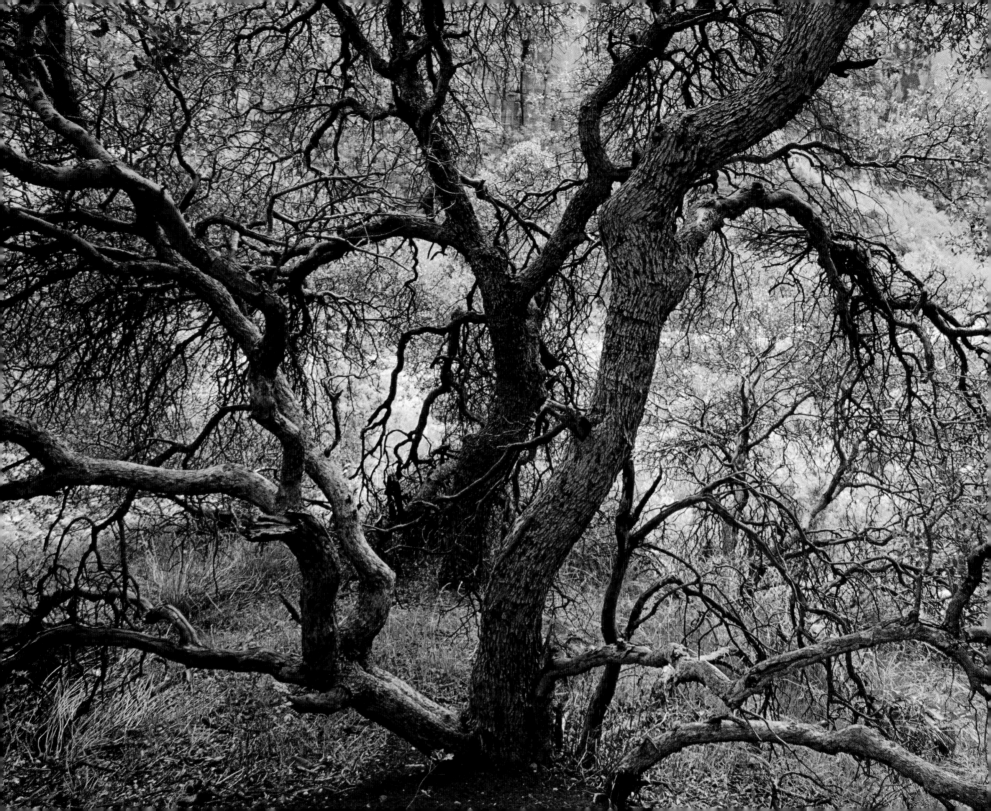

Contents

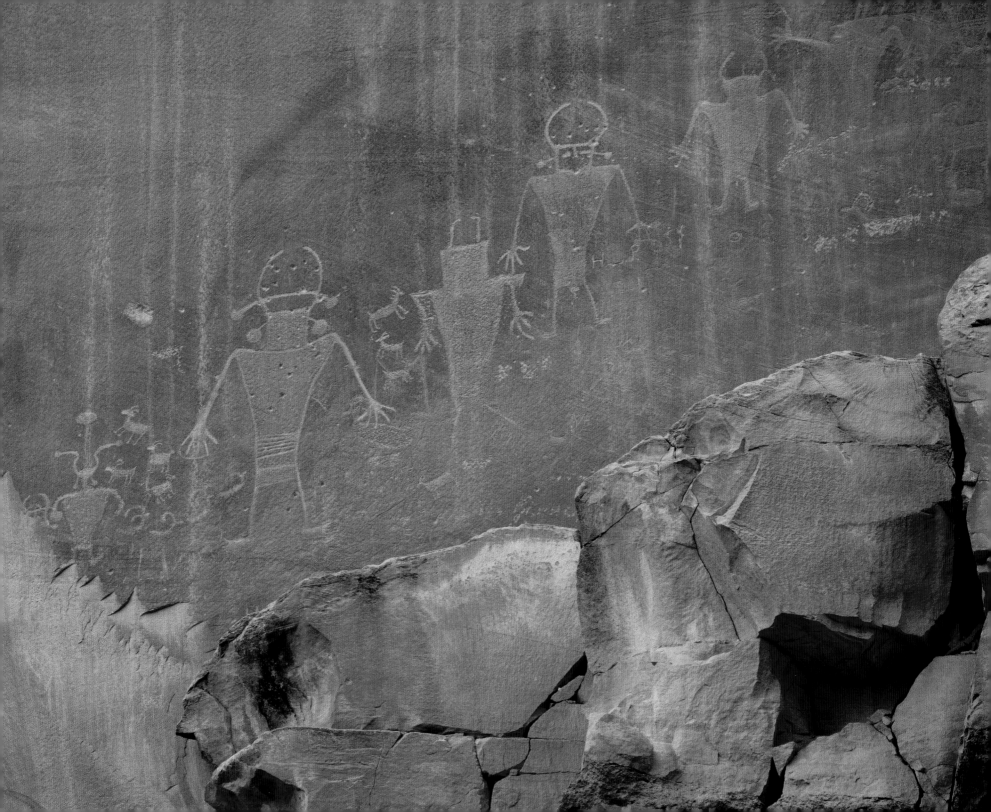

I WOULD LIKE TO ACKNOWLEDGE

Michelle Branson and Suzanne Taylor for providing me an opportunity to fulfill my dream of having my work published,

Mekele Reynolds for her awesome editing skills, and Michael Fatali for being a great friend and mentor.

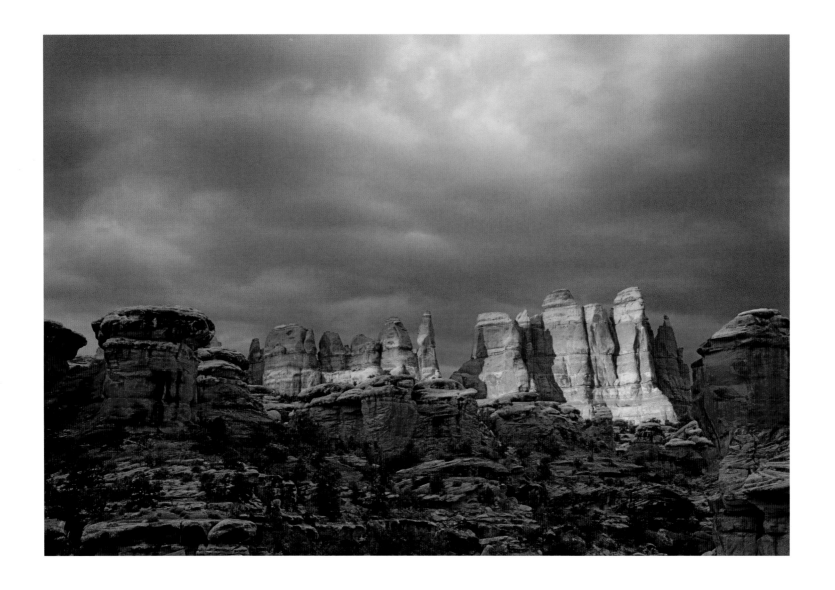

INTRODUCTION

Utah has some of the most diverse, unique, and beautiful landscapes of any place in the world. Few other locations have the geology so openly exposed. The mountains, deserts, and the massive expanse of the red rock with its mesas, balancing rocks, and arches have spoken to me for more than thirty years. I have been compelled to search for, explore, and discover the treasures this amazing state has to offer. I am honored to help celebrate its wonders.

No matter what our personal beliefs might be, I think we can all agree that our origins as humans began in the wilderness. It was our first home, so naturally we are drawn to wild places. It's encoded in our DNA. We find ourselves drawn back to the memory of our first home, the forests, the deserts, anywhere wild. When the demands and pressures of the modern world get too great, we all should have a place to run to. We need to escape from the cities and urban sprawl, down that dirt road that leads to exciting adventures, sometimes more exciting than hoped for or wanted. It is important to slow down, to open our eyes, and to absorb what nature has to teach us.

Photography is my medium of expression, much like a painter would use paint and brush. It motivates me to see more clearly the beauty around me and seek out details in nature that others may pass by. Creating images that I can return to again and again allows me to relive those moments of wonder experienced in wild places. With my photography, it is my hope that I can to express the magnificence, wonder, and beauty that the natural world has to share, and use those images to stir that same sense of wonder and awe in others.

While this book only offers some of the wilderness and wildlife throughout the state of Utah, please enjoy what I can share, and then go outside and see what you can see, wherever you may be.

All we have, it seems to me, is beauty of art and nature and life, and the love which that beauty inspires.

—EDWARD ABBEY

Northern Utah

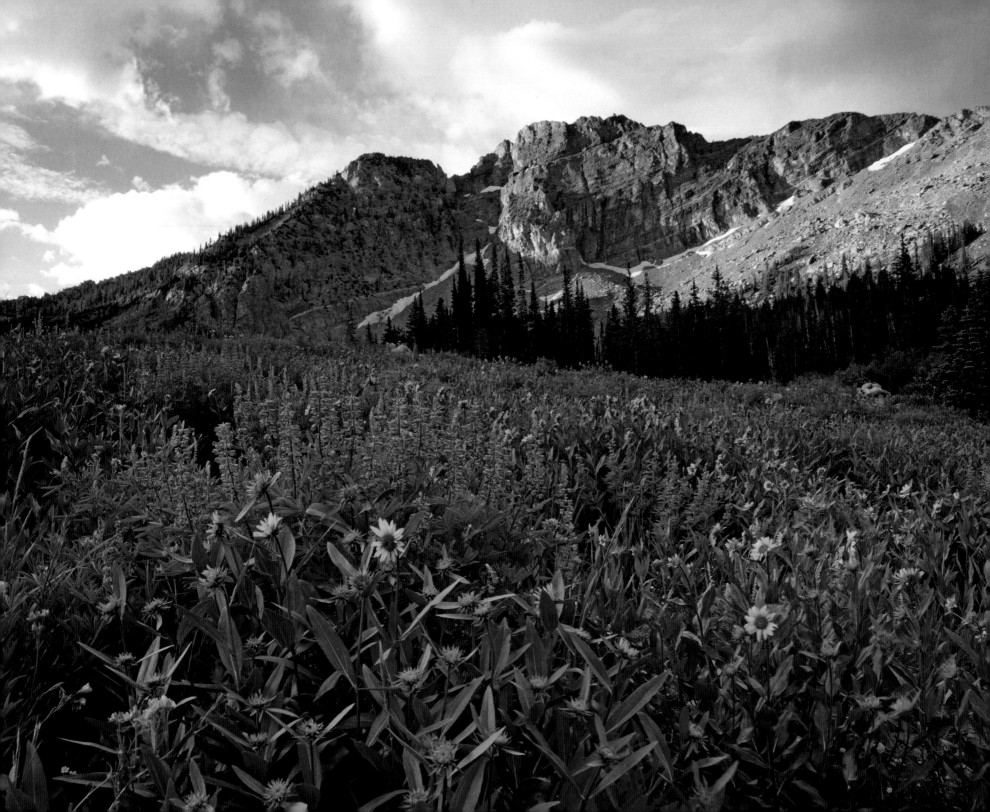

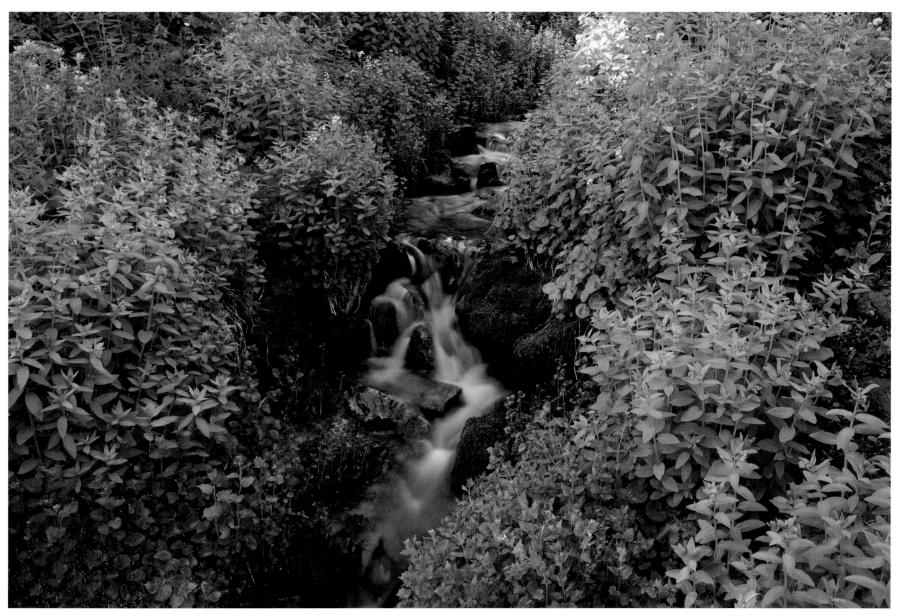

Alta

May your trails be crooked, winding, lonesome, dangerous, leading to the most amazing view. —EDWARD ABBEY

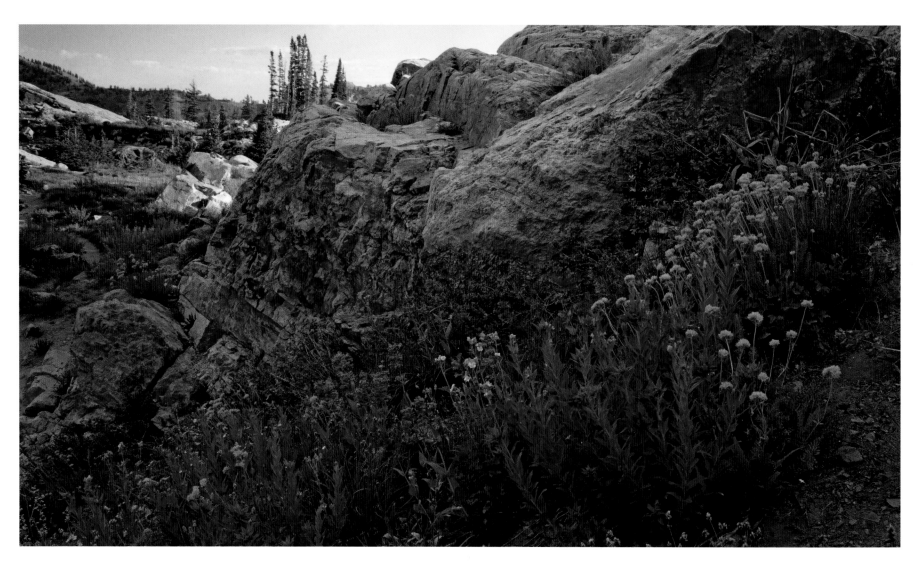

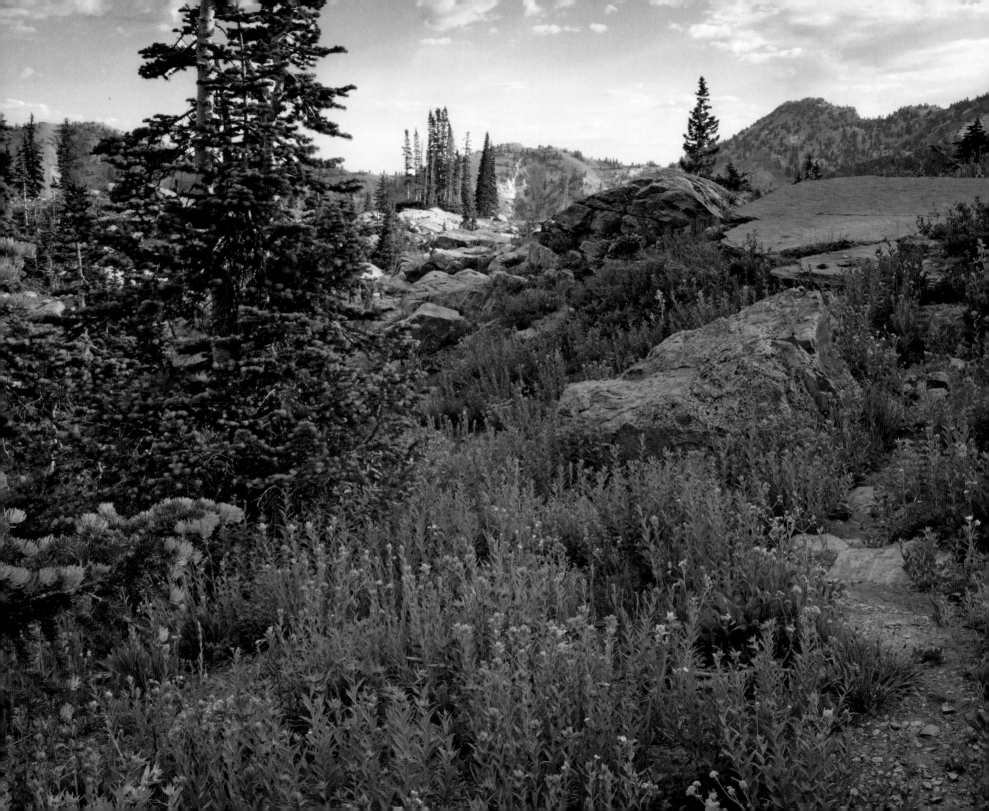

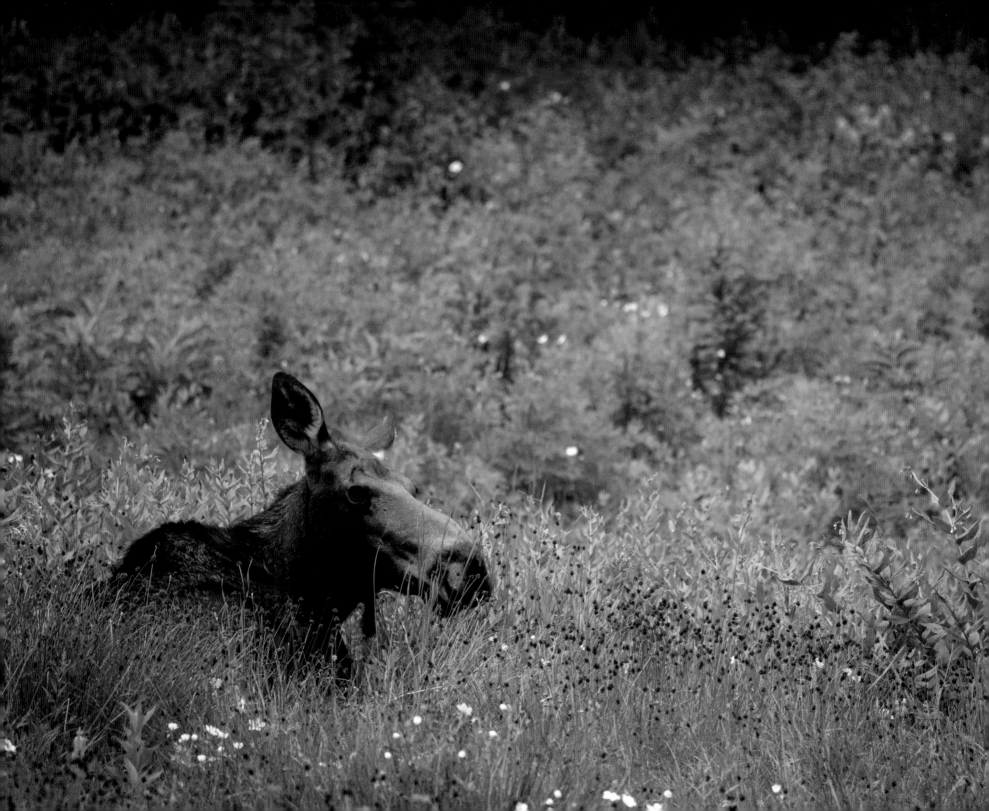

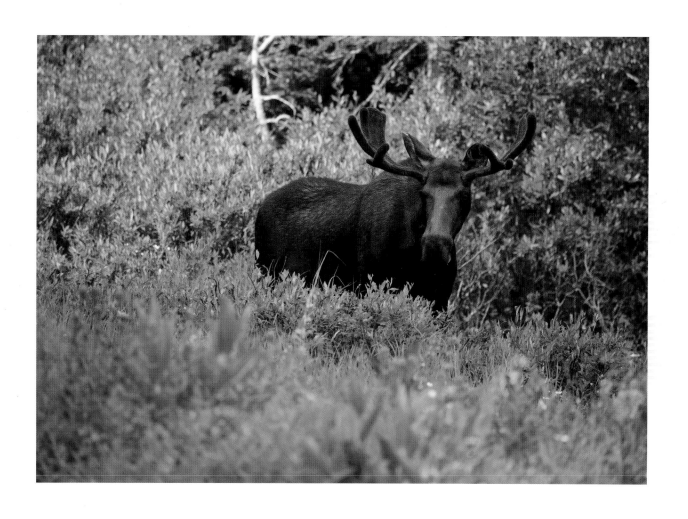

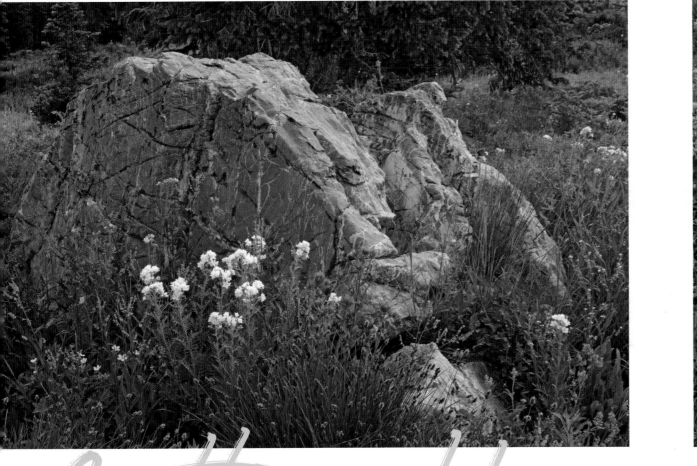

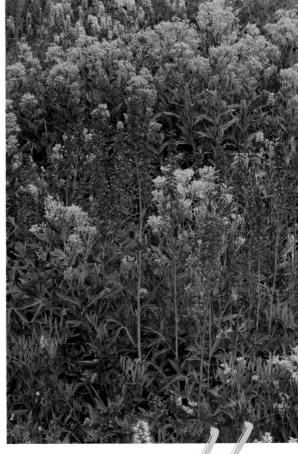

In the wilderness is the

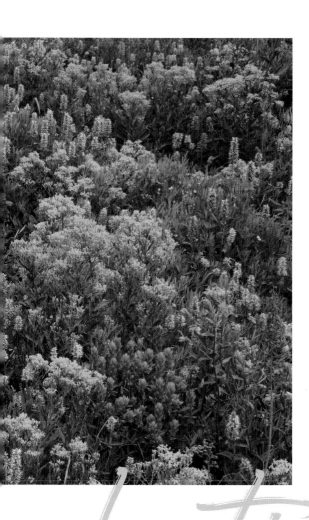

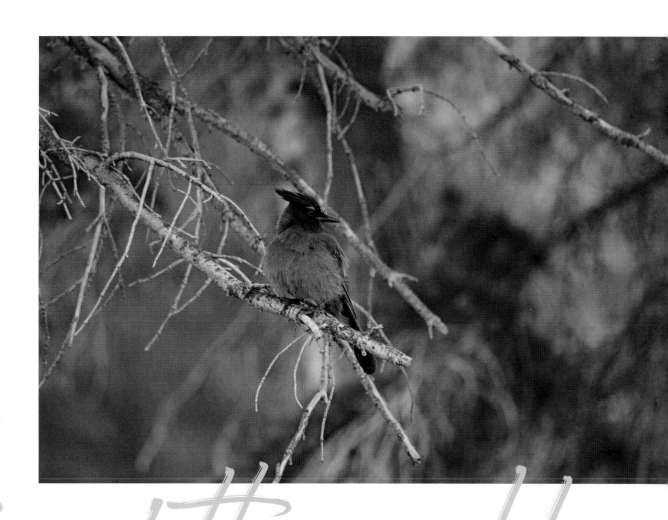

salvation of the world.

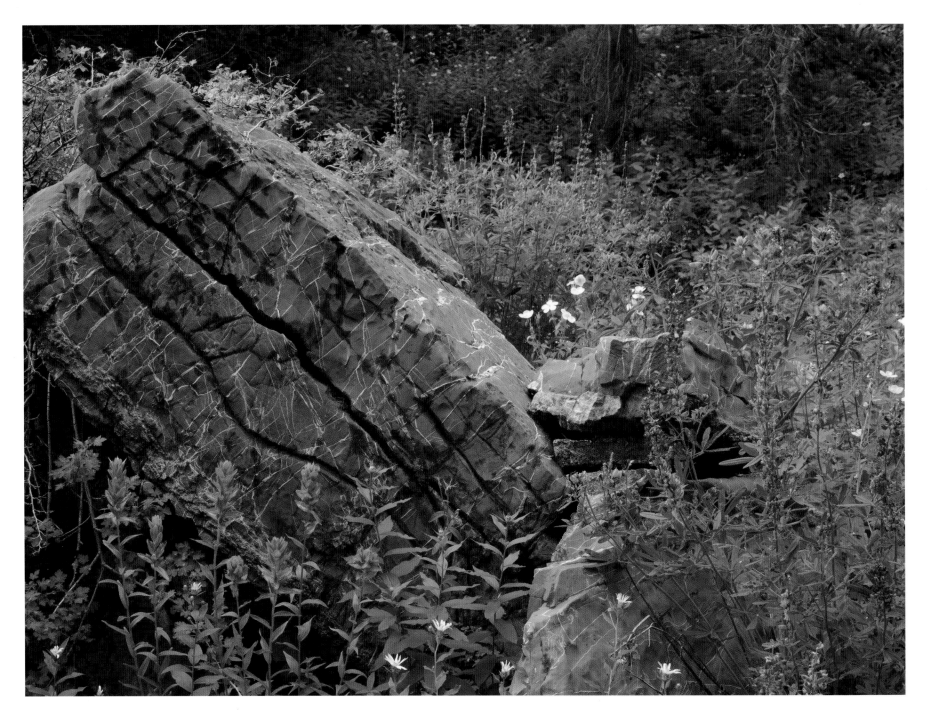

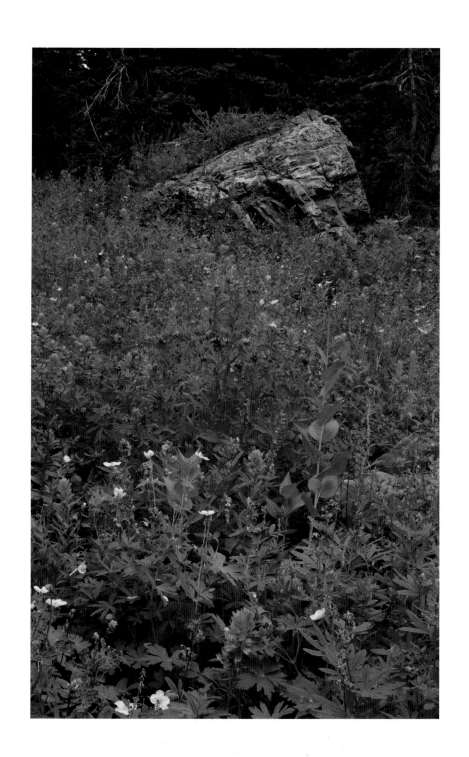

Life's a dog and then you die? No
no. Life is a joyous dance through
daffodils beneath cerulean blue
skies and then, then what? I forget
what happens next.

—EDWARD ABBEY

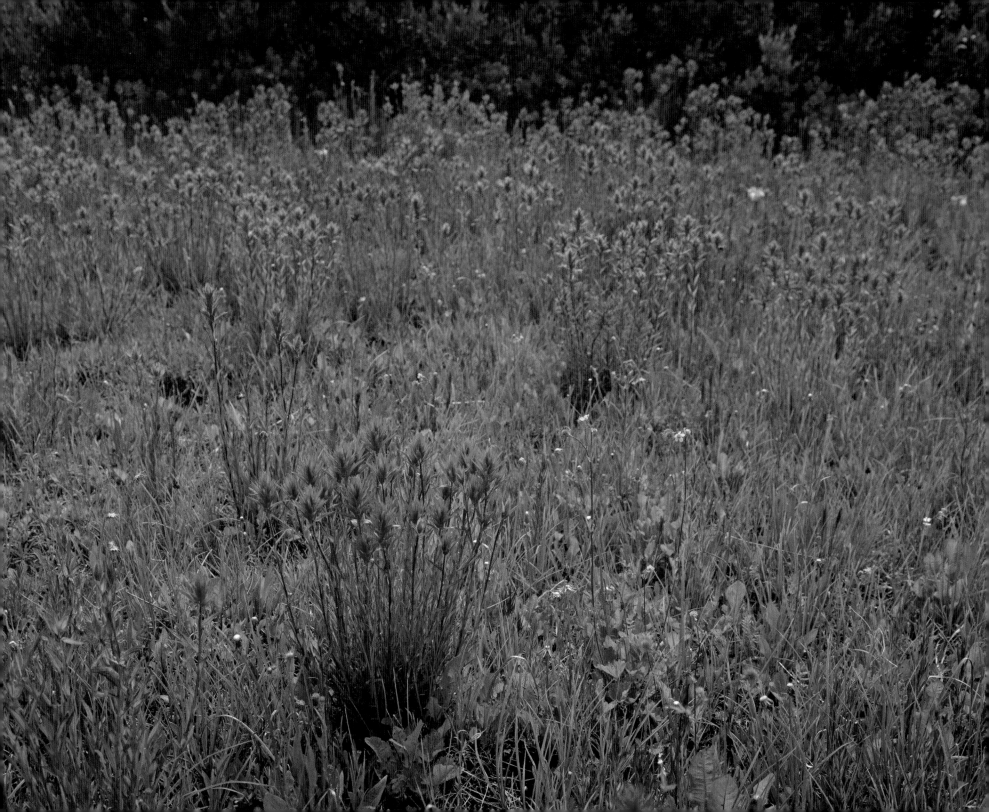

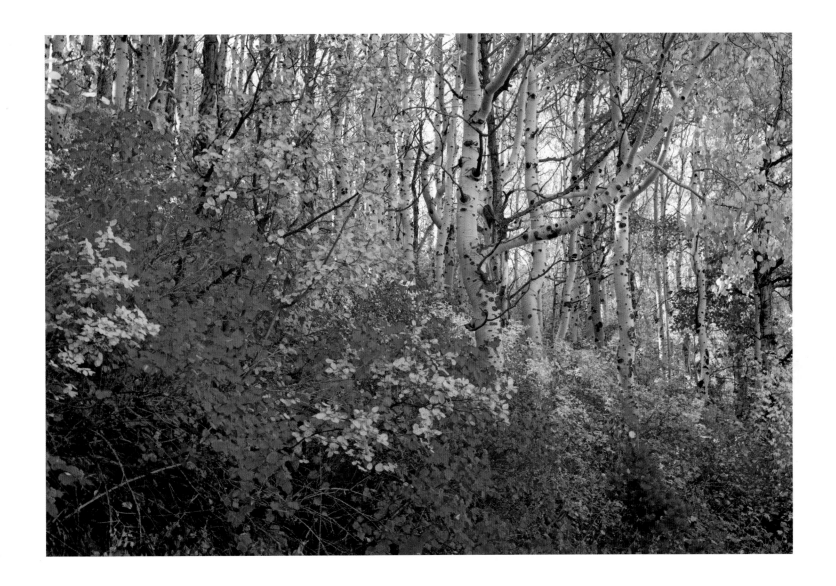

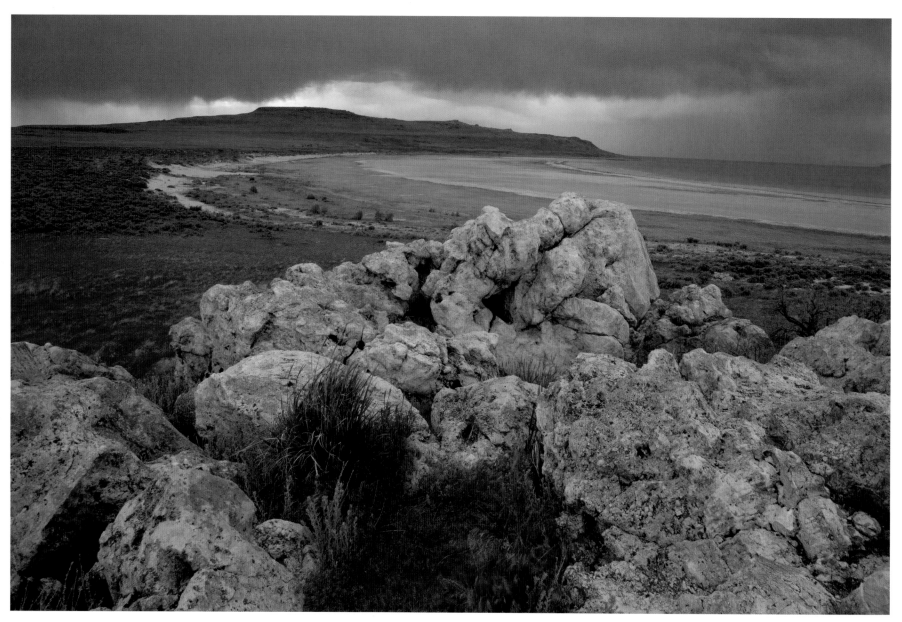

Antelope Island

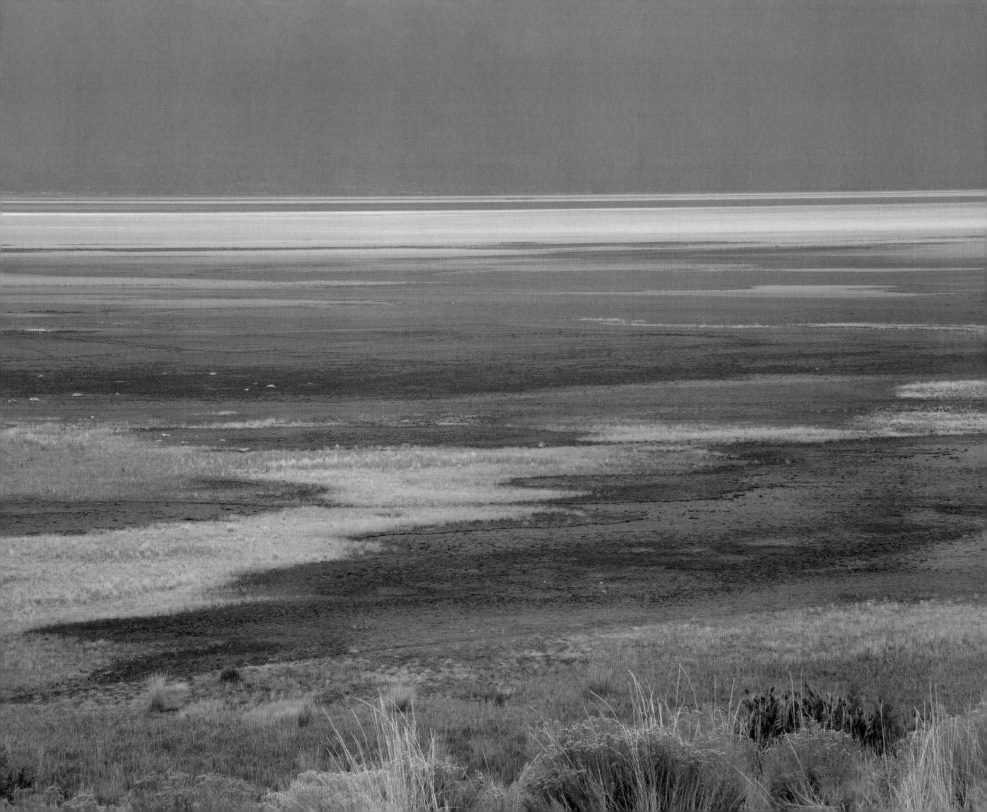

Wilderness is not a luxury but a necessity of the human spirit, and as vital to our lives as water and good bread. —EDWARD ABBEY

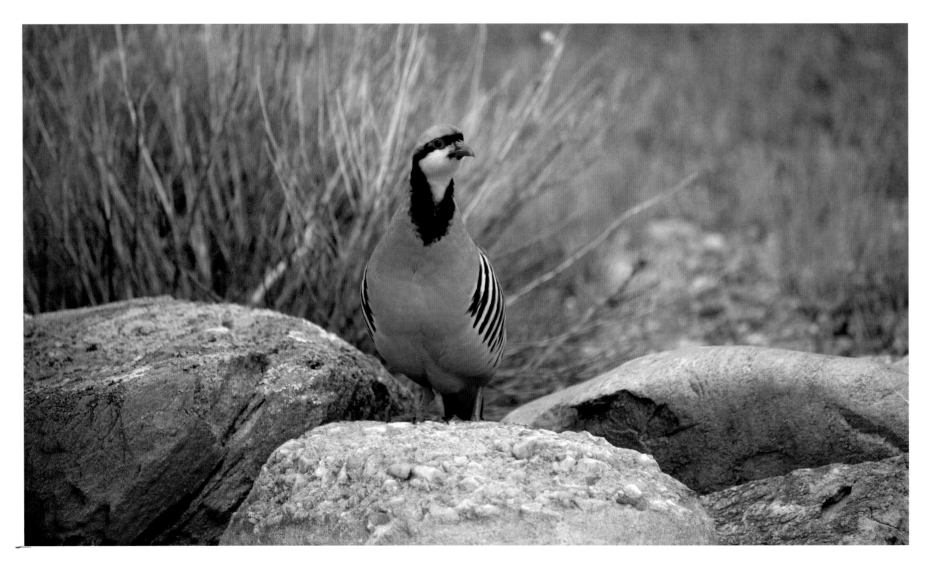

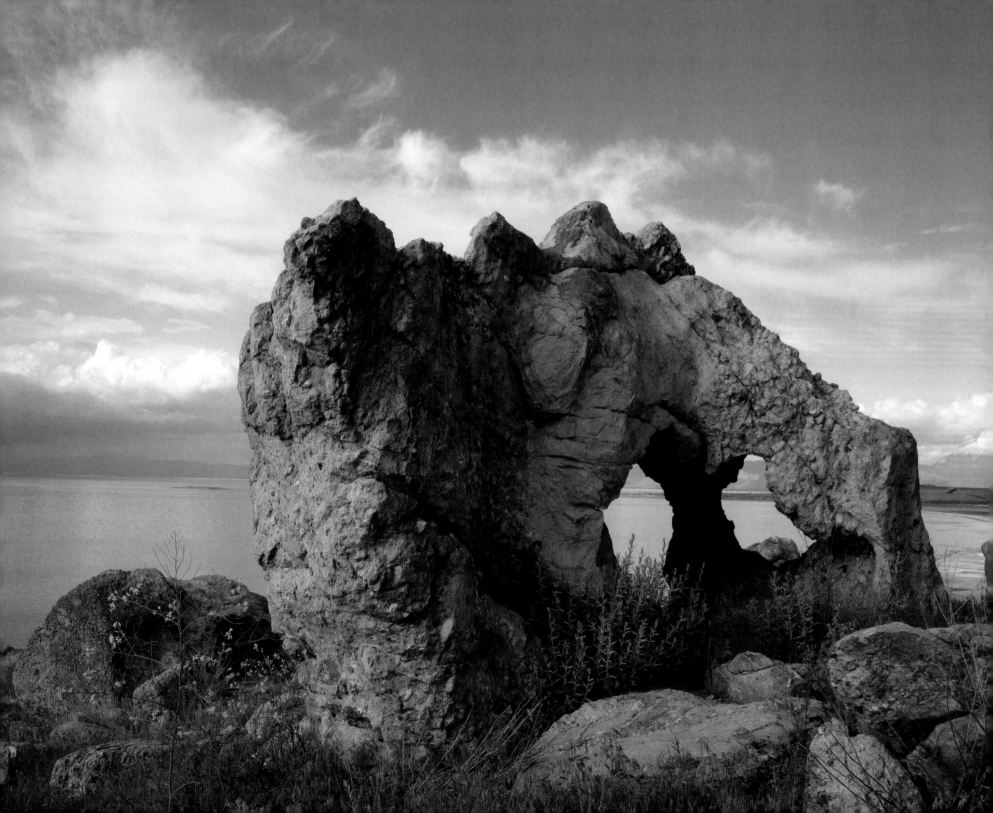

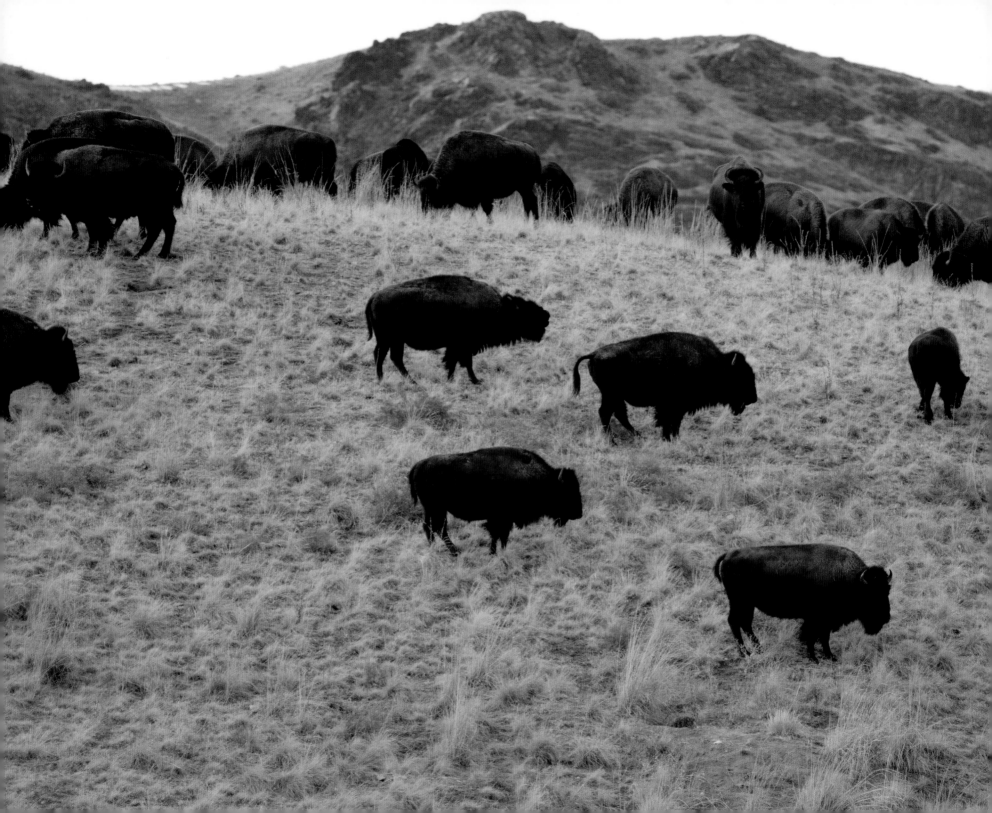

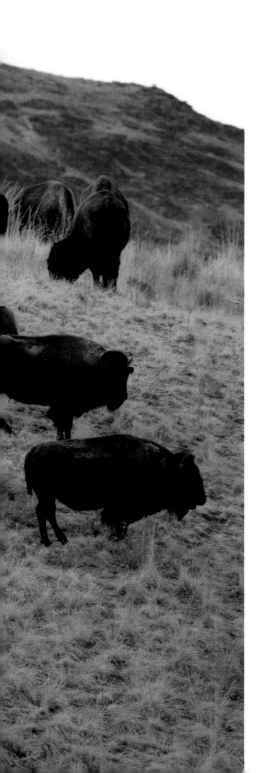
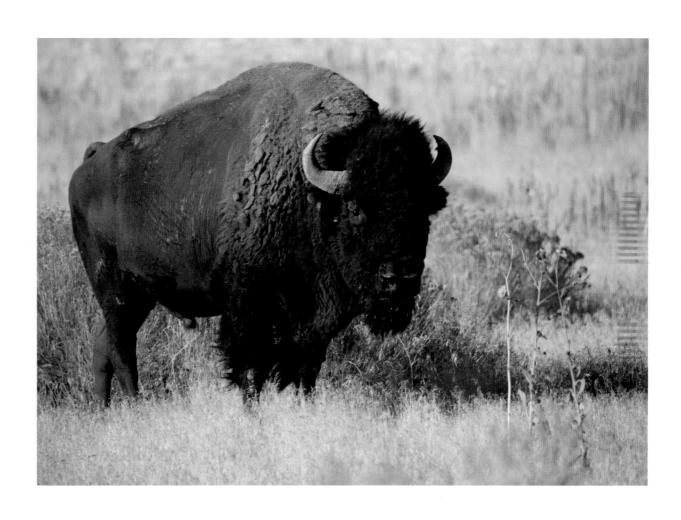

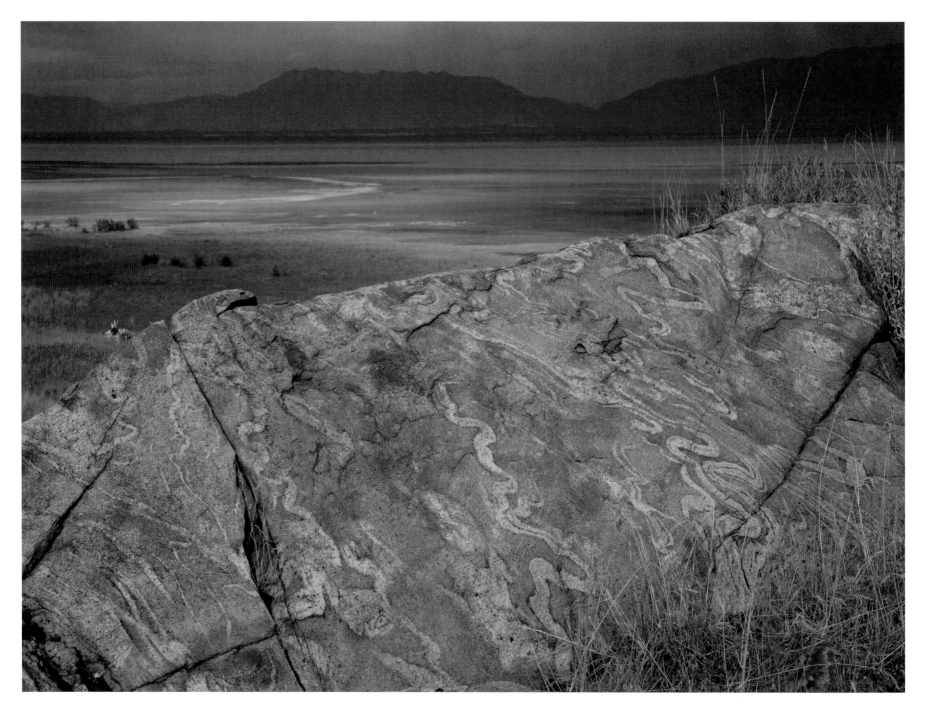

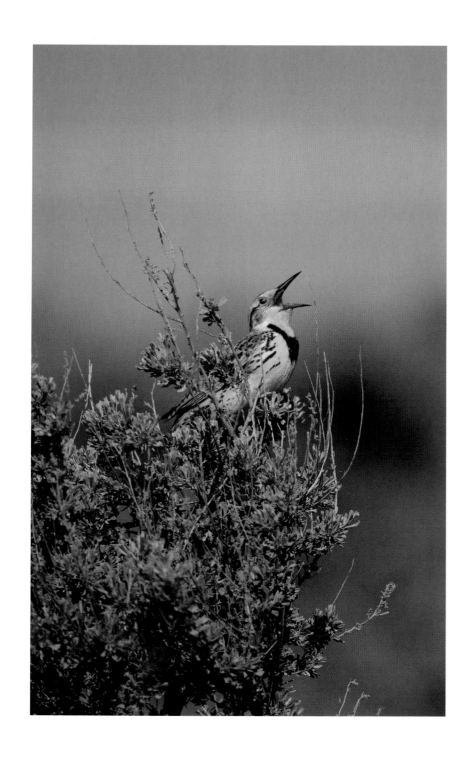

Always I shall be one who

loves the wilderness:

Swaggers and softly creeps

between the mountain peaks;

I shall listen long to the sea's

brave music; I shall sing my

song above the shriek of

desert winds.

—EVERETT RUESS

33

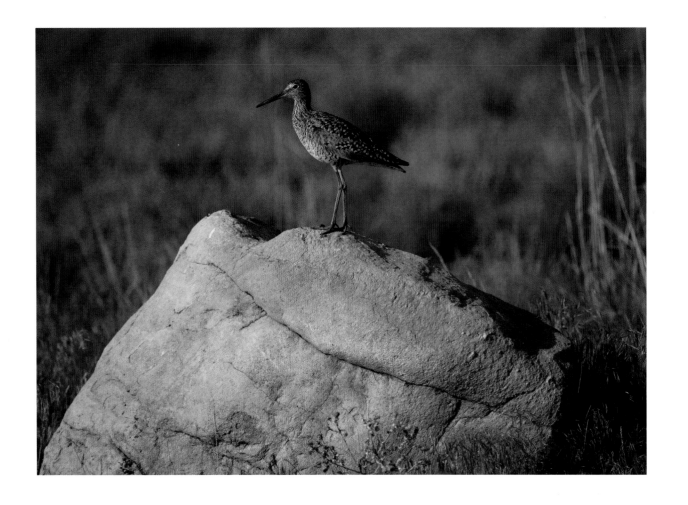

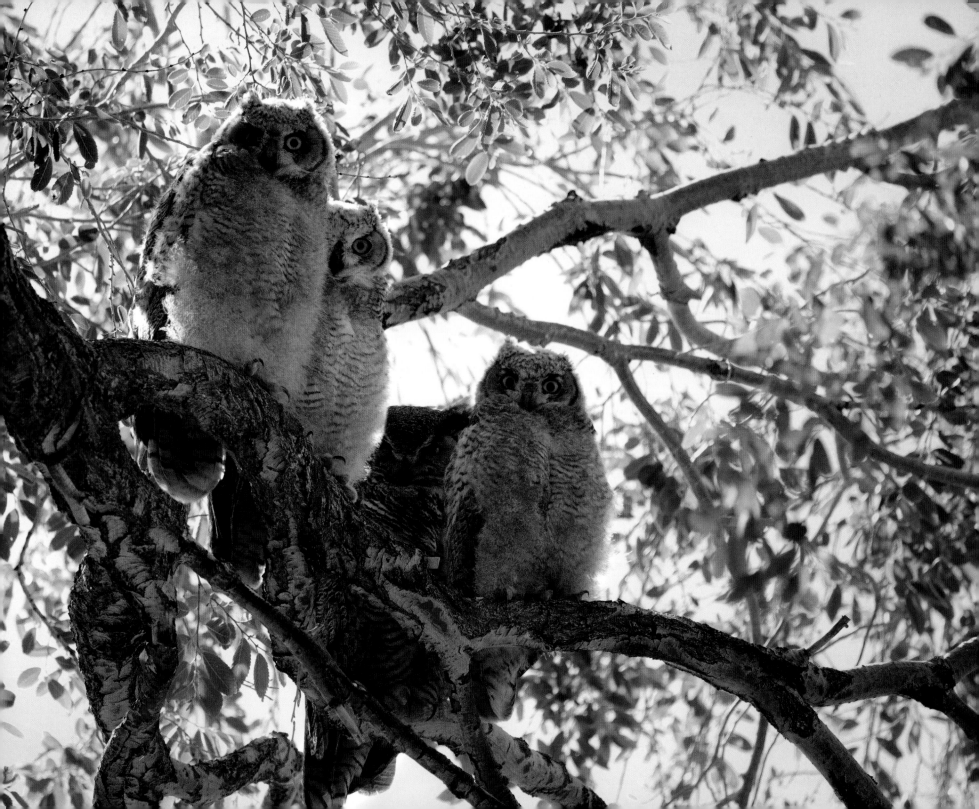

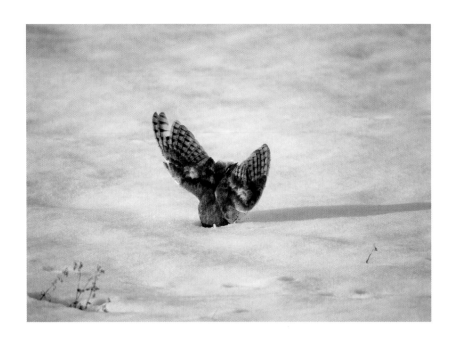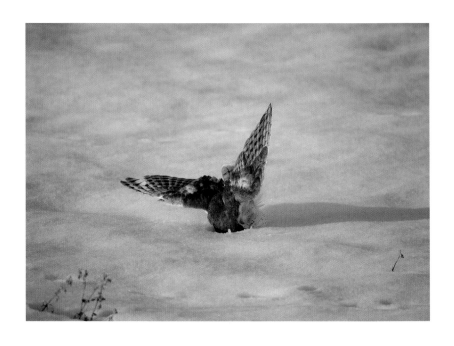

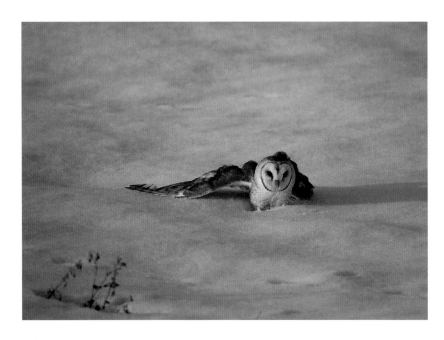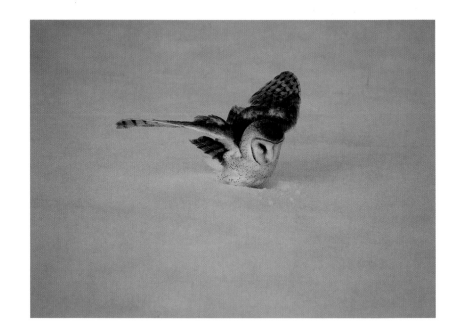

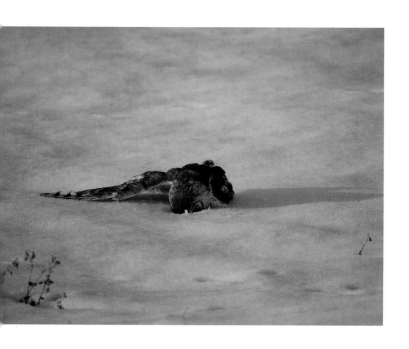

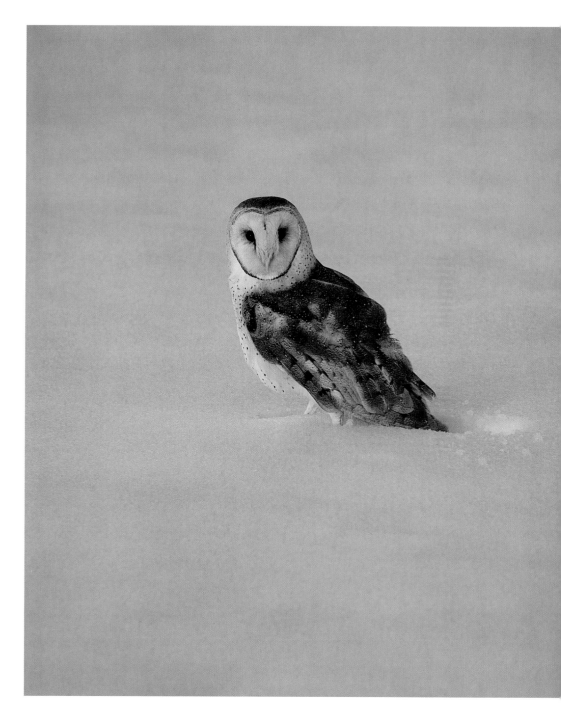

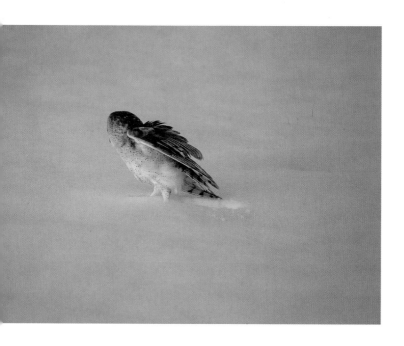

Wilderness touches the heart, mind and soul of each individual in a way known only to himself. —MICHAEL FROME

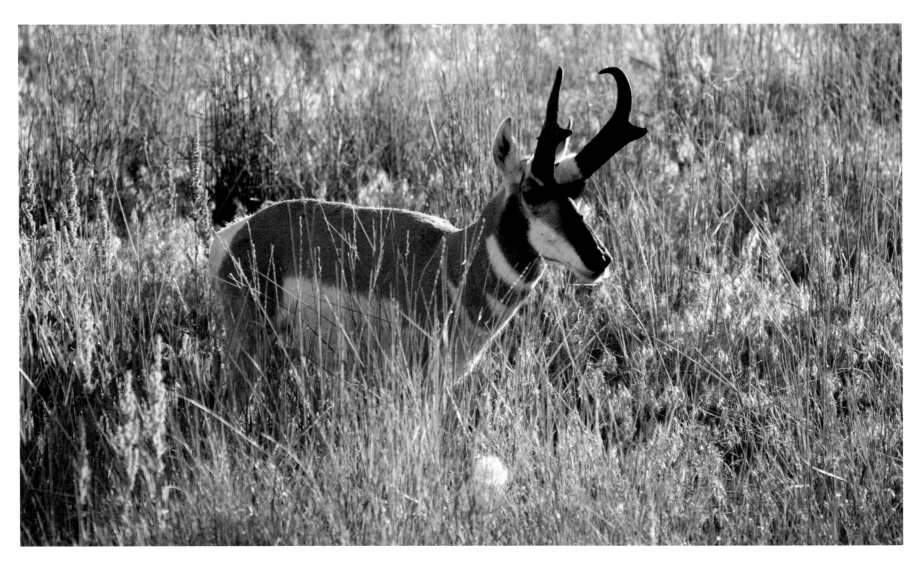

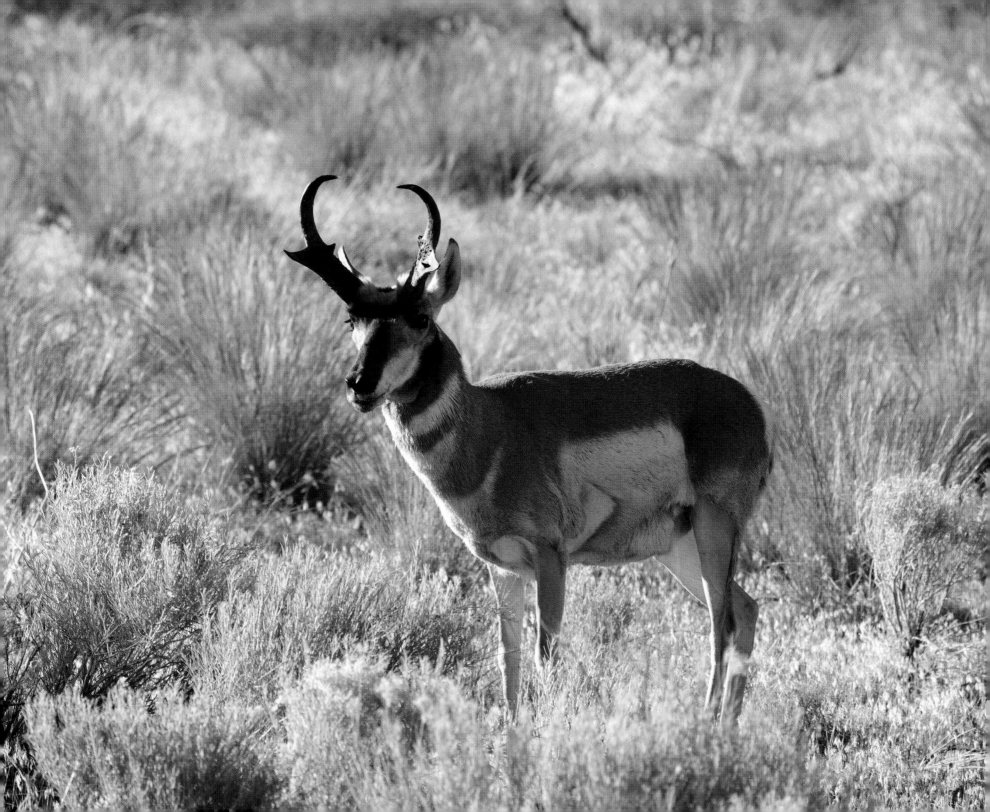

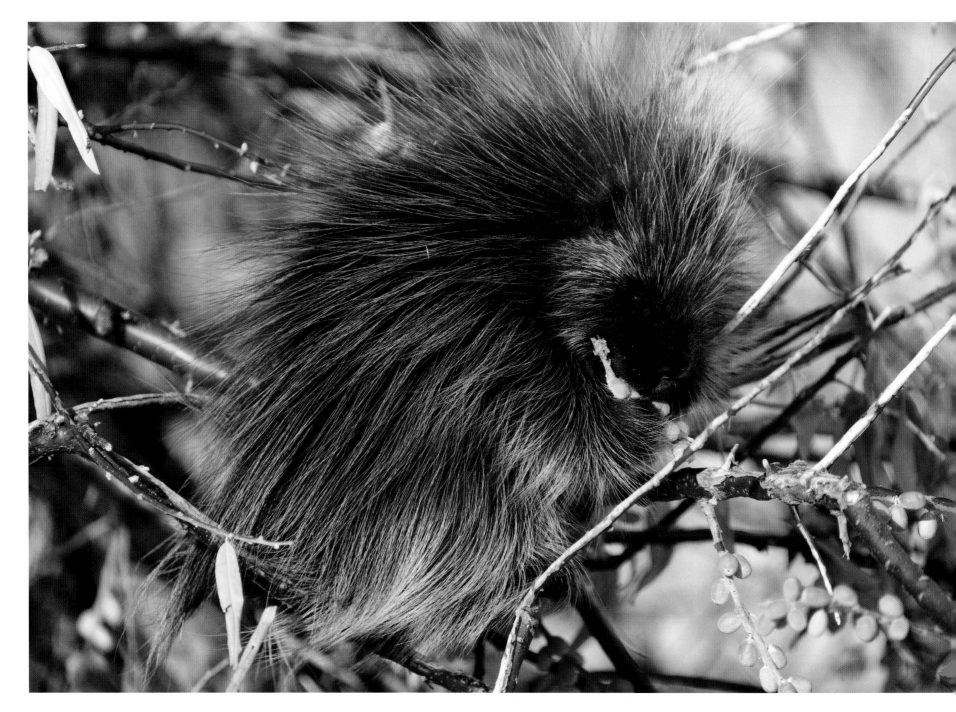

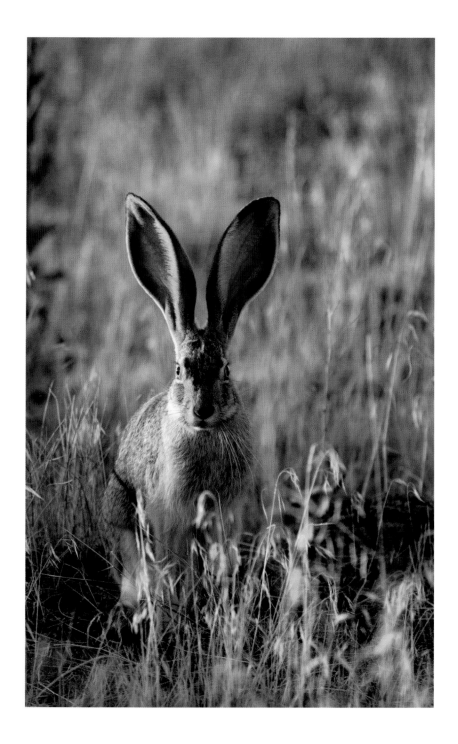

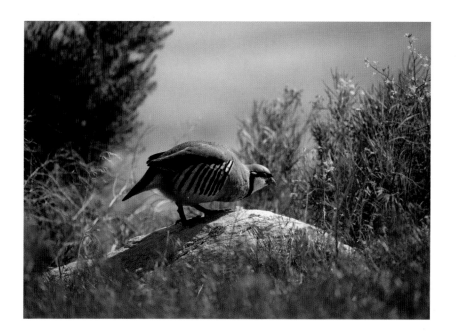

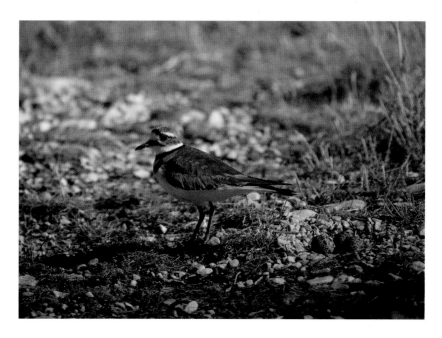

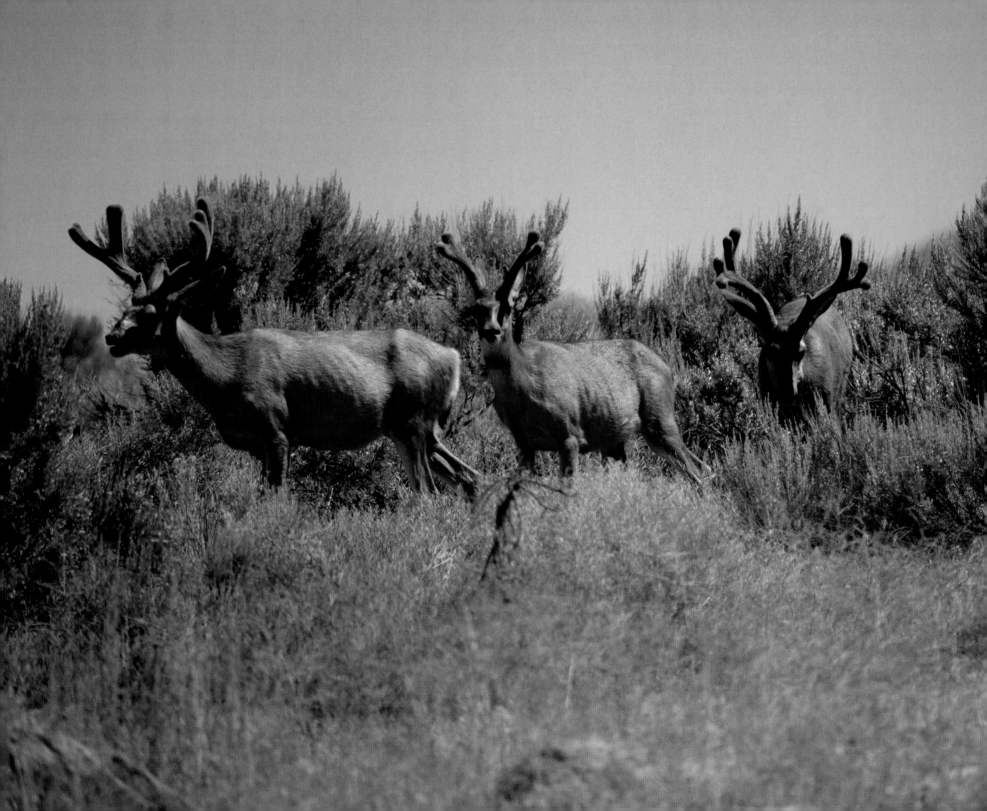

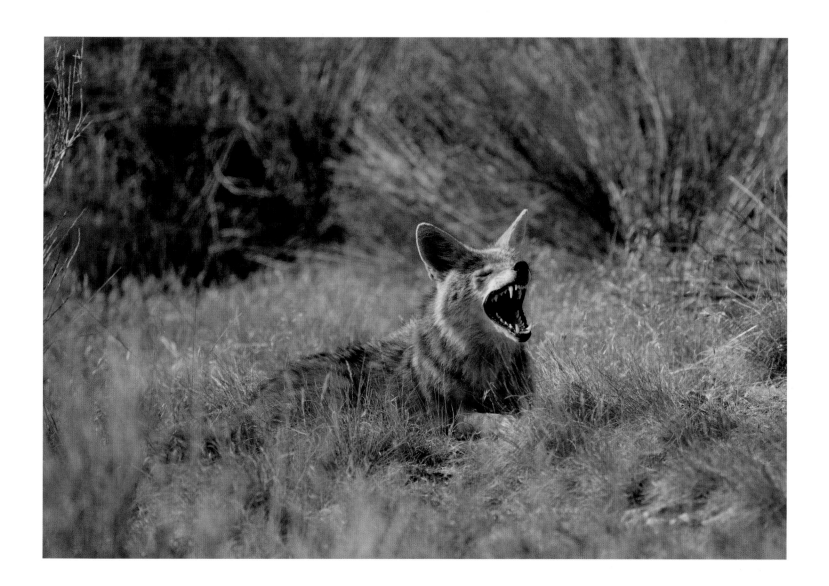

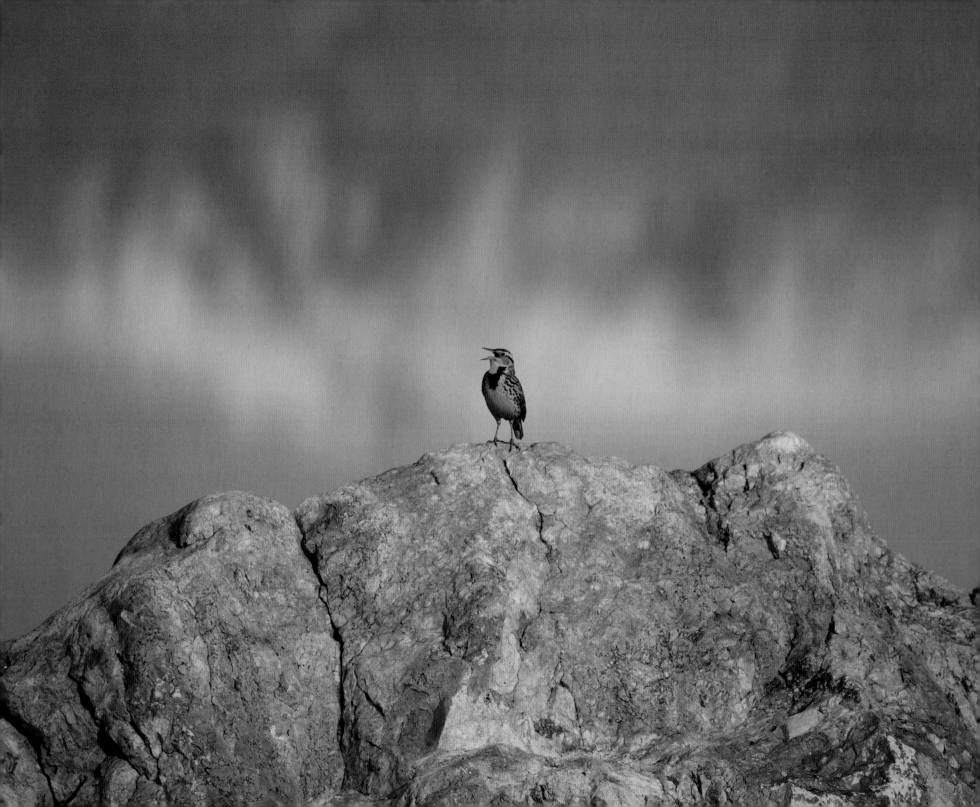

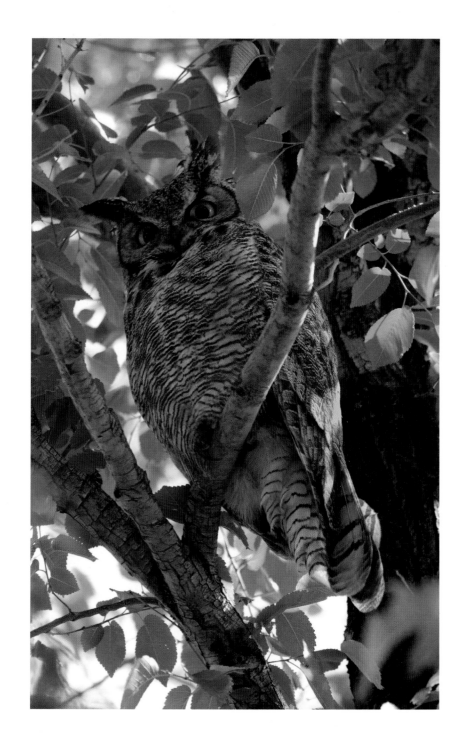

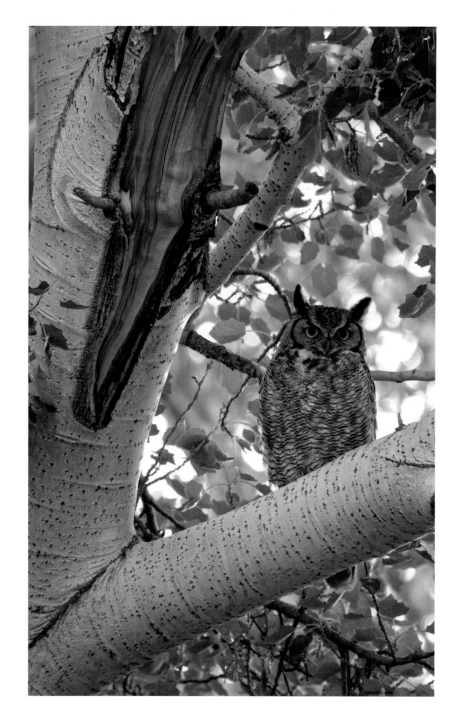

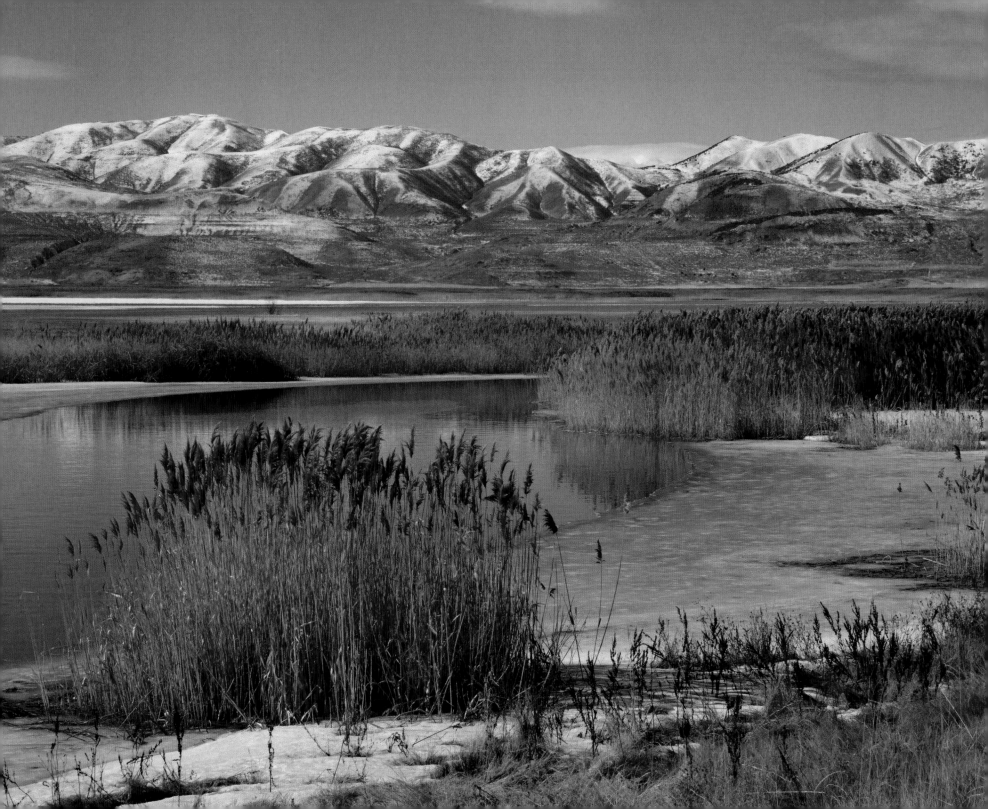

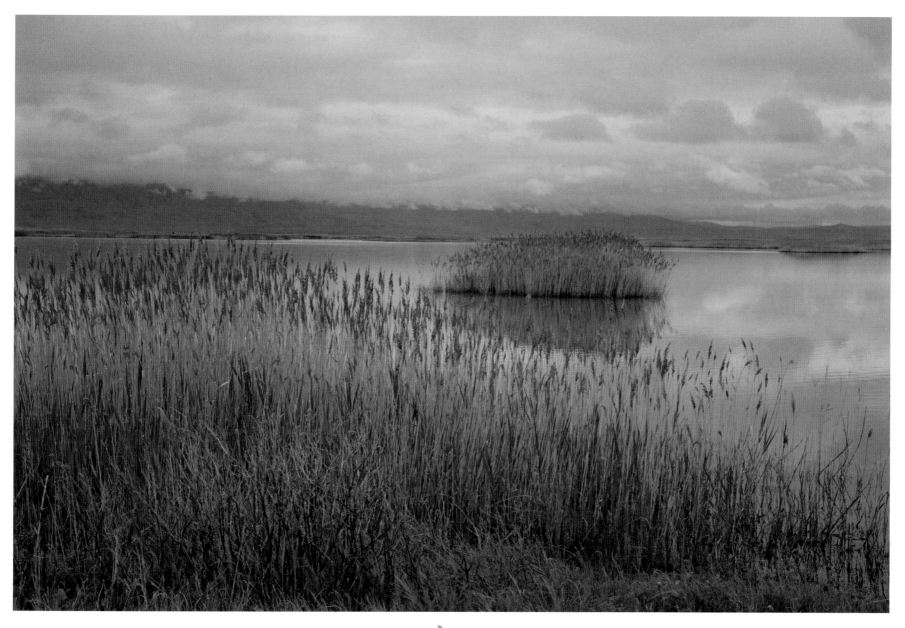

Bear River Migratory Bird Refuge

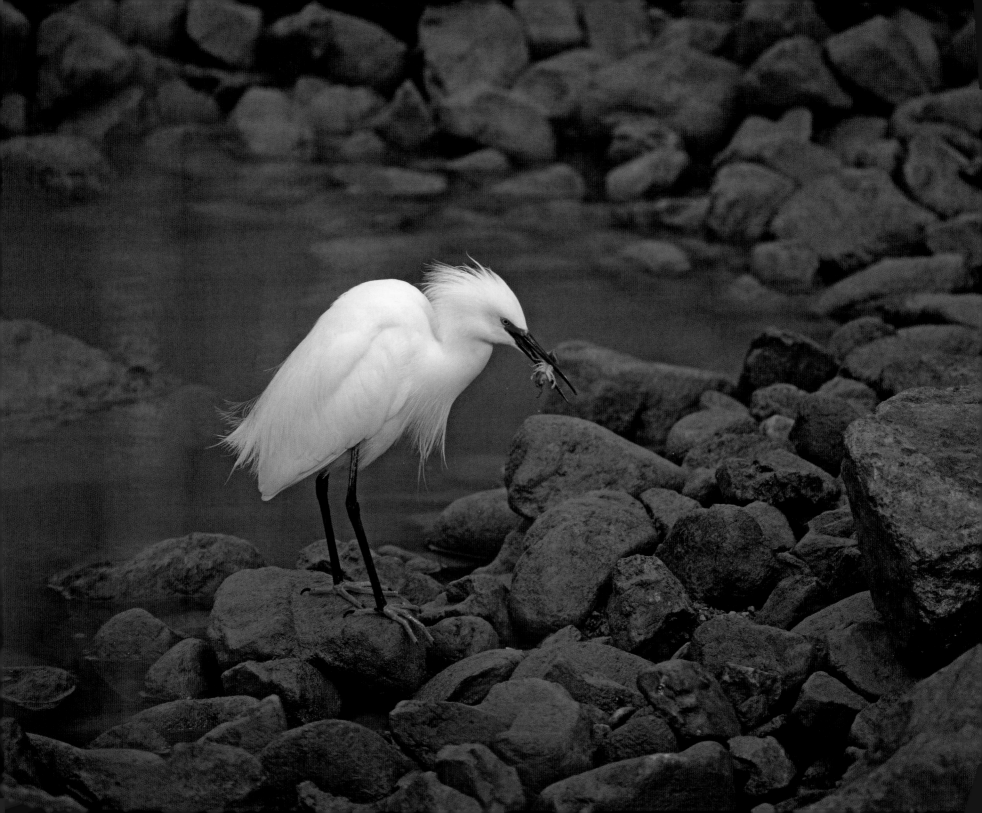

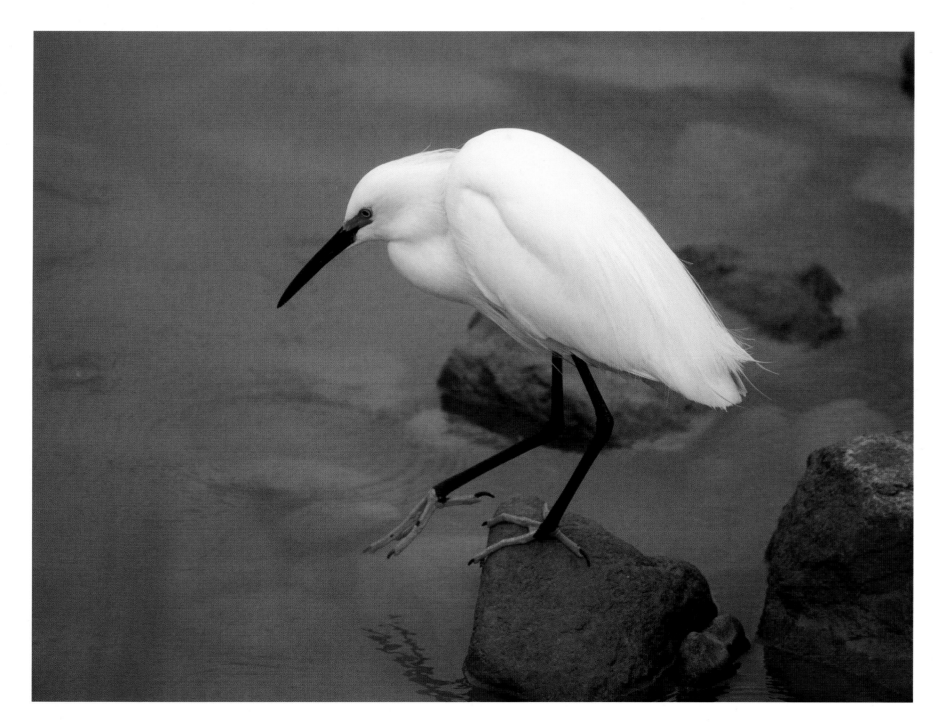

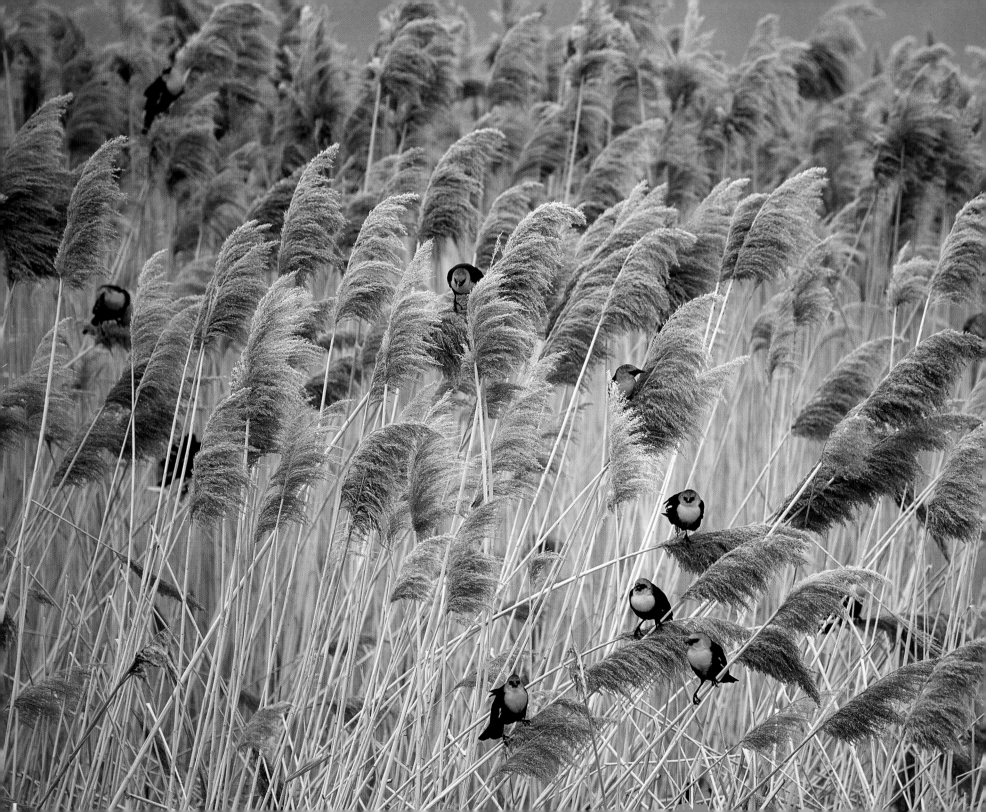

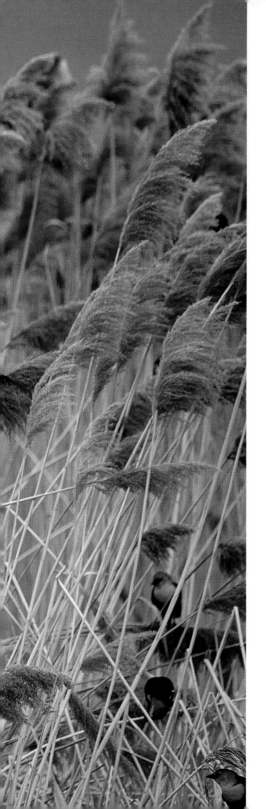

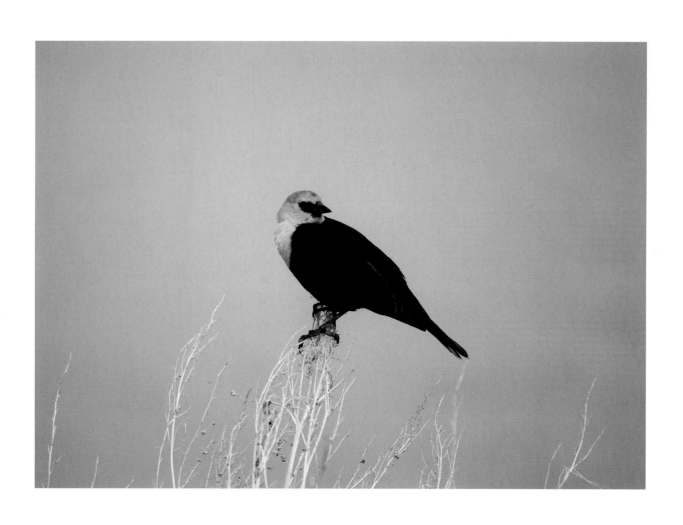

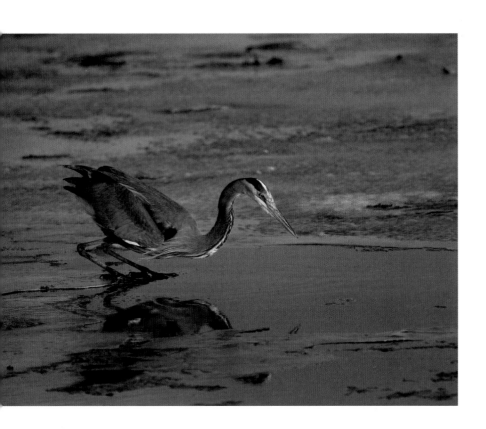
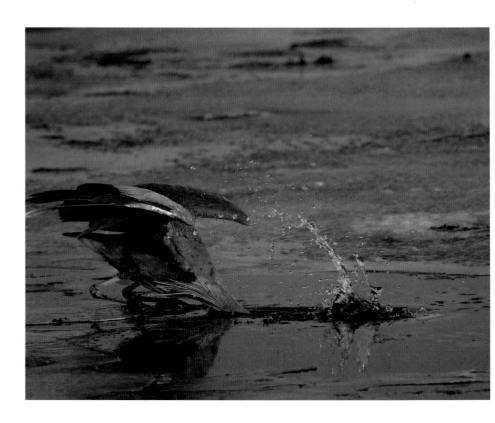

Wilderness. The

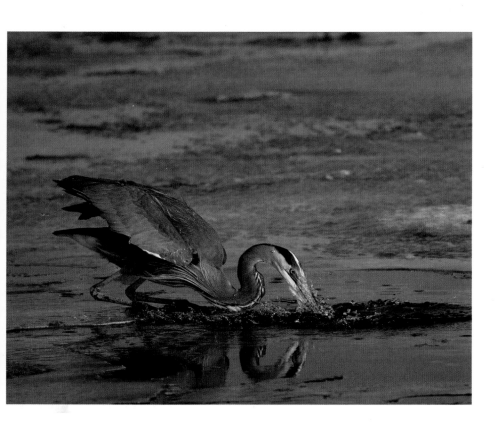 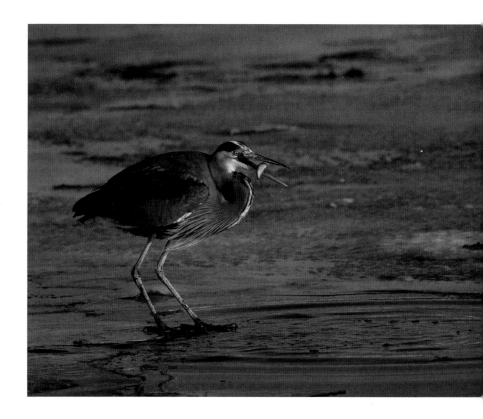

...word itself is music.

—EDWARD ABBEY

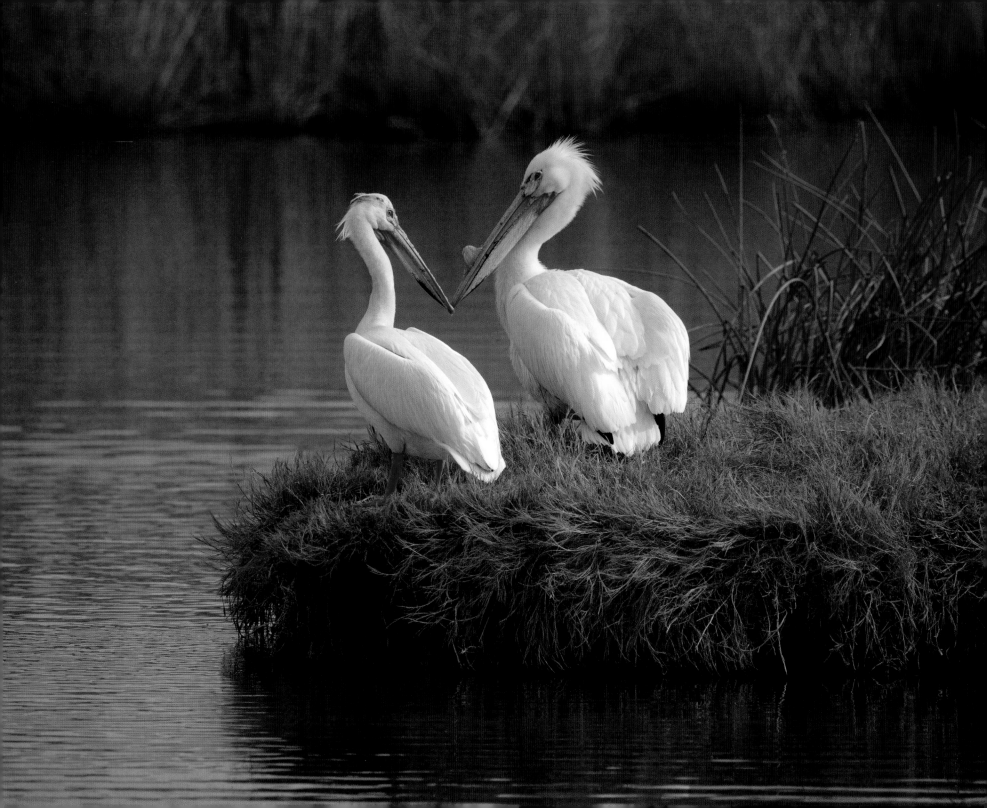

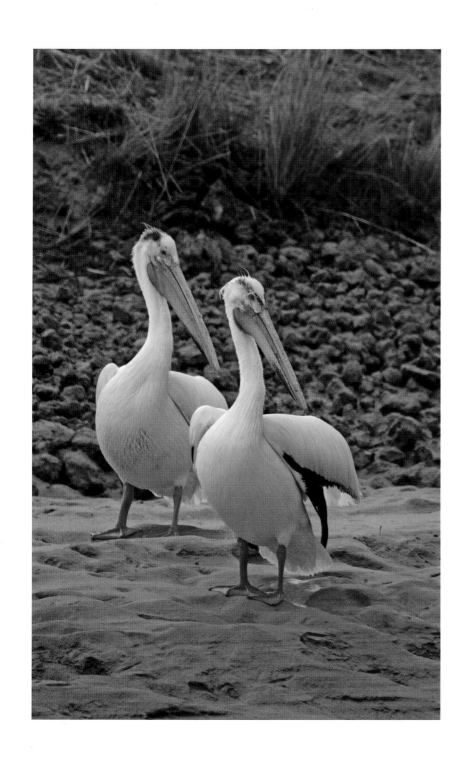

I pray to the birds because they remind me of what I love rather than what I fear. And at the end of my prayers, they teach me how to listen.

–TERRY TEMPEST WILLIAMS

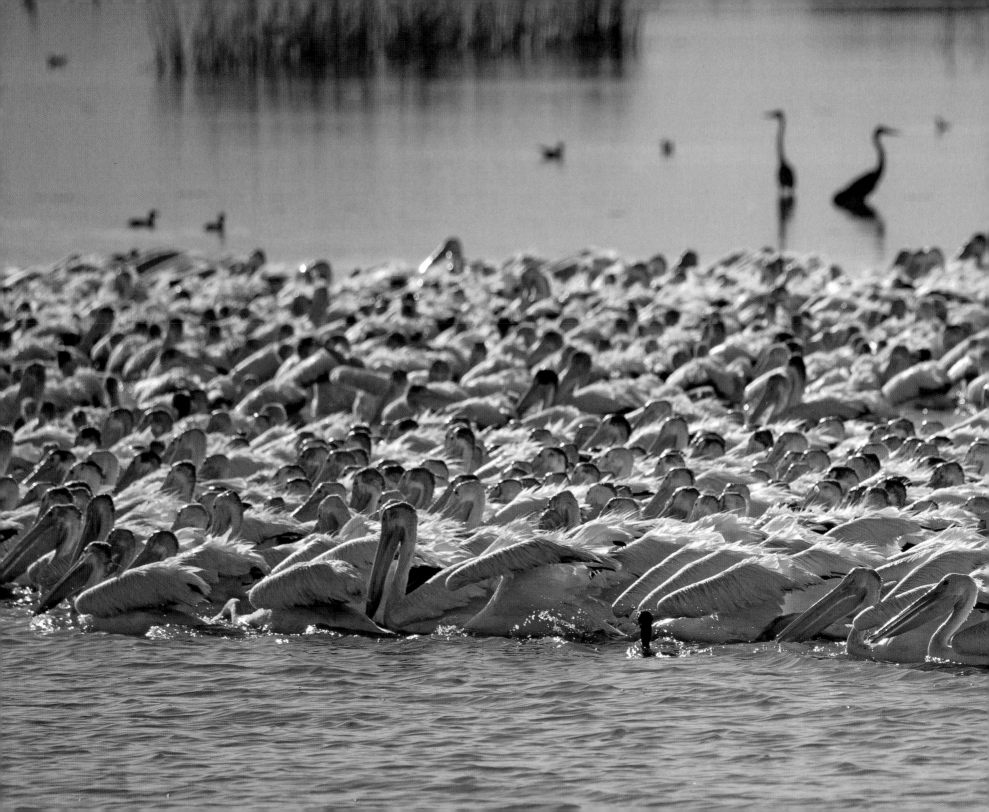

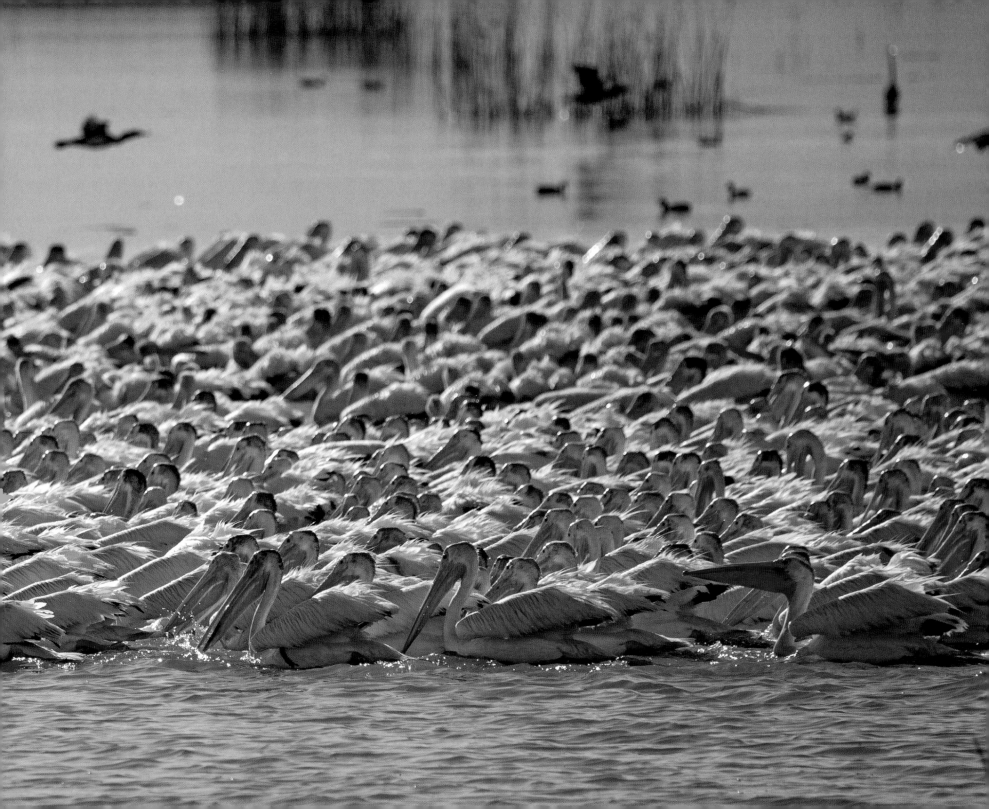

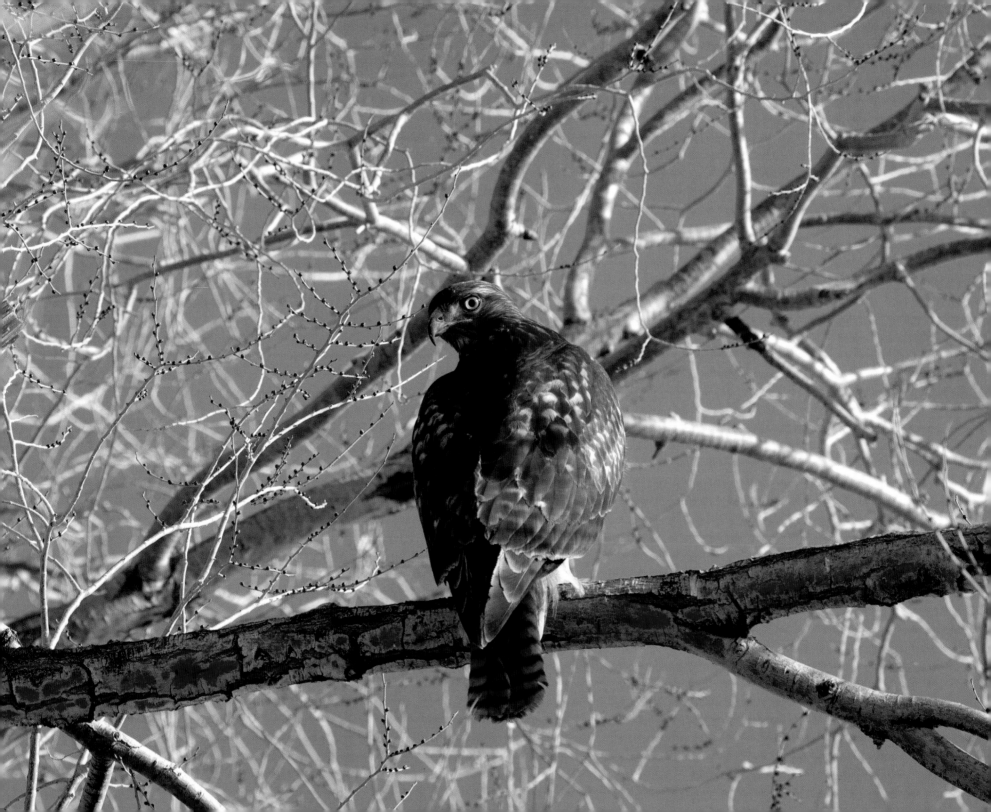

I should be glad if all the meadows on the earth were left in a wild state, if that were the consequence of man's beginning to redeem themselves. —HENRY DAVID THOREAU

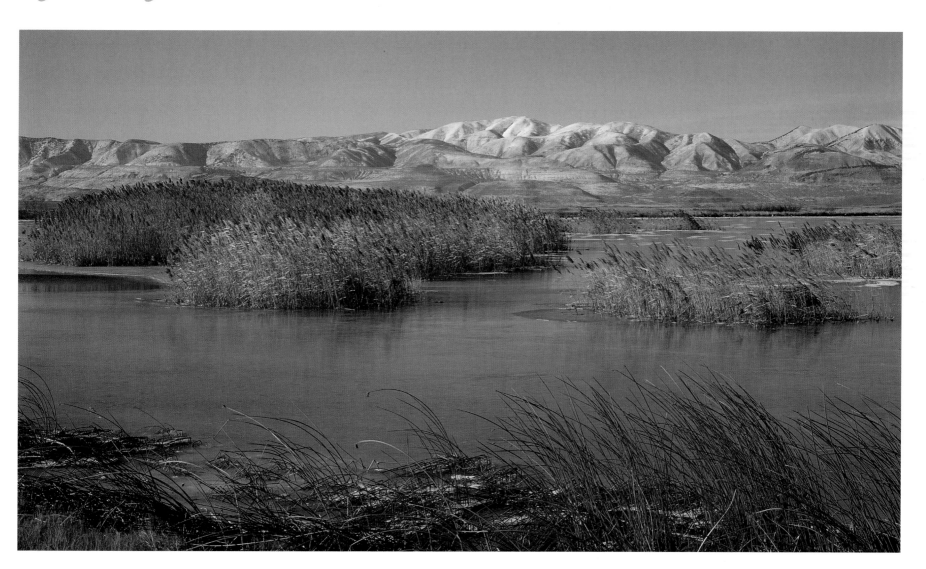

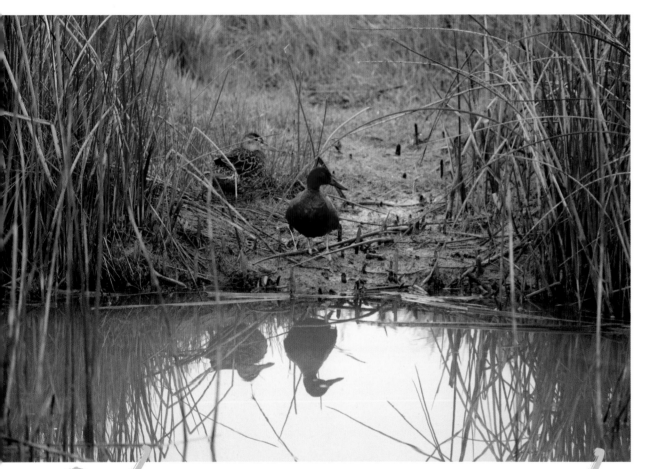

I have seen almost more

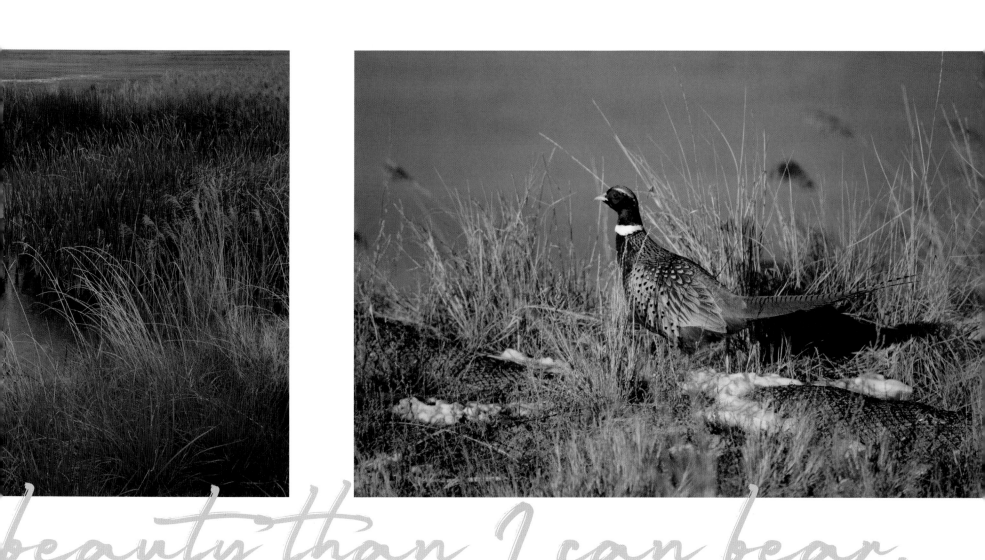

beauty than I can bear.

—EVERETT RUESS

The wilderness holds answers to questions man has not yet learned to ask. —NANCY NEWHALL

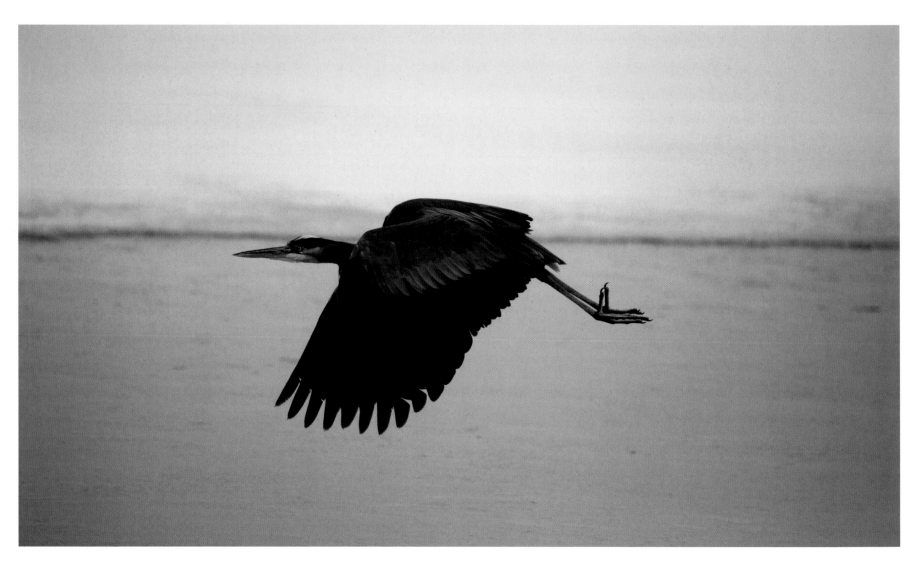

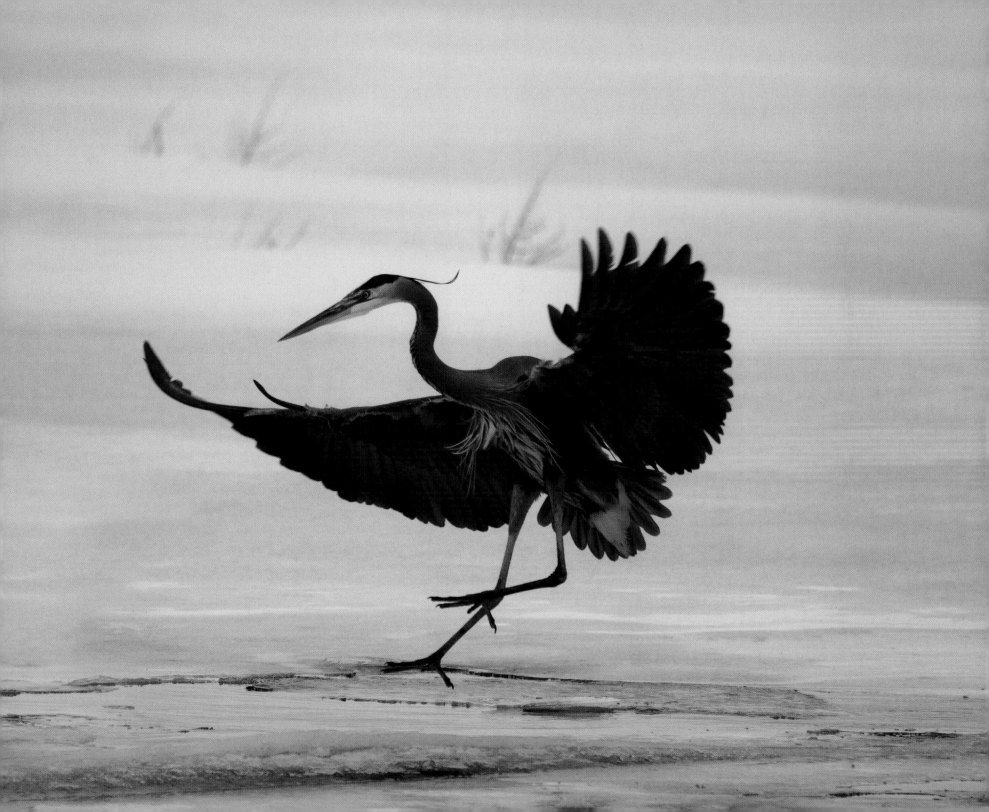

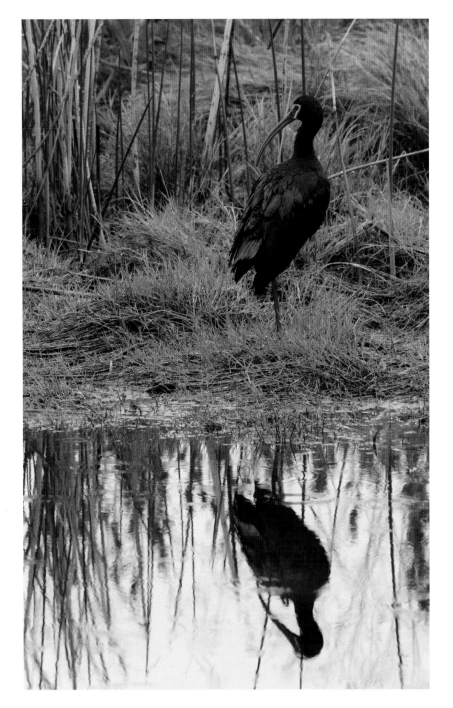

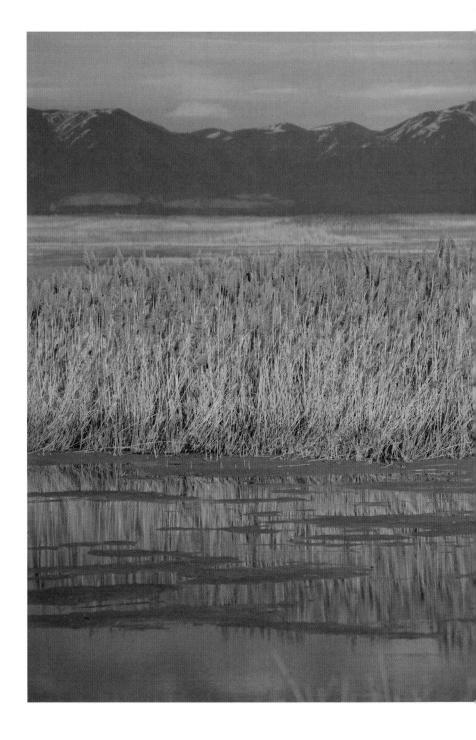

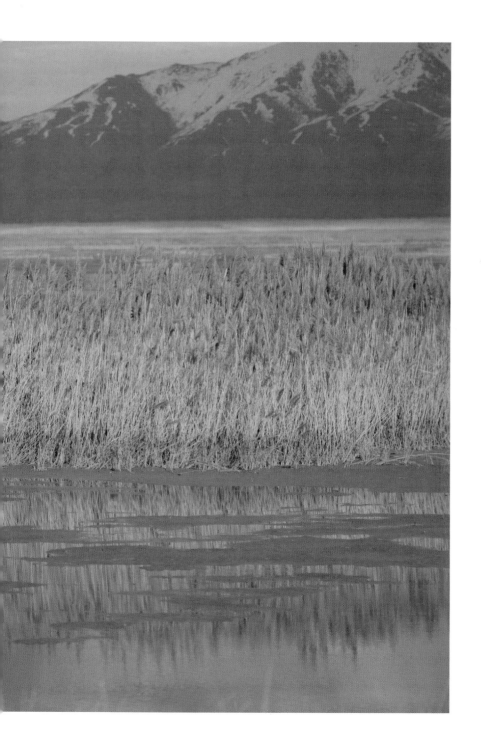

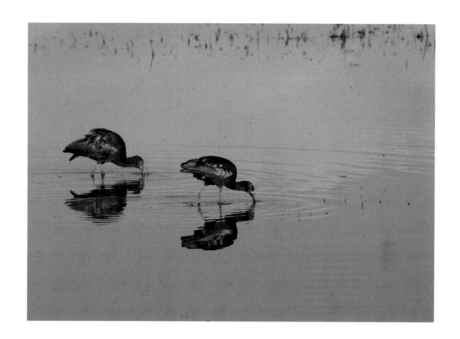

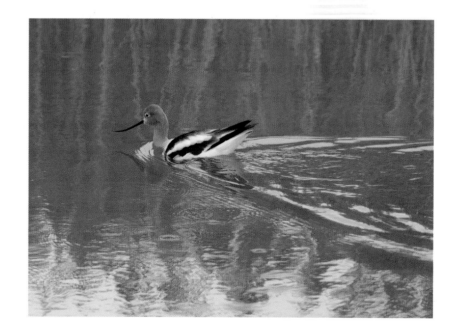

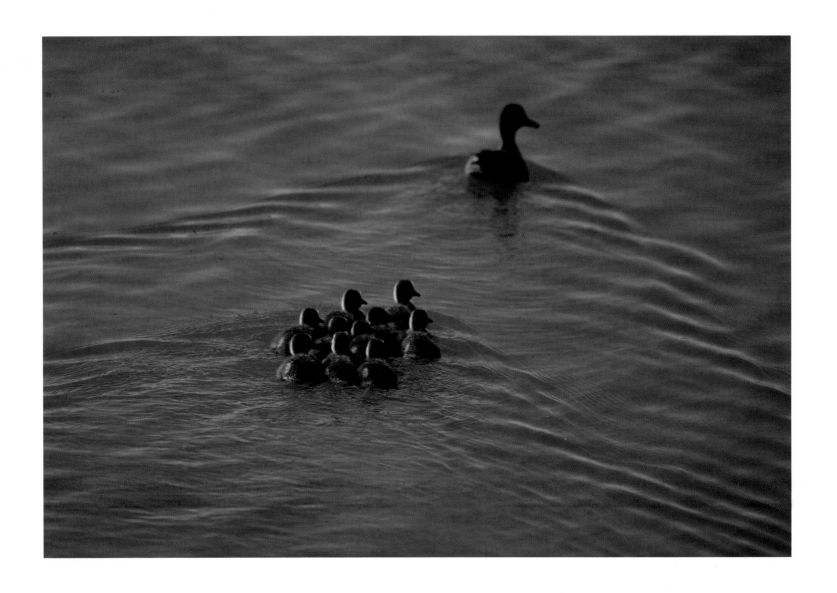

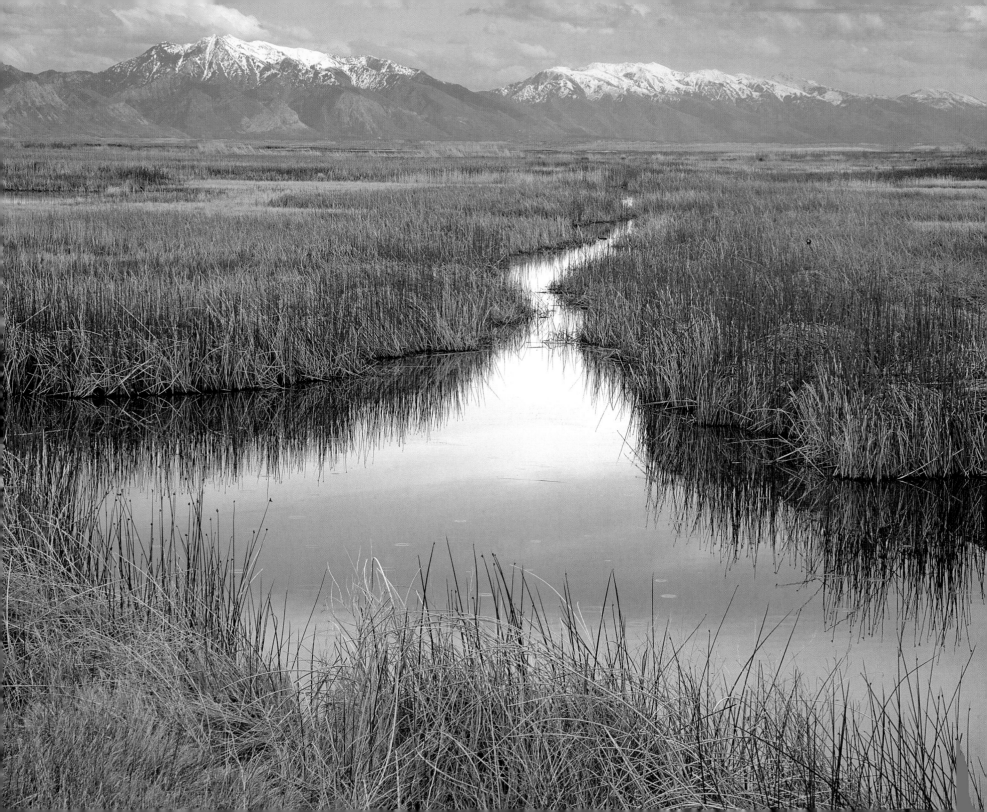

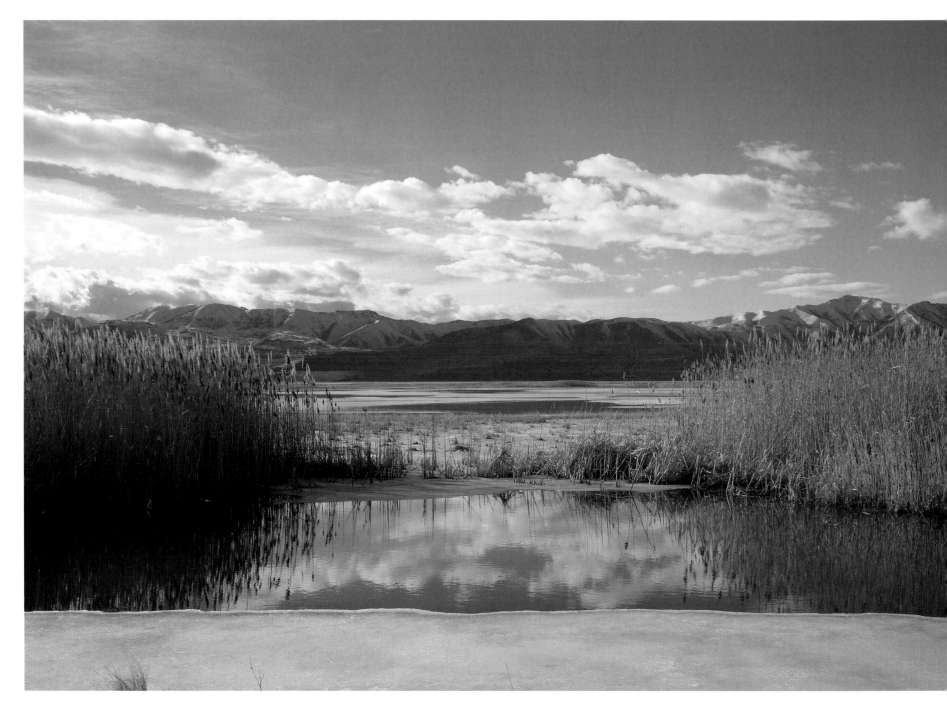

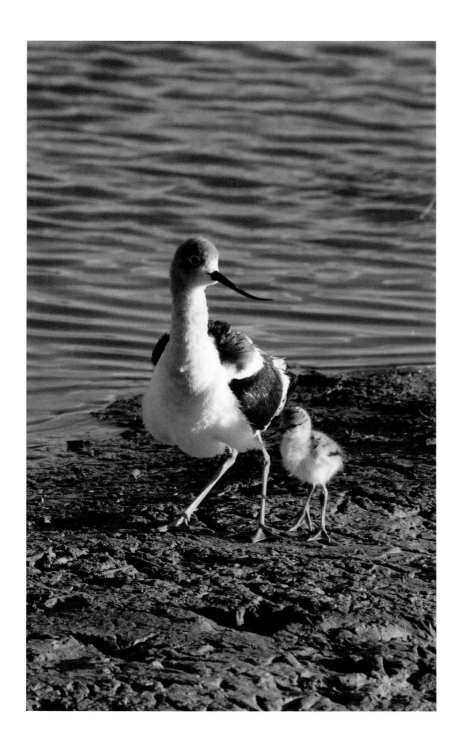

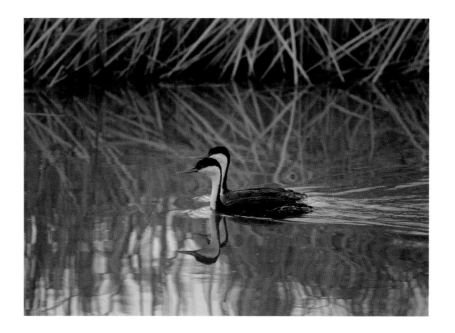

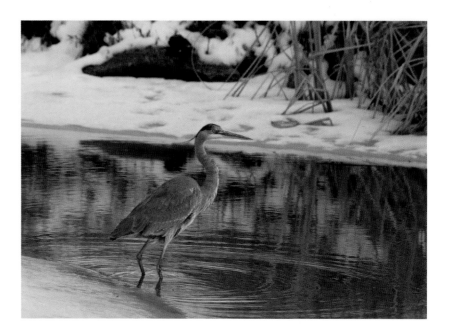

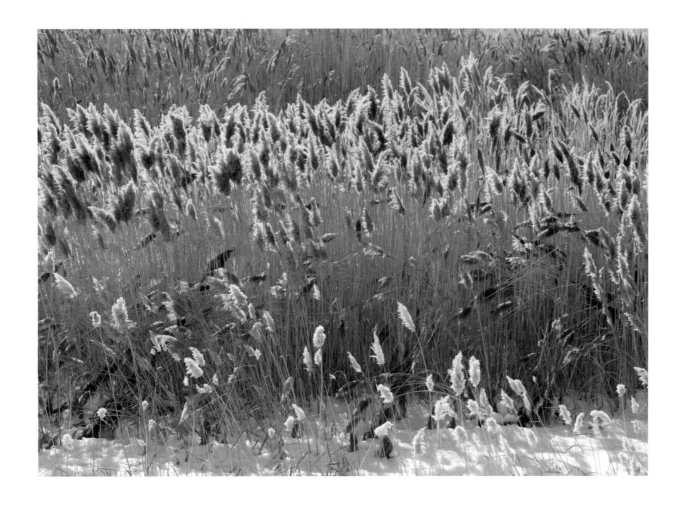

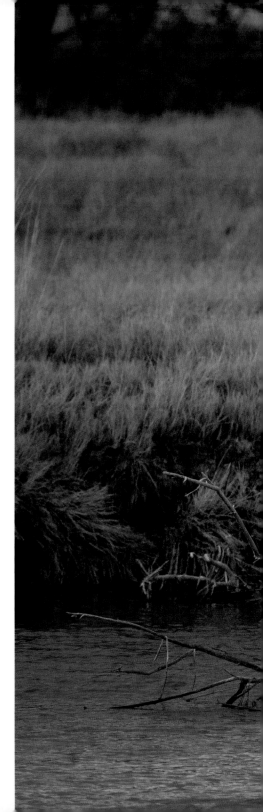

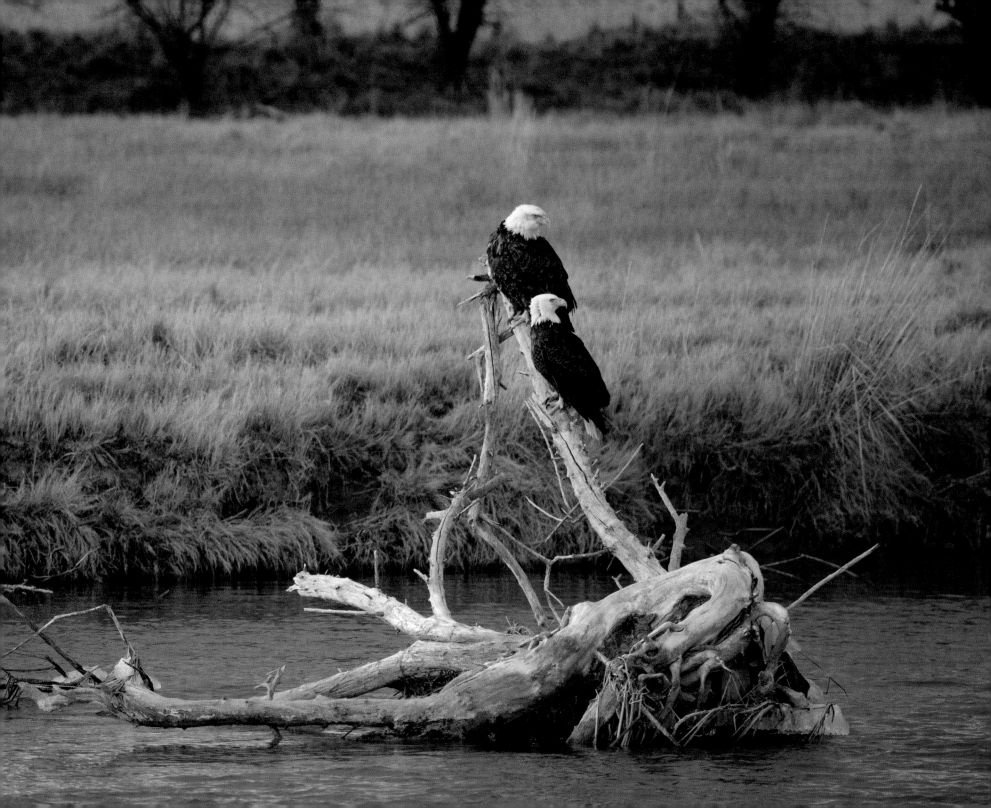

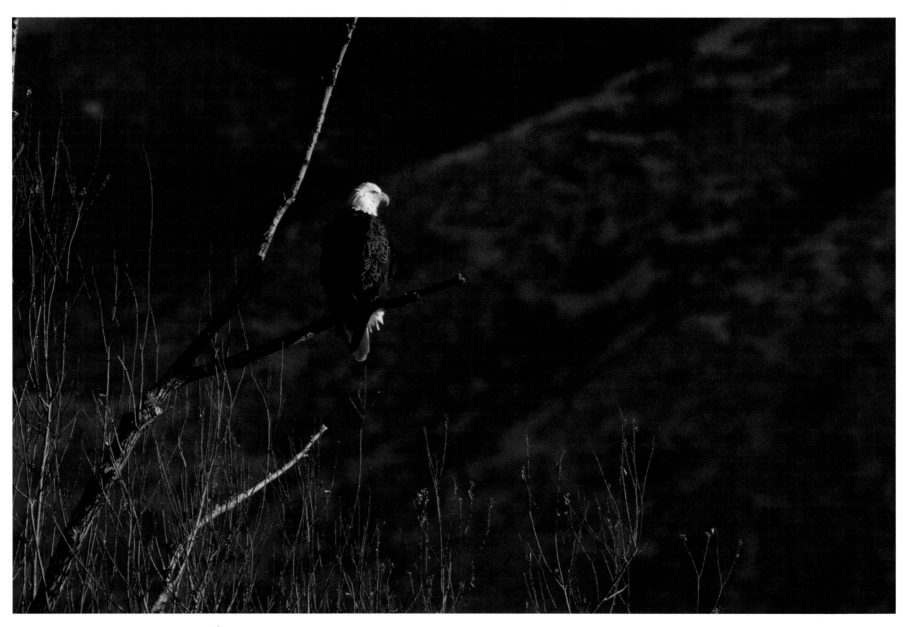

Farmington Bay

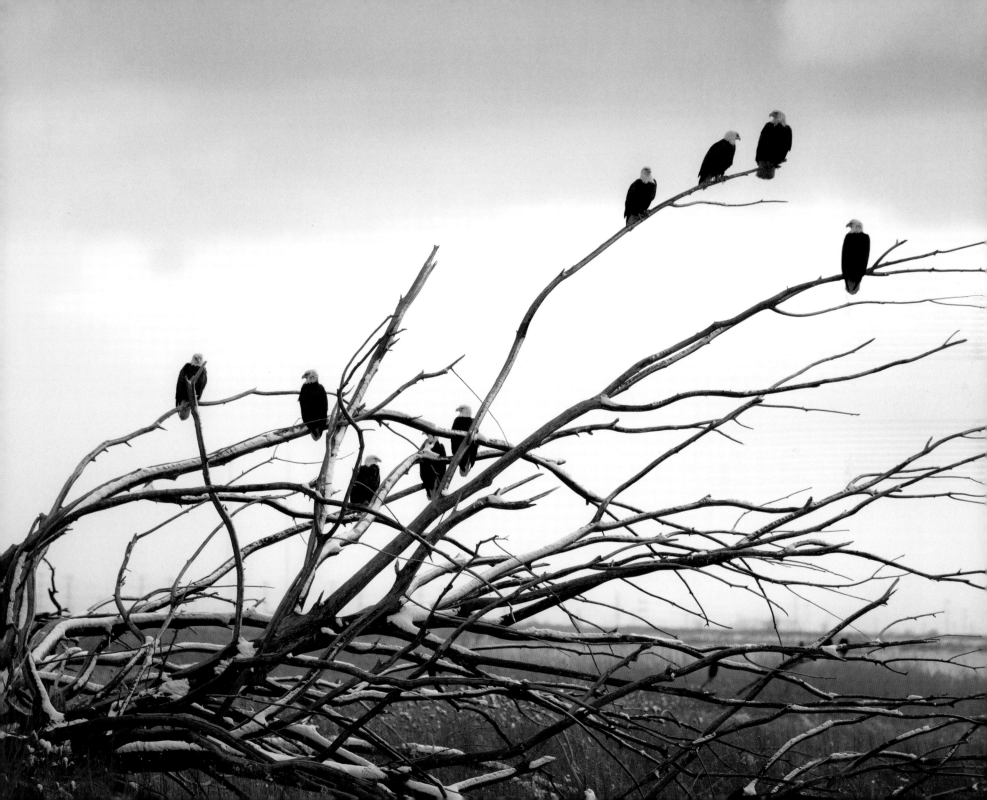

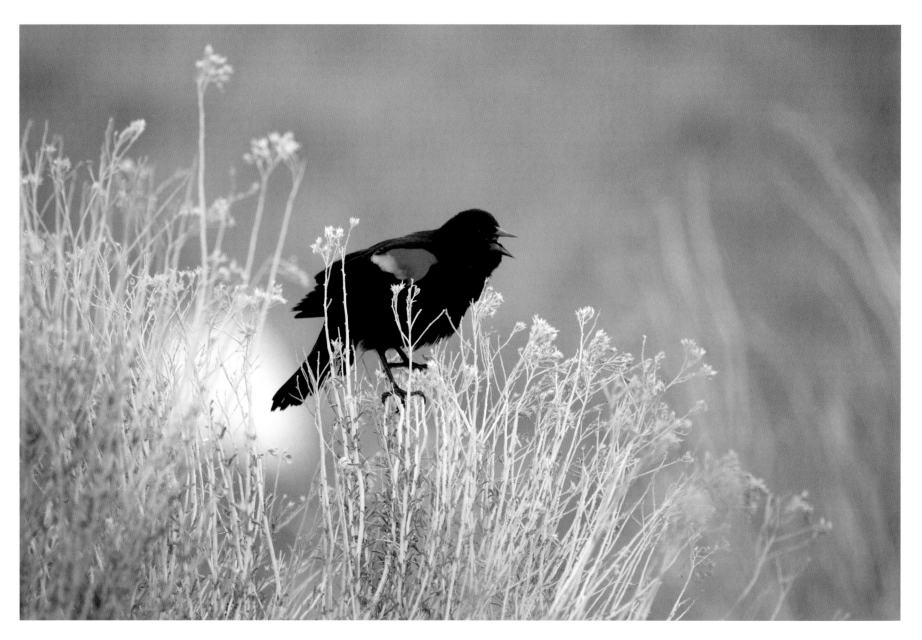

Henefer

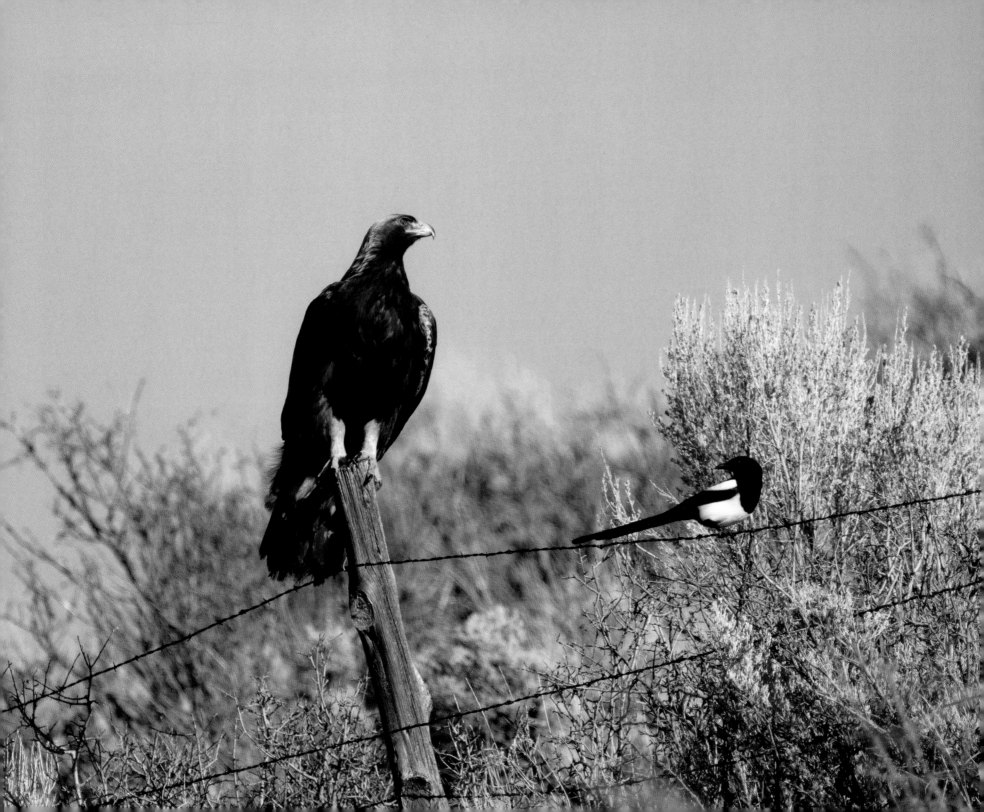

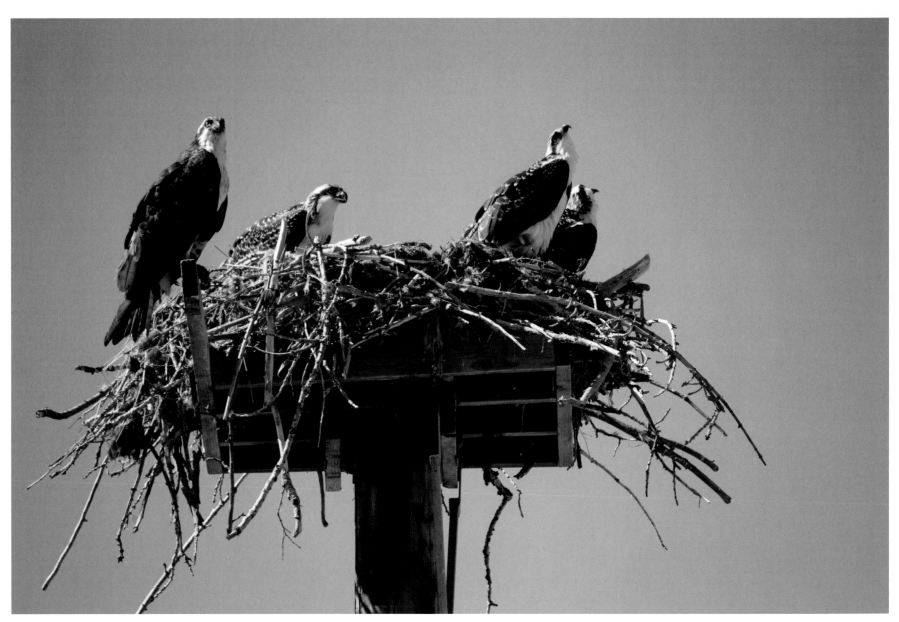

Huntsville

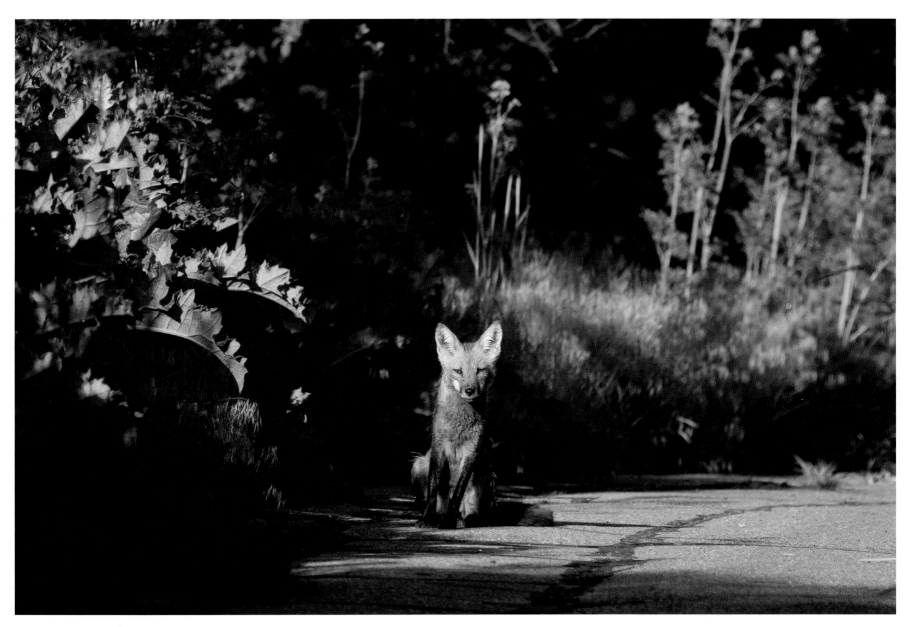

Layton

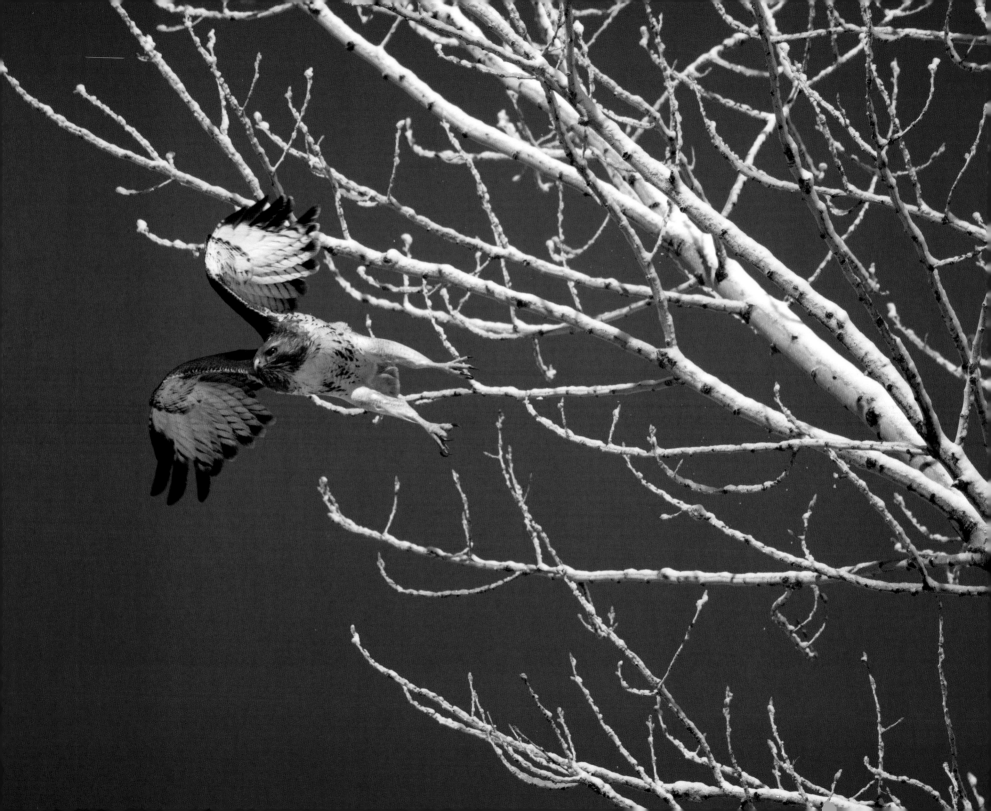

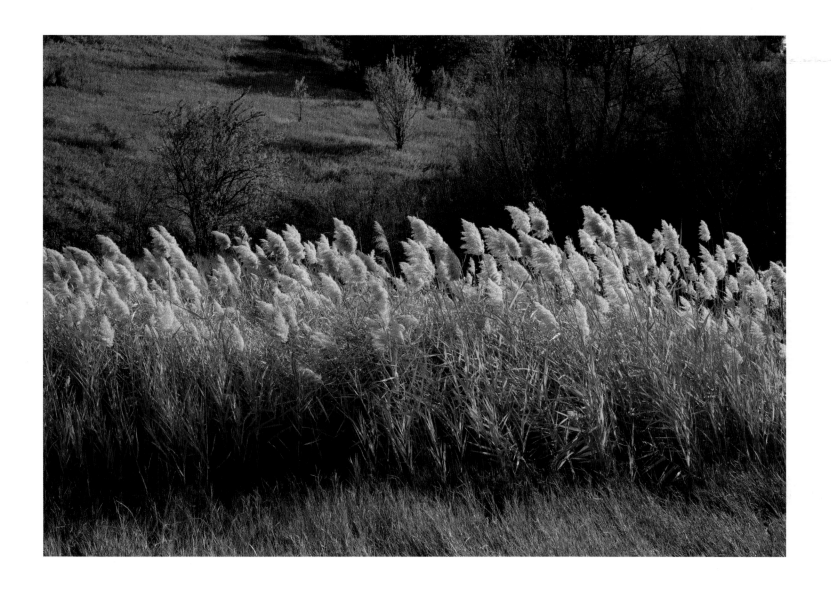

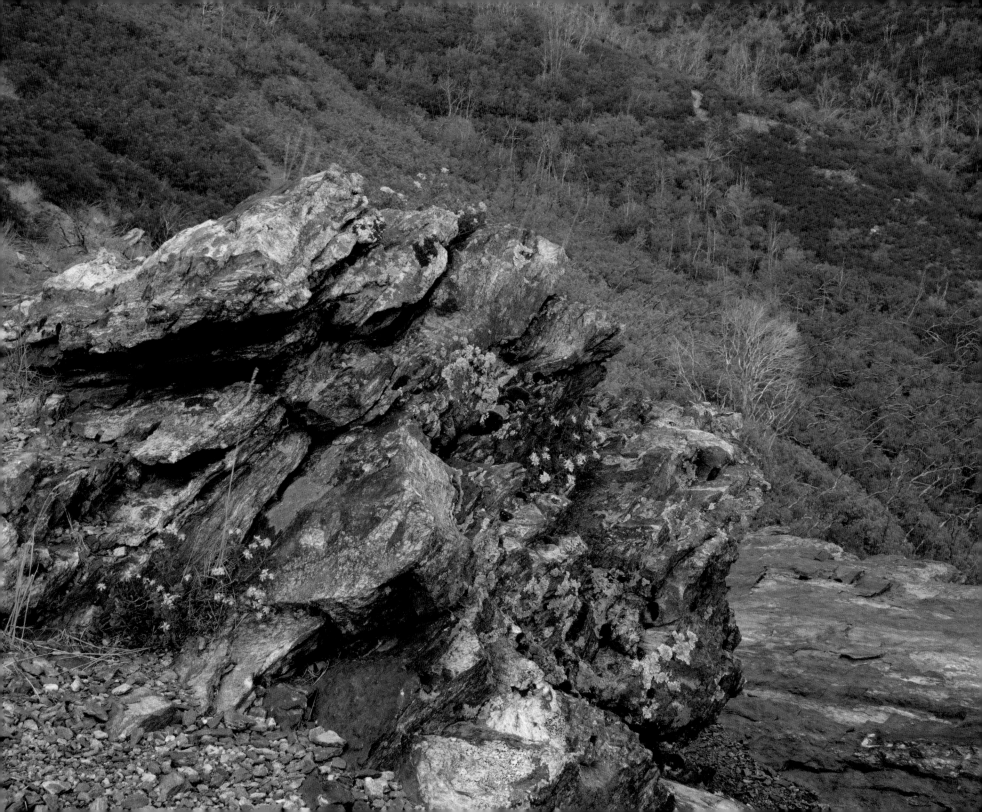

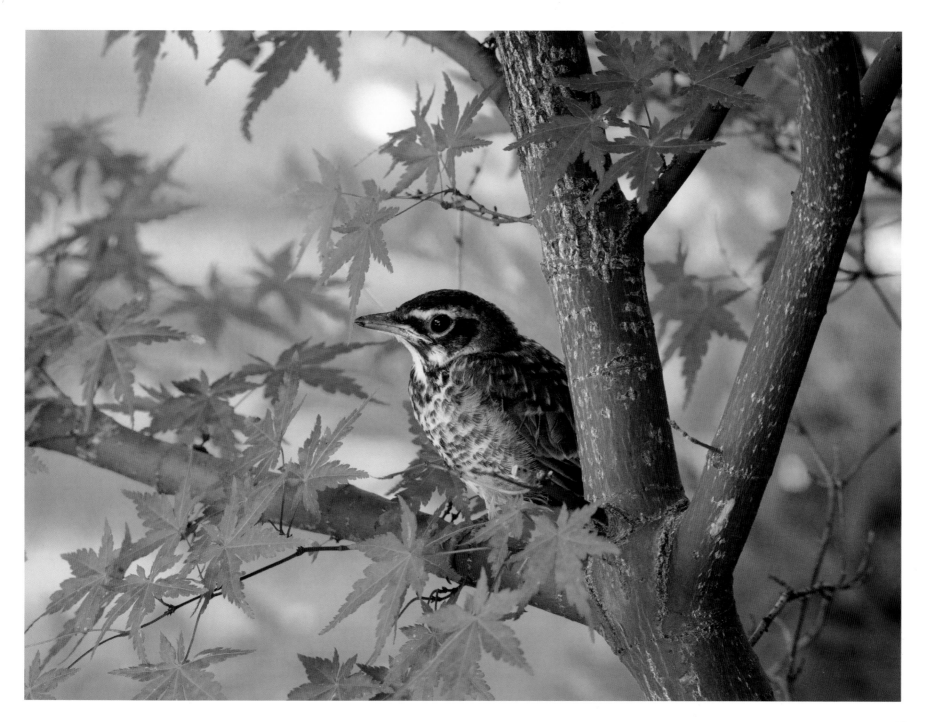

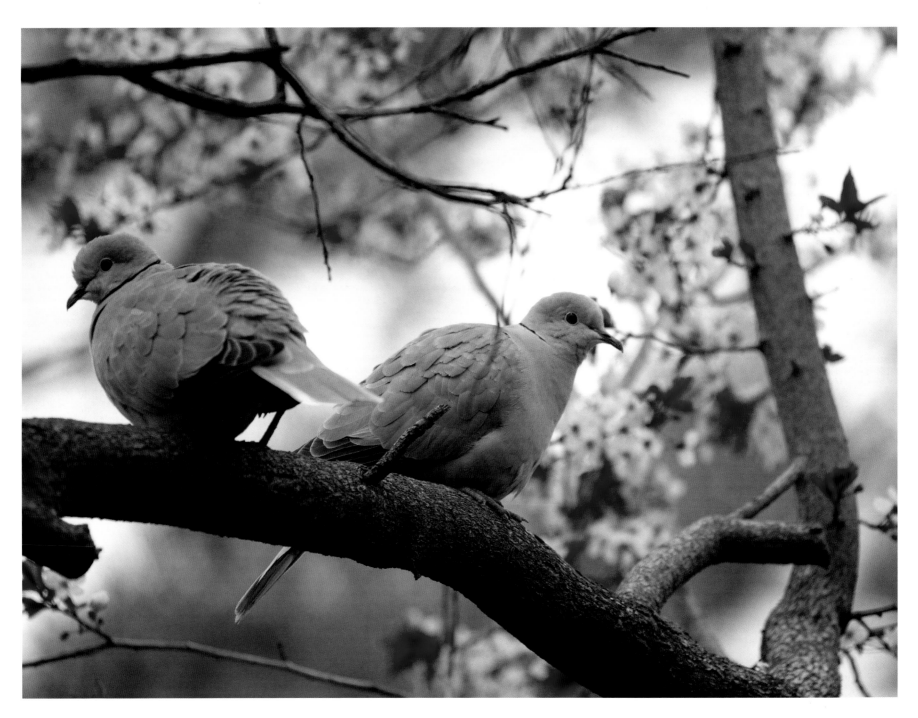

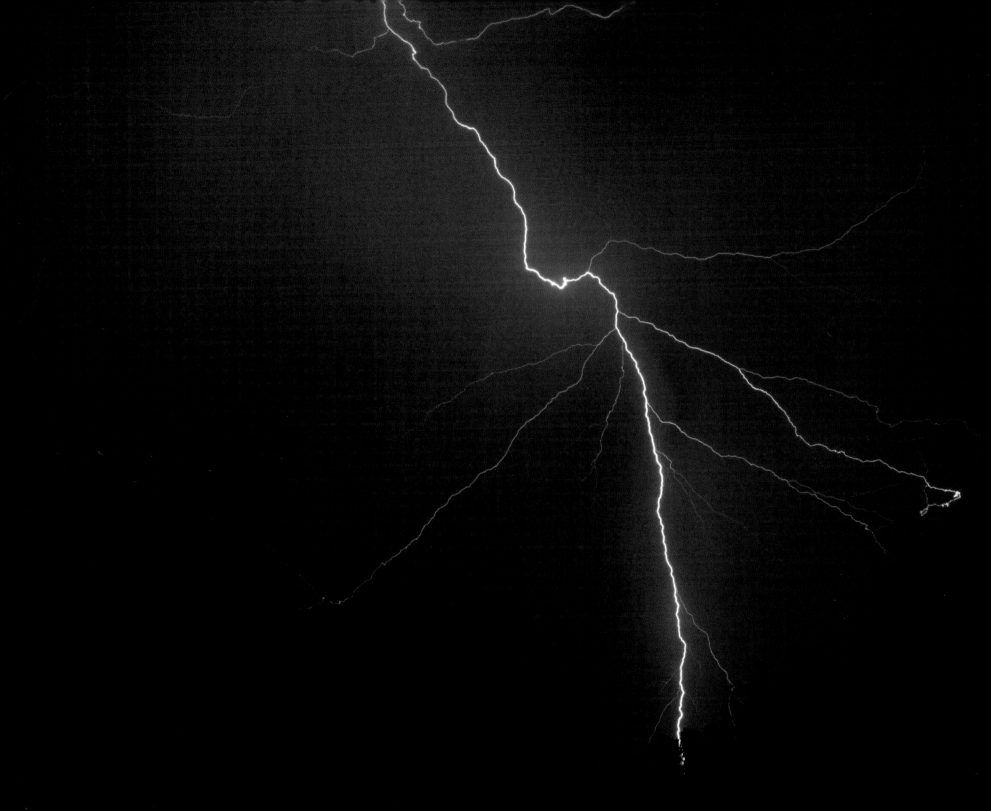

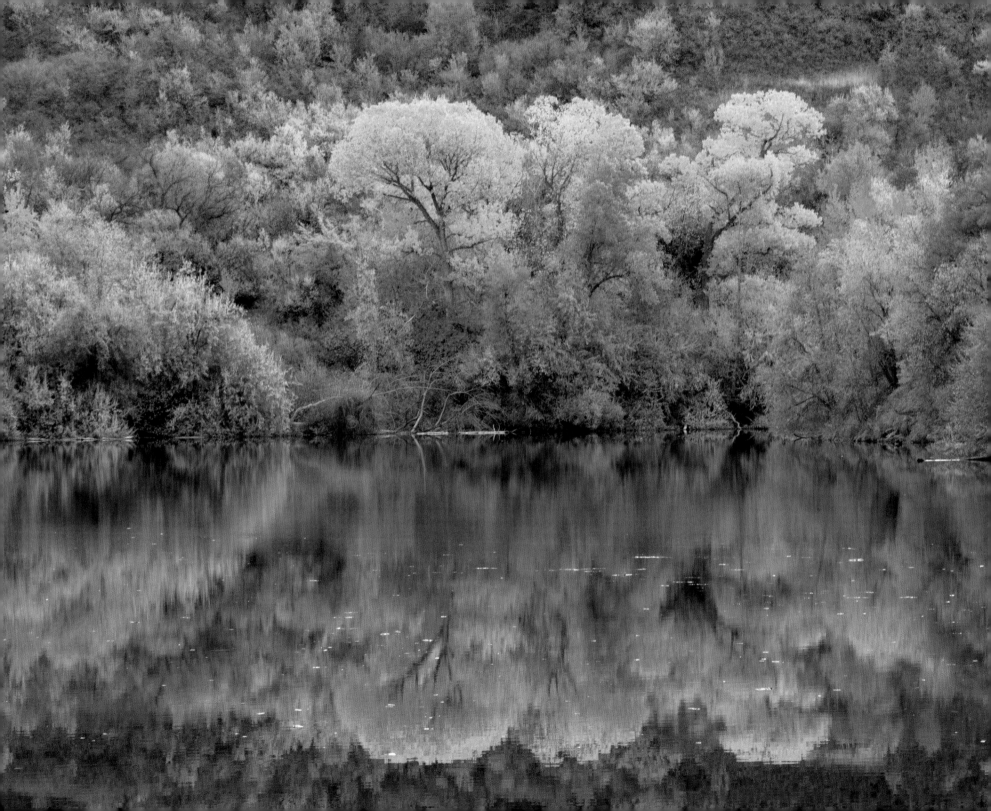

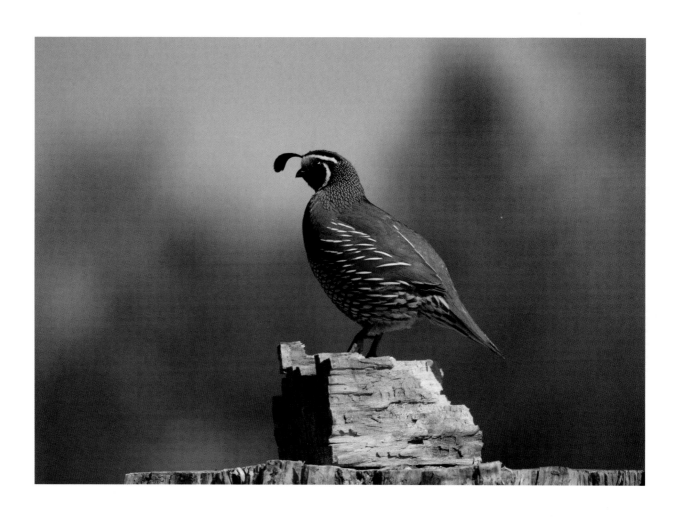

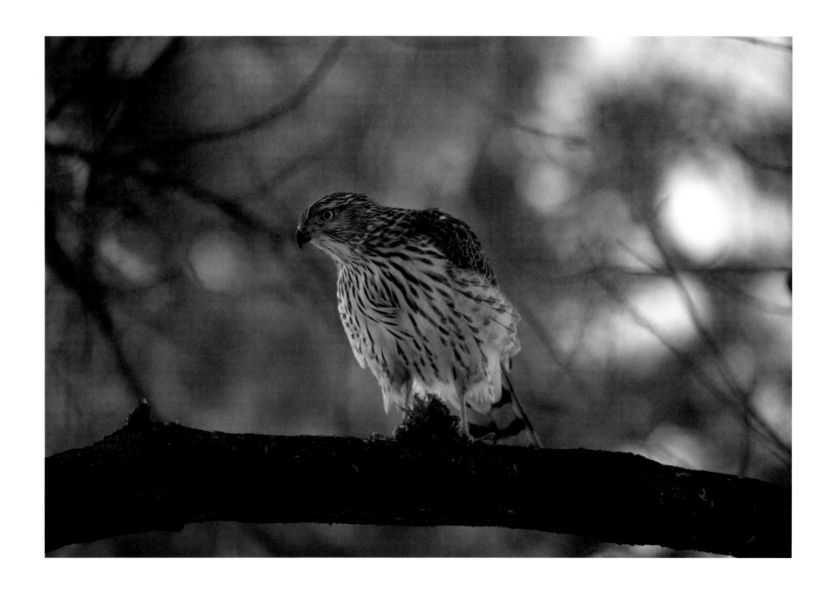

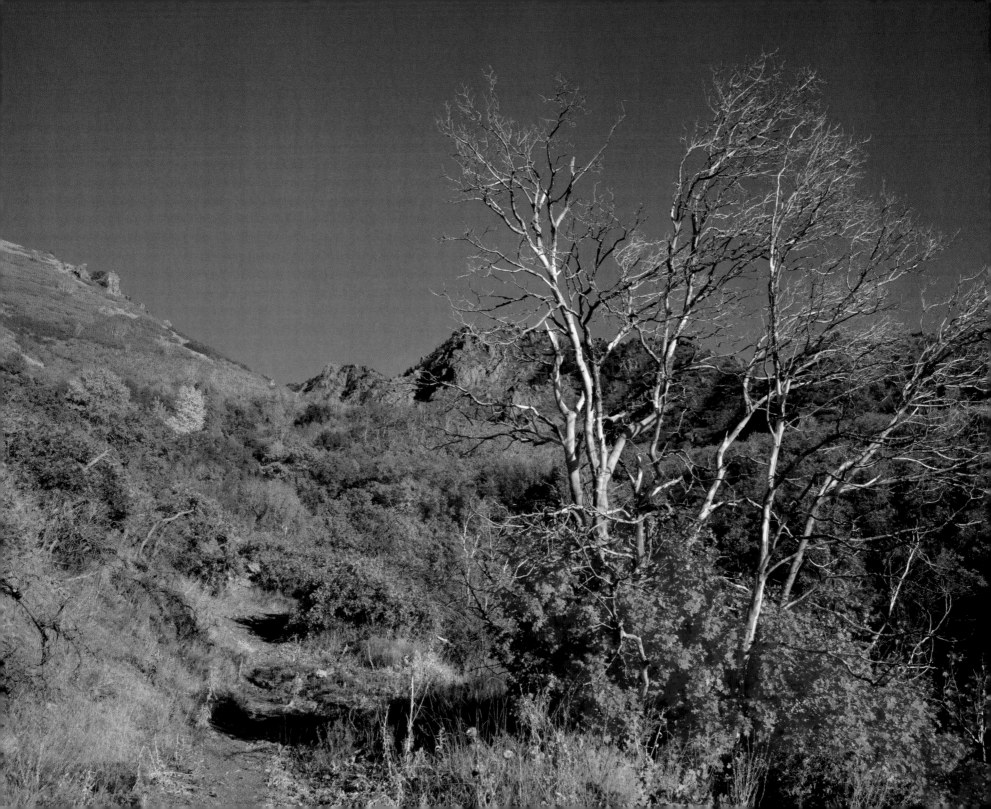

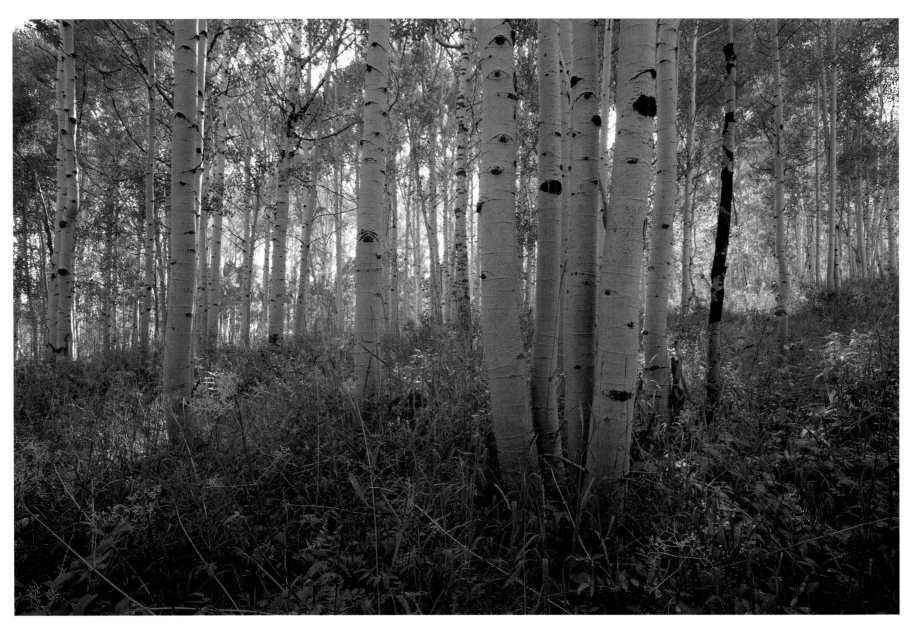

Mount Pleasant

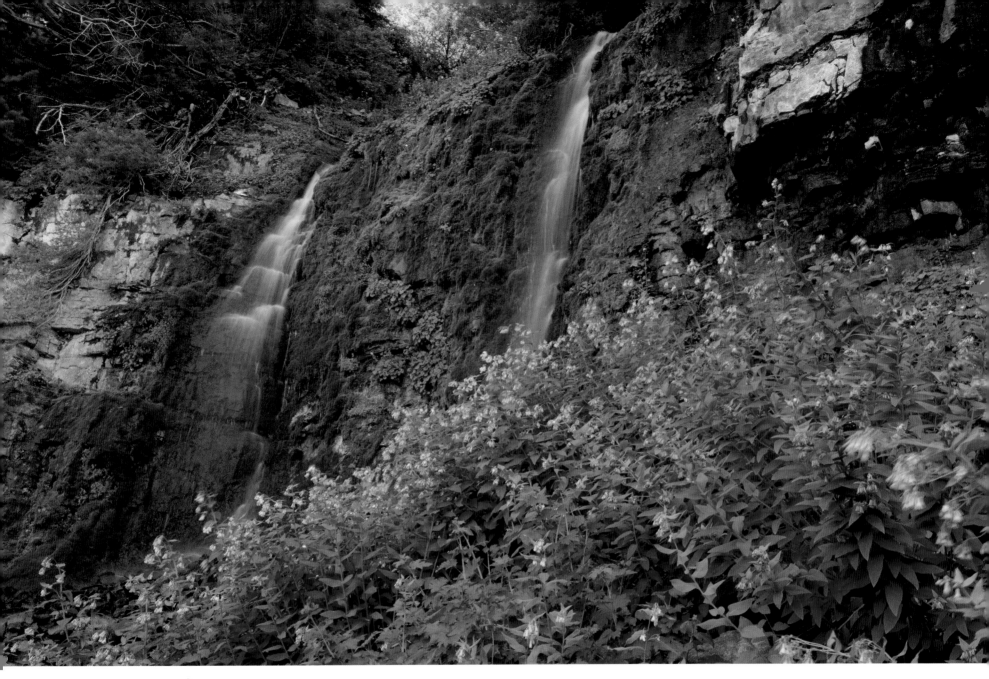

Mount Timpanogos

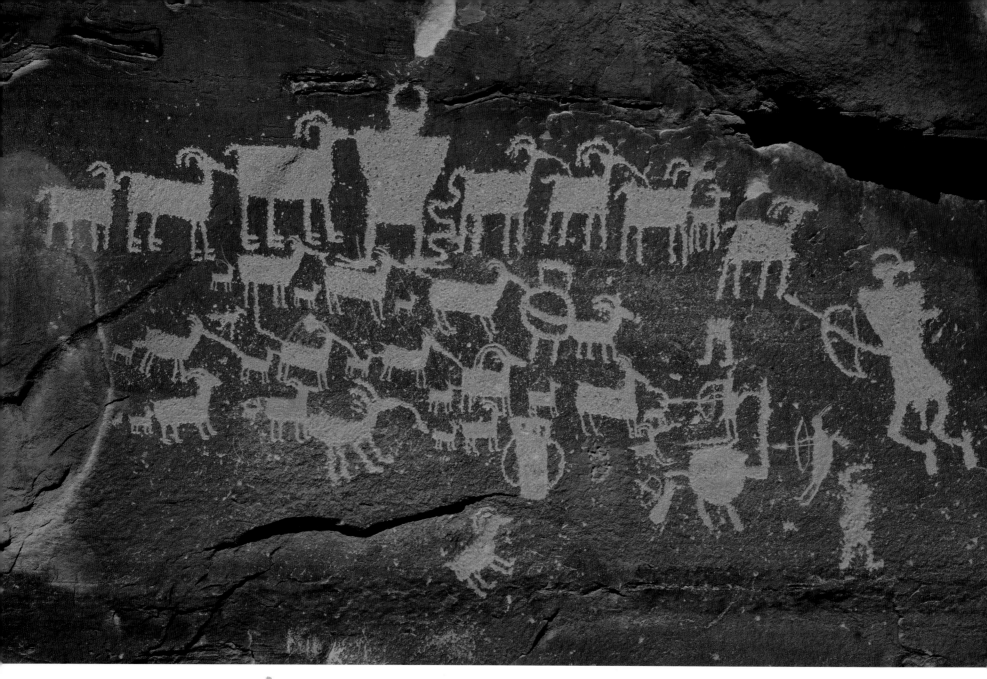

Nine Mile Canyon

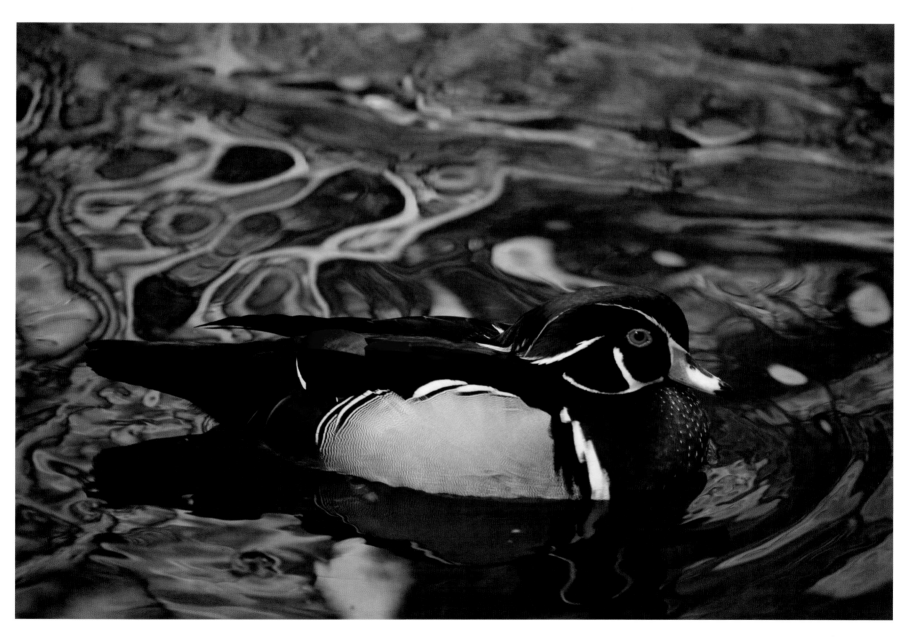

Provo

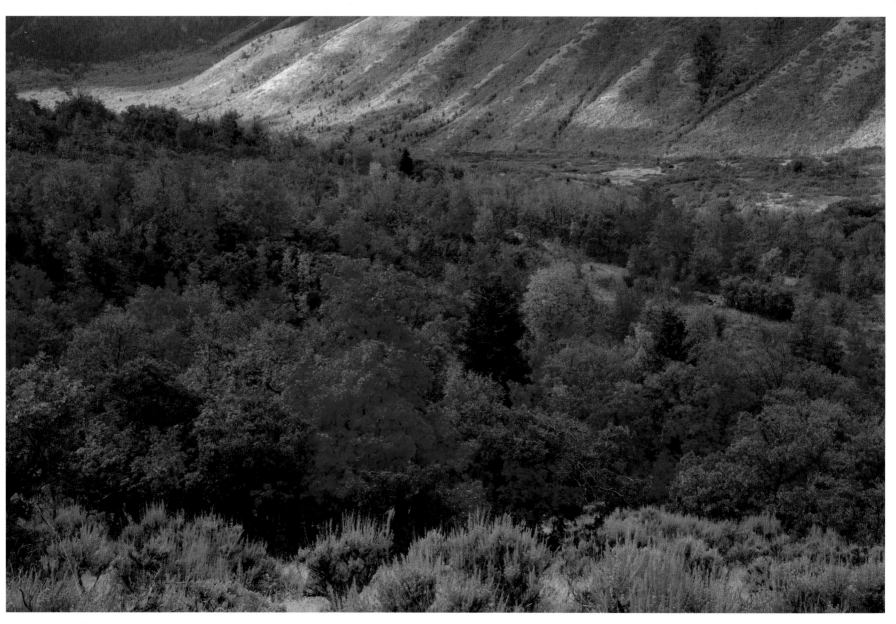

Salem

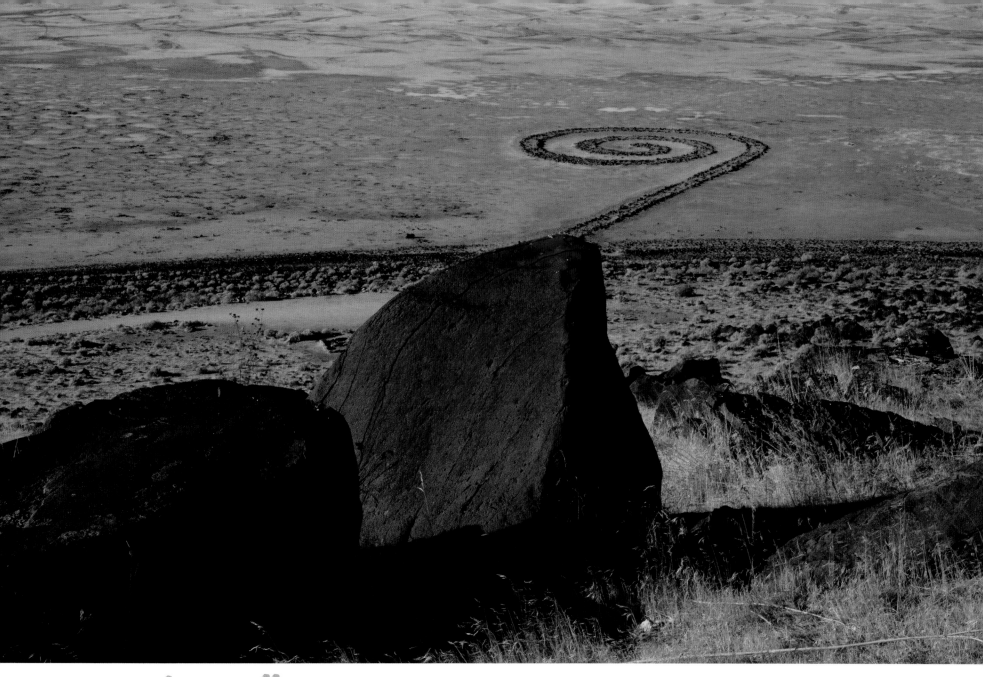

Spiral Jetty

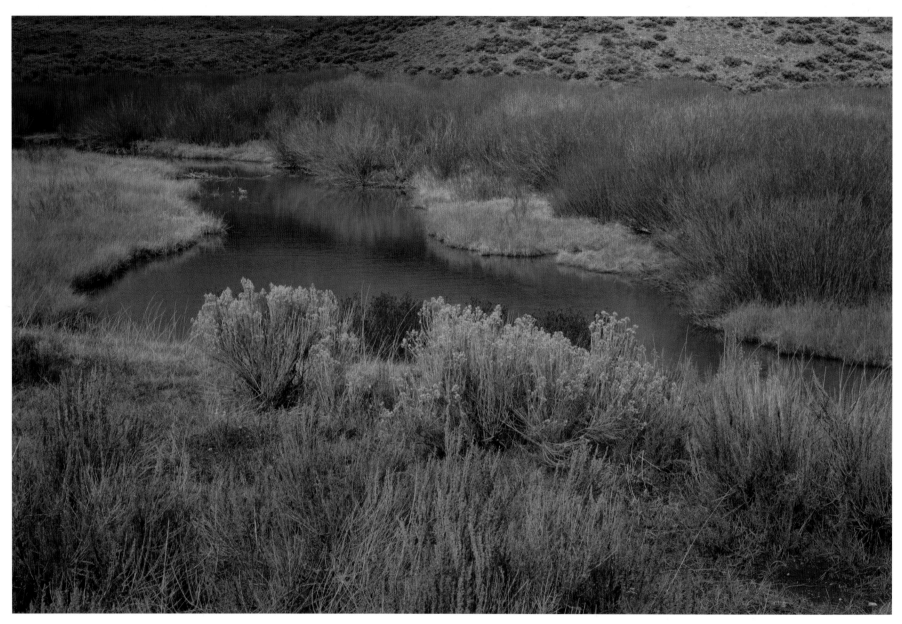

Soldier Creek

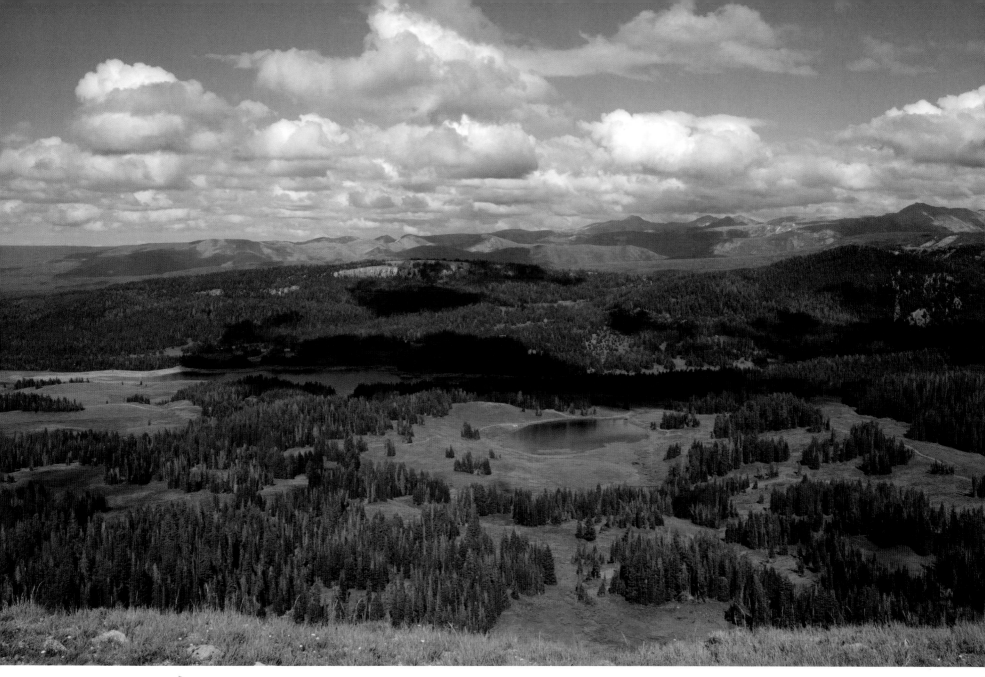

Uintahs

At times, the impact of the natural world was so far beyond my powers to convey that it almost made me despair.

–EVERETT RUESS

Southern Utah

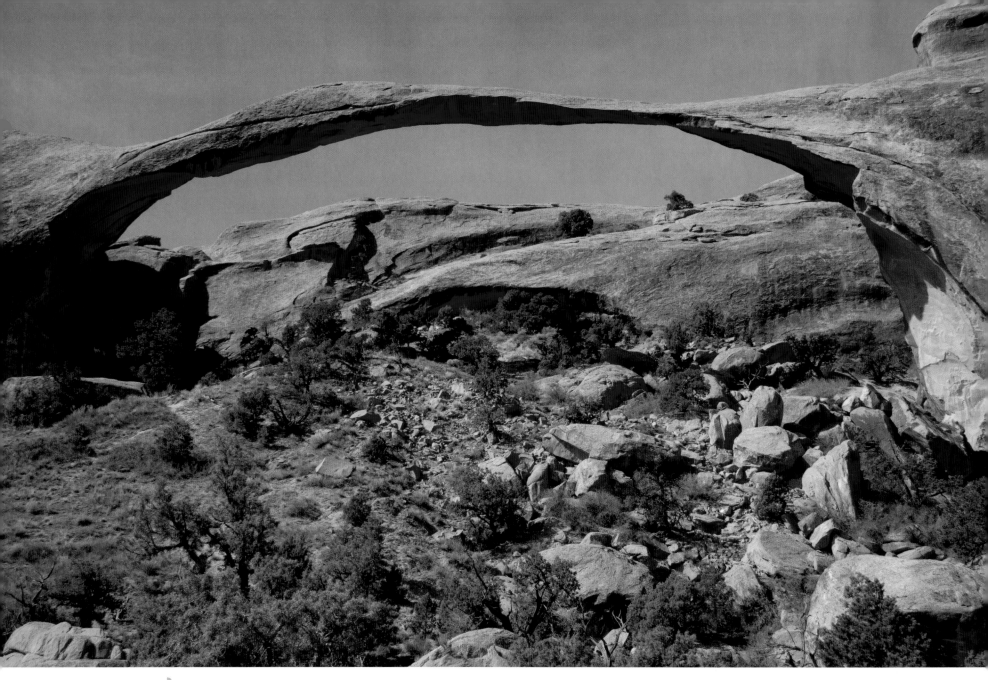

Arches

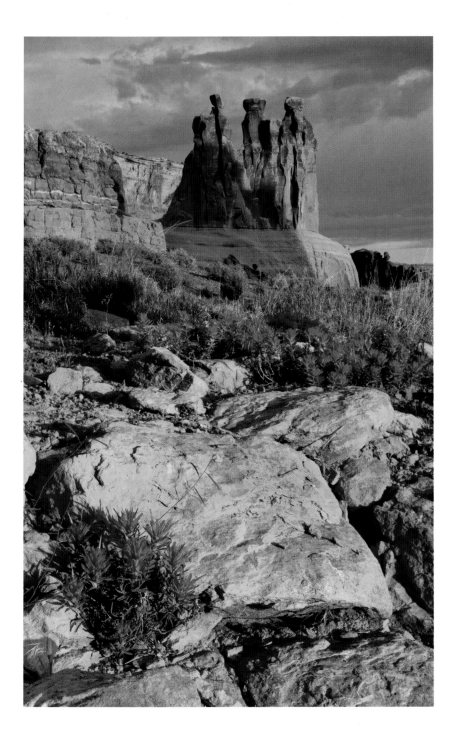

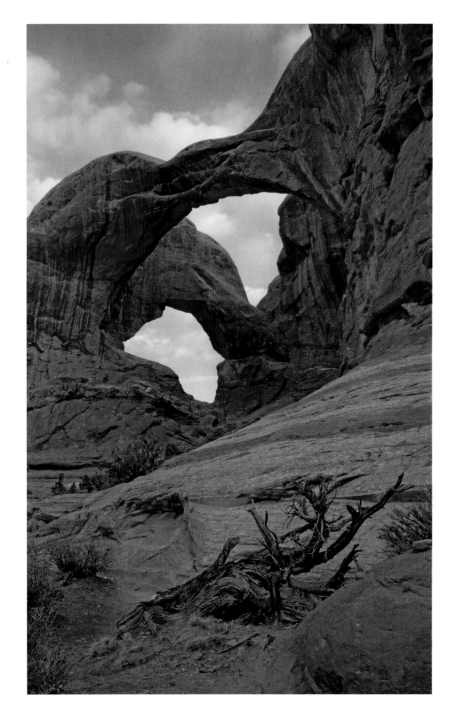

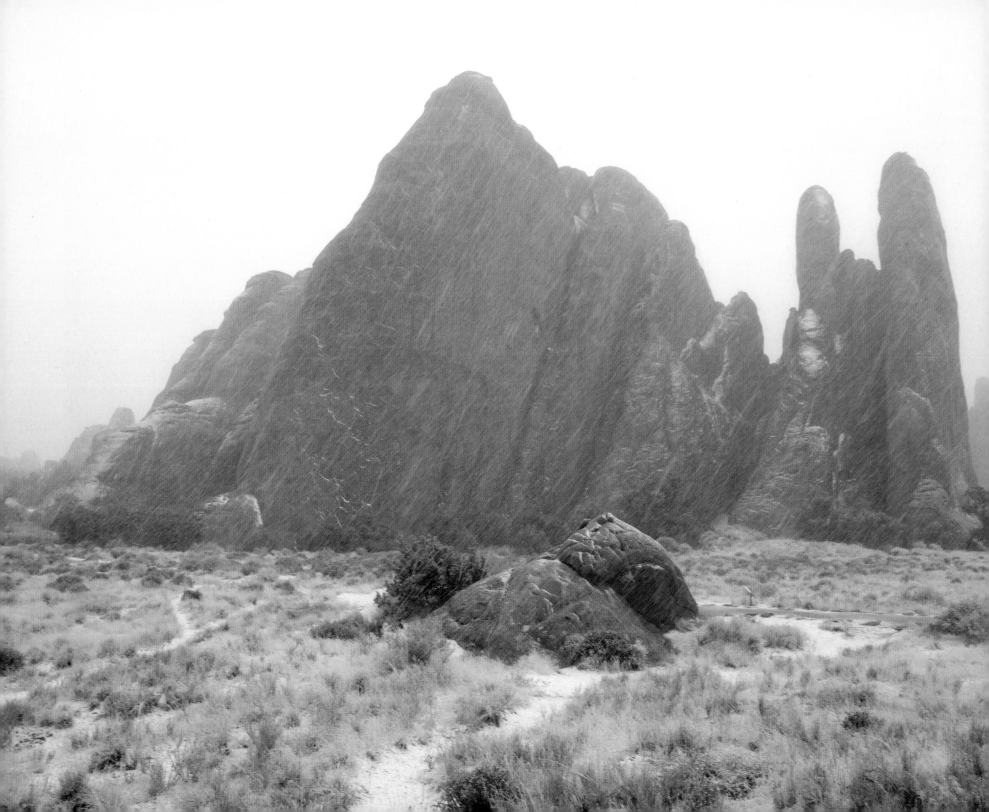

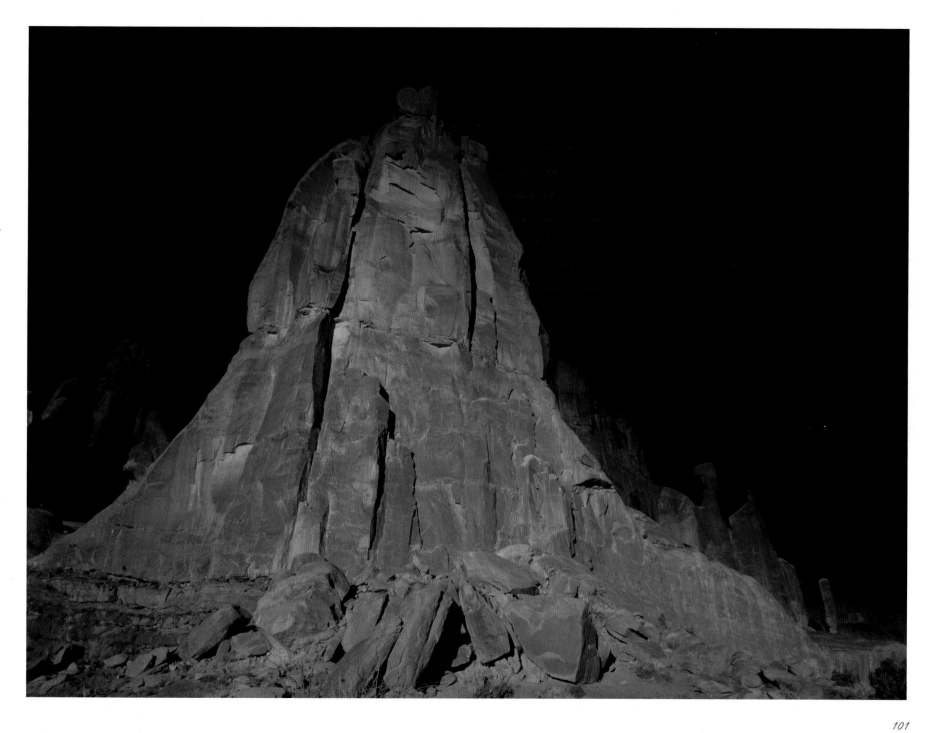

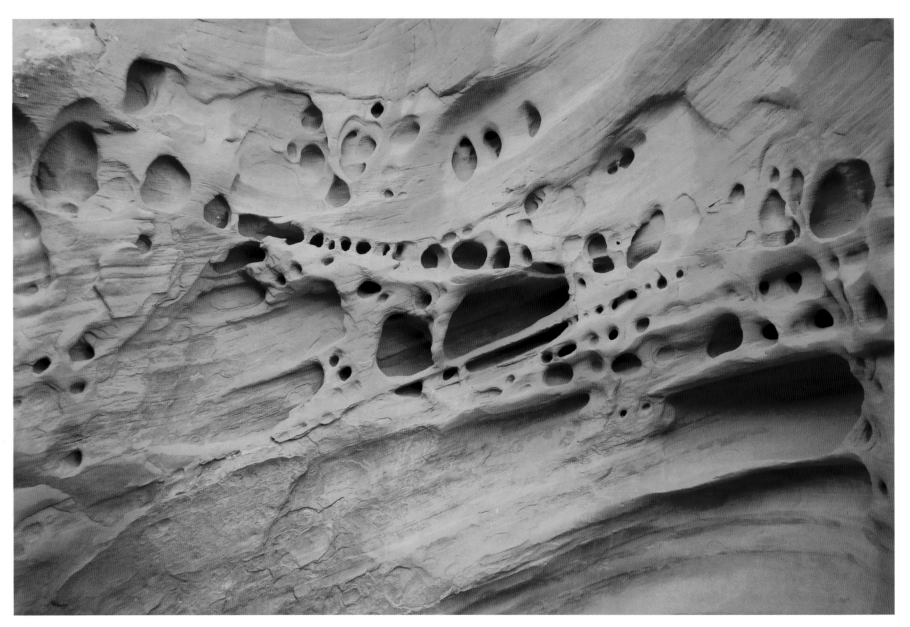

Boulder

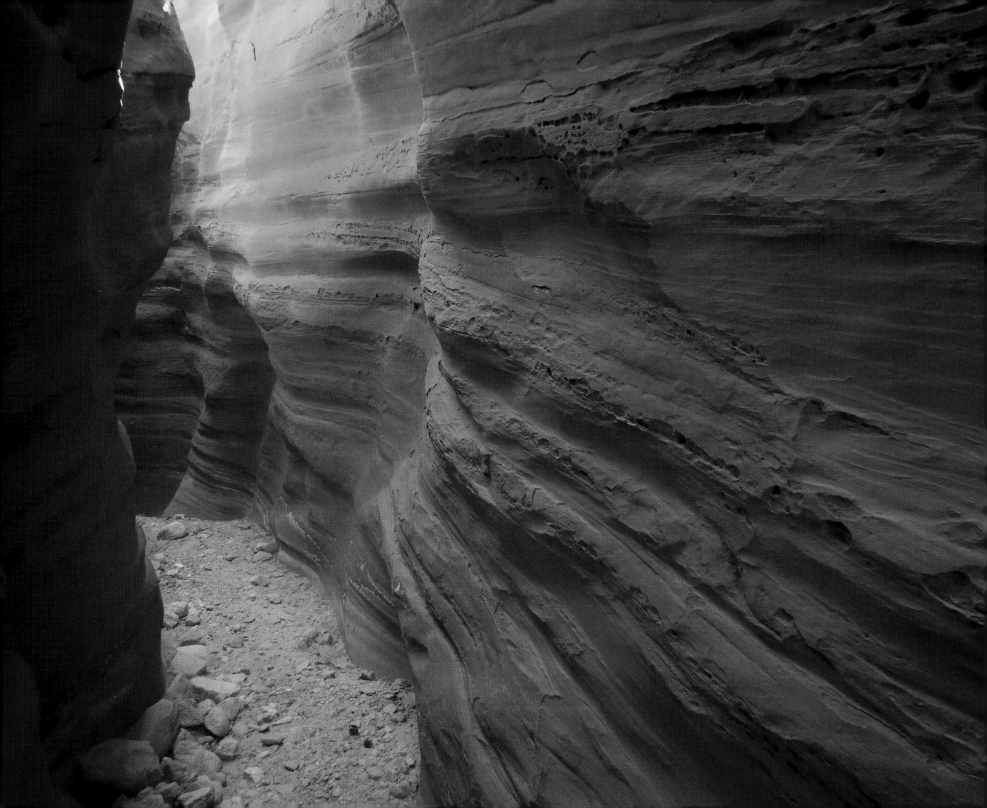

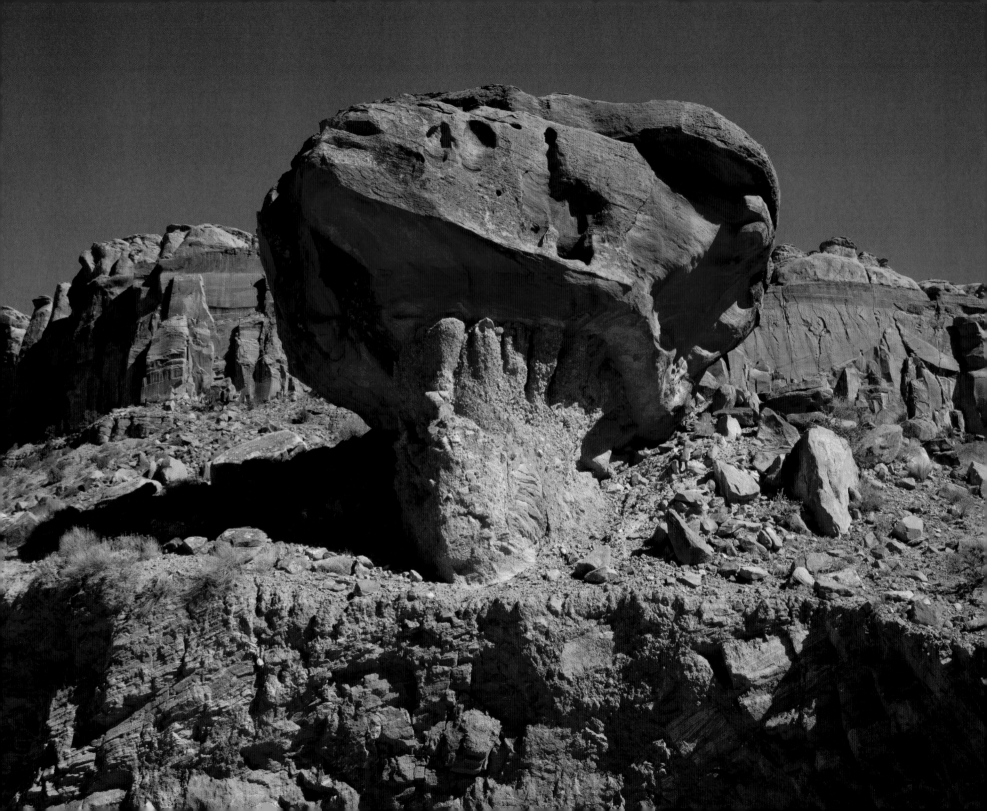

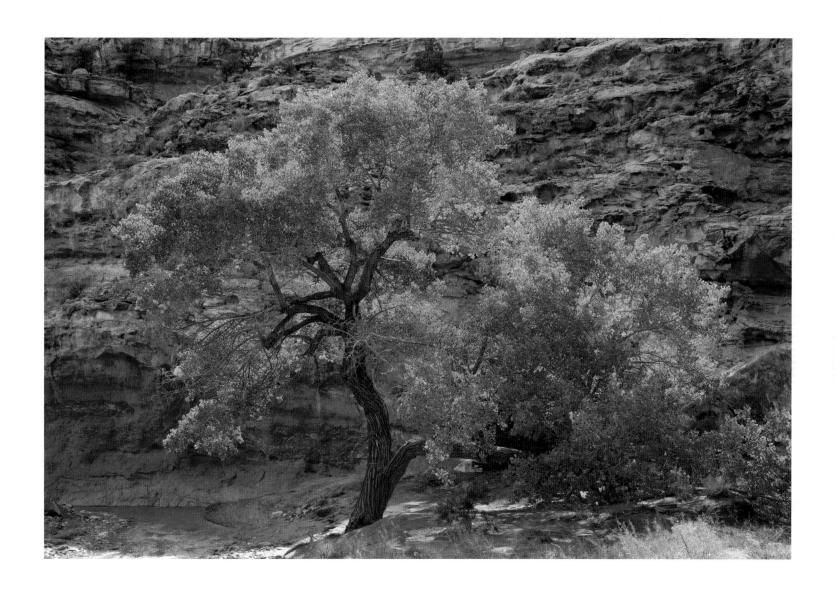

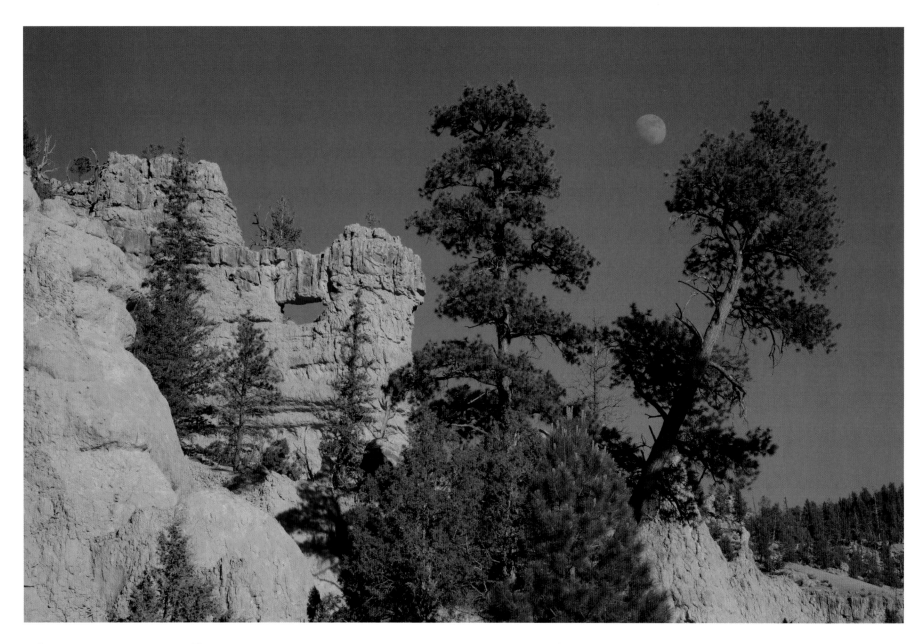

Bryce Canyon

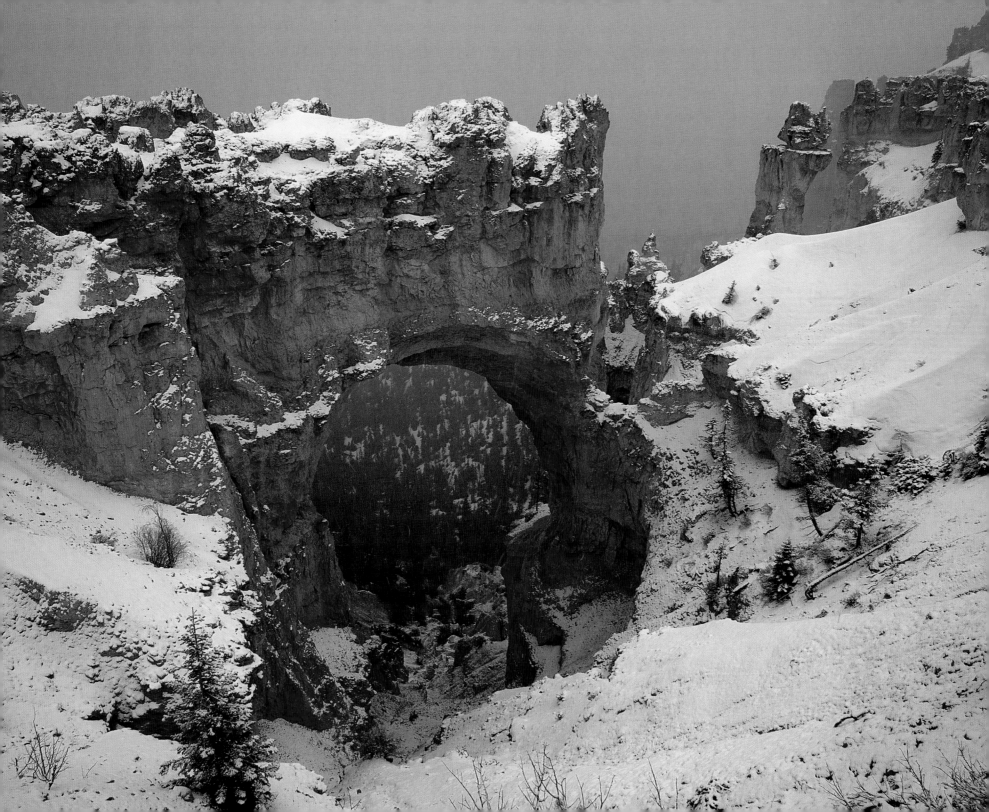

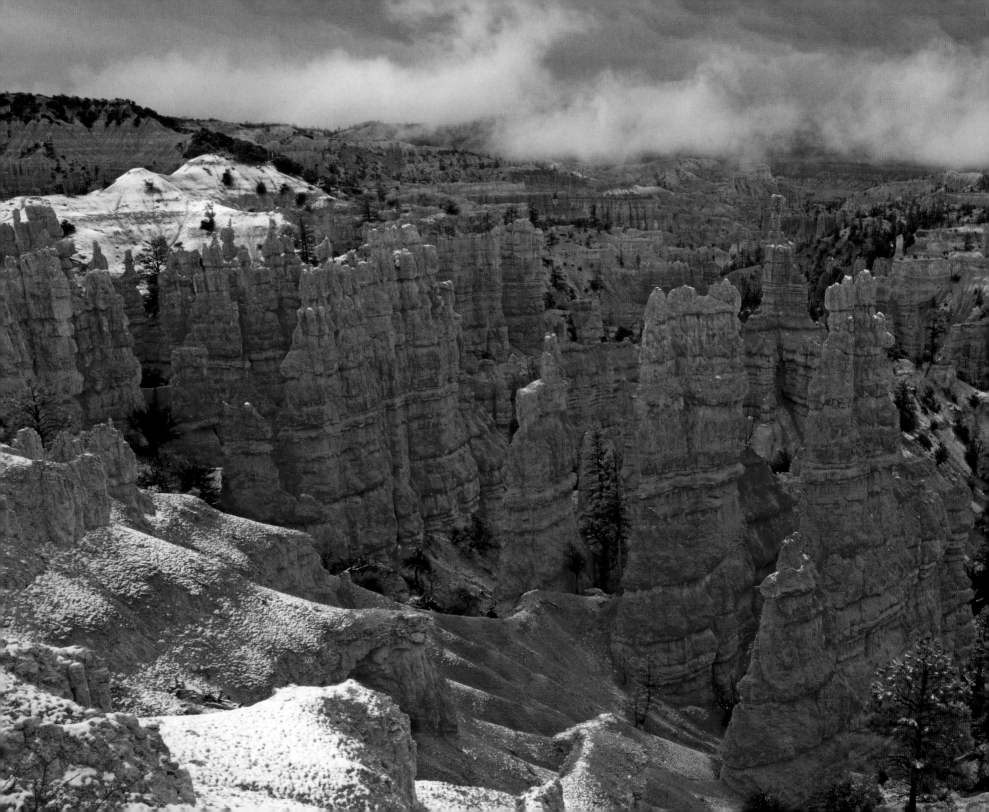

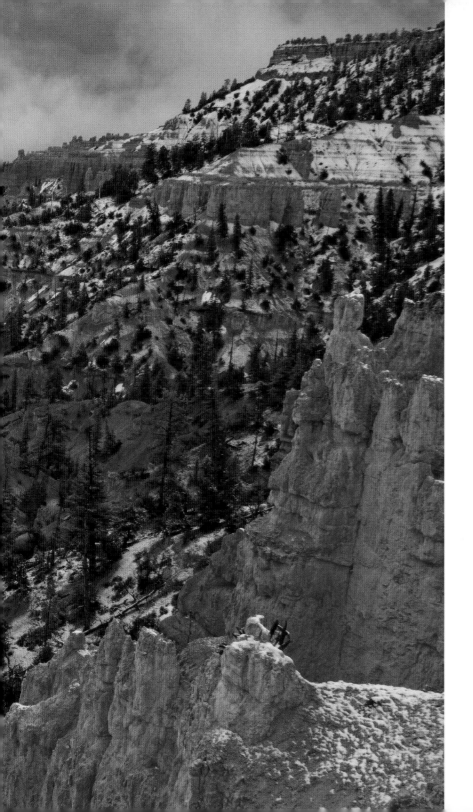

National Parks are the best idea
we ever had. Absolutely American,
absolutely democratic, they reflect us
at our best rather than at our worst.

–WALLACE STEGNER

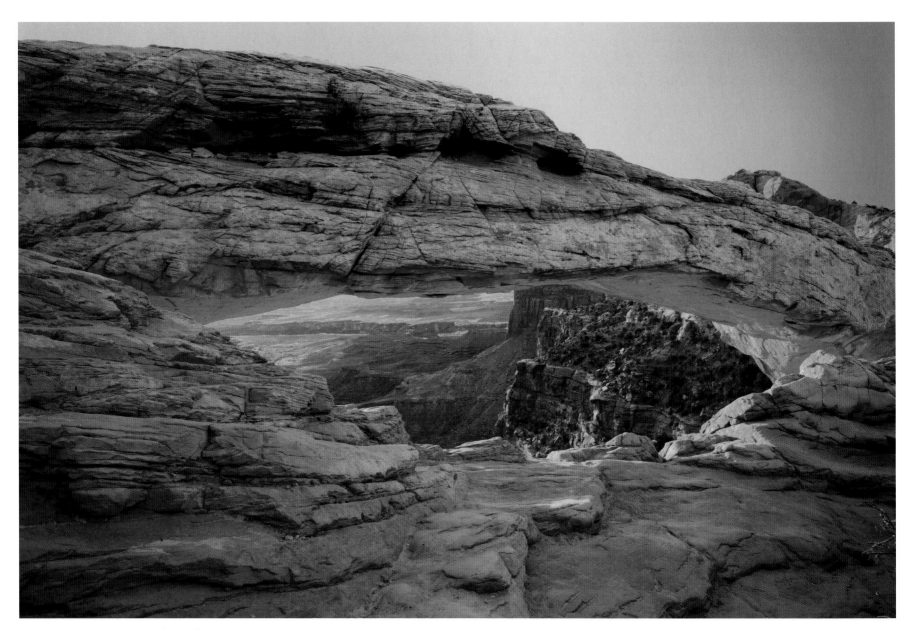

Canyonlands

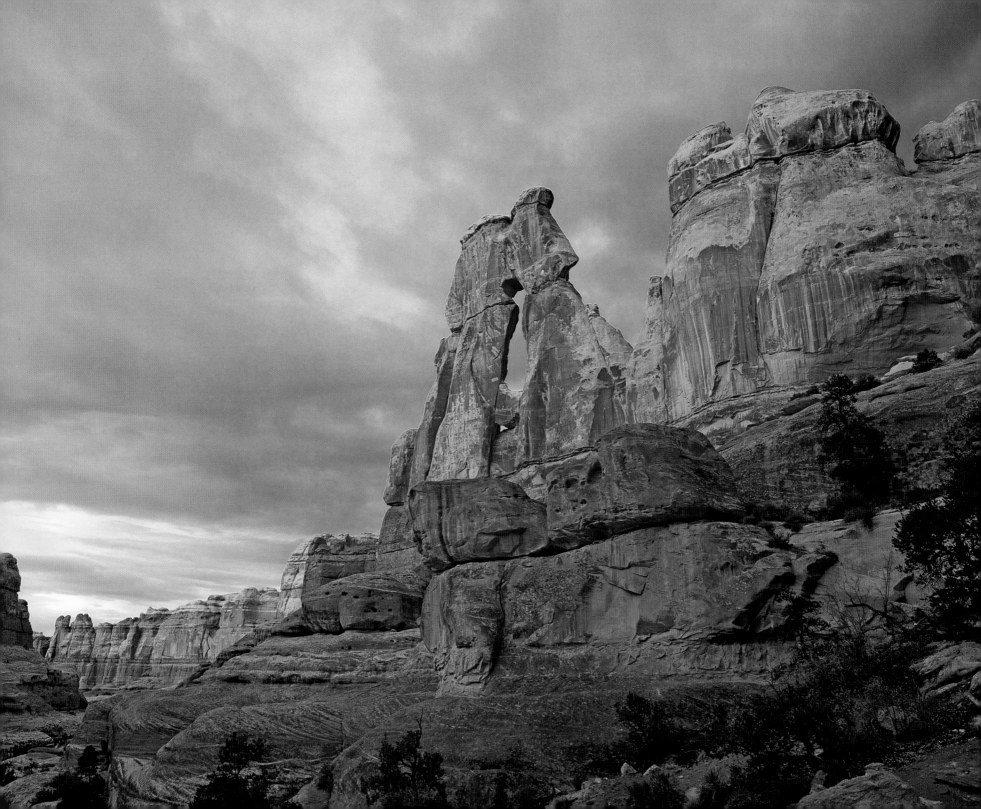

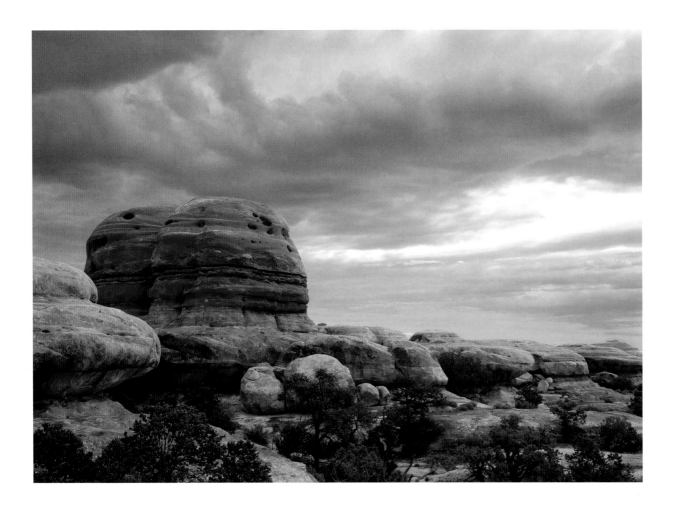

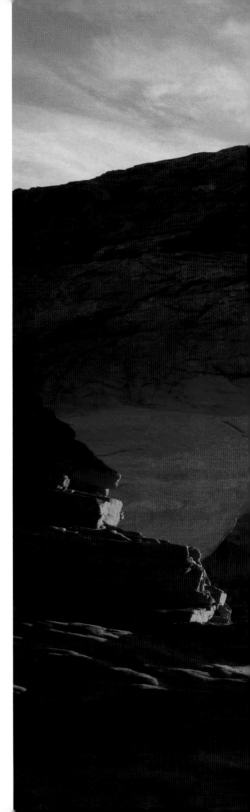

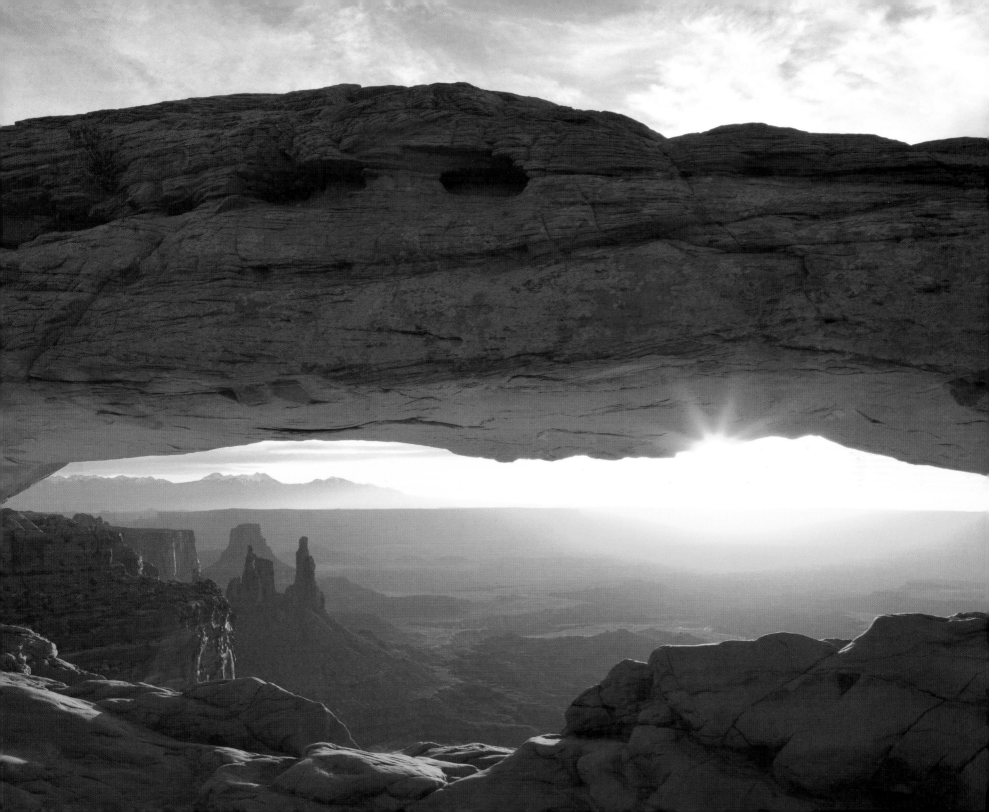

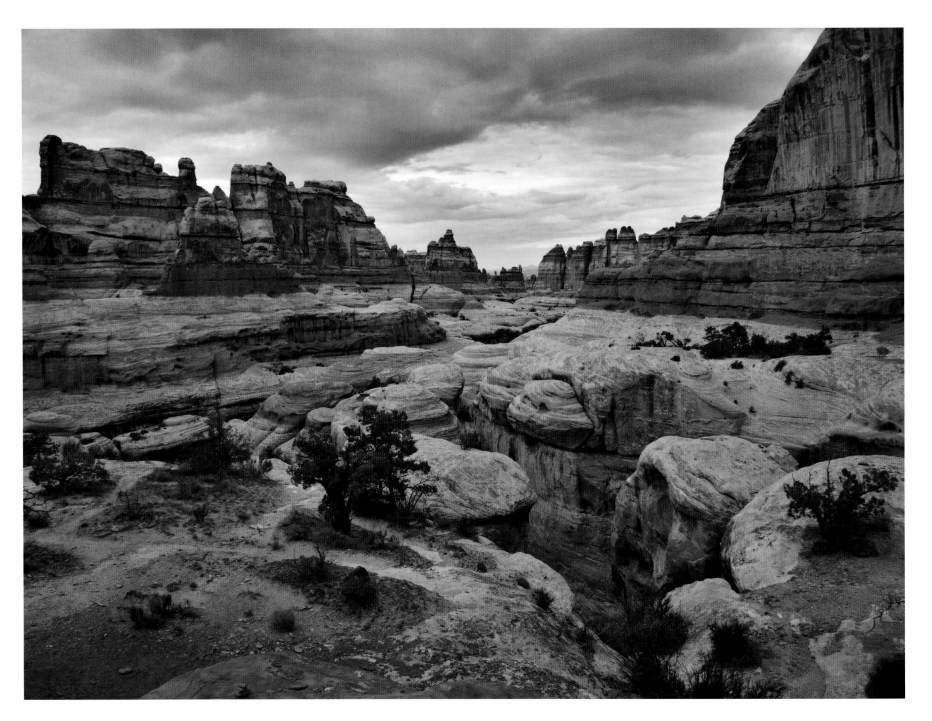

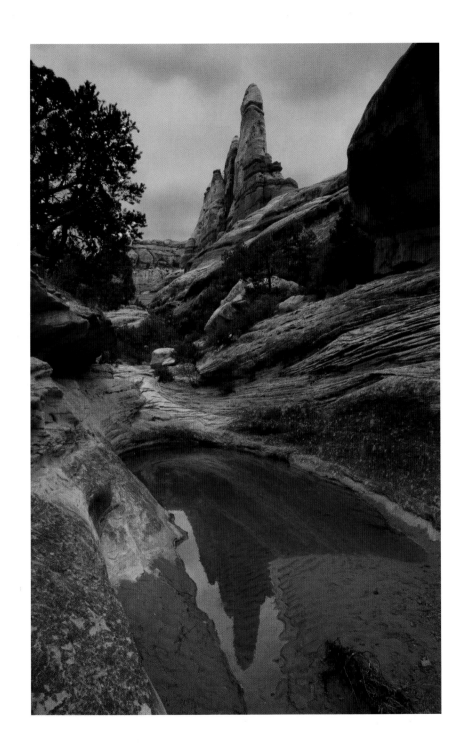

Something will have gone out of us as a people if we ever let the remaining wilderness be destroyed. We simply need that wild country available to us, even if we never do more than drive to its edge and look in.

—WALLACE STEGNER

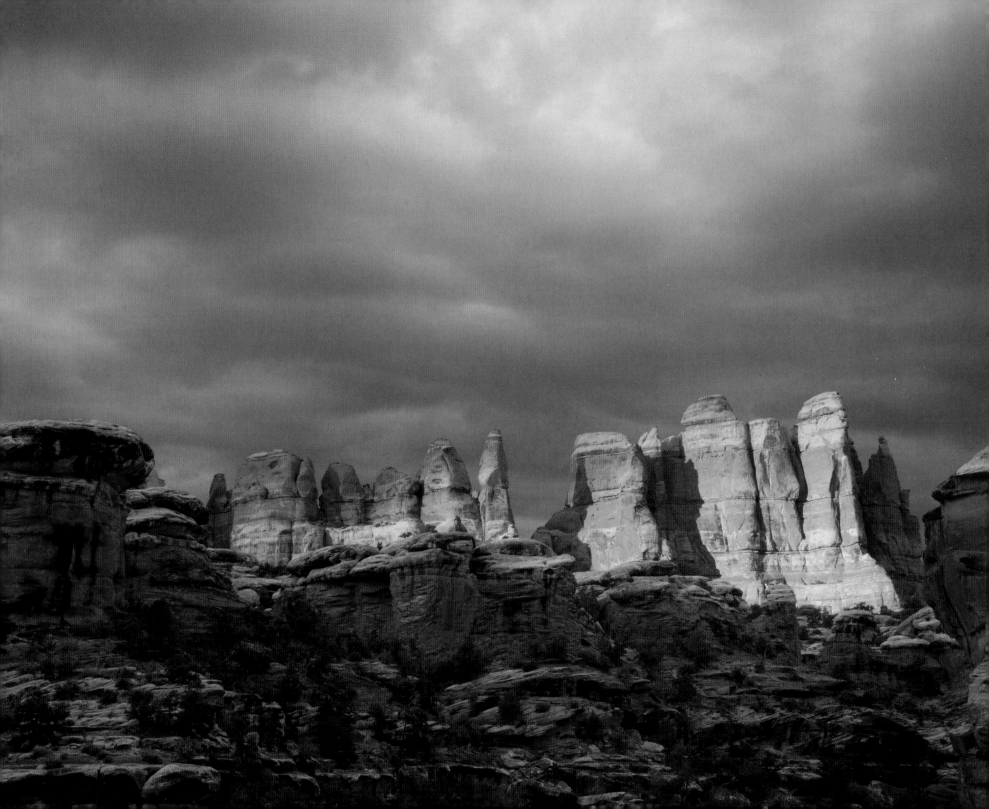

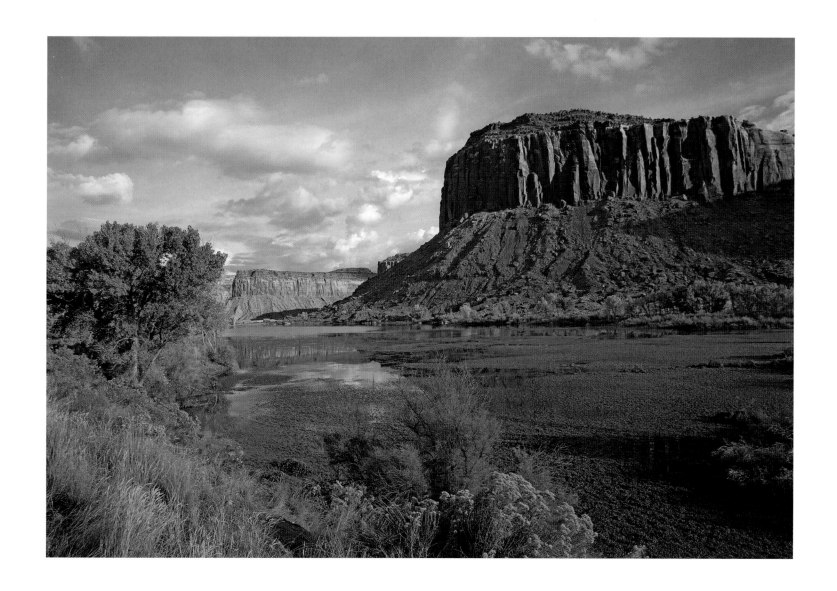

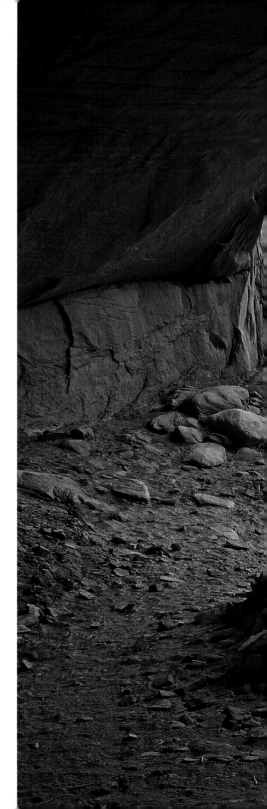

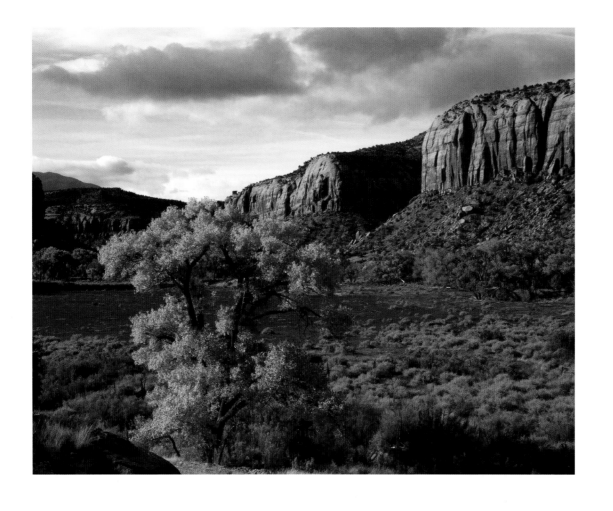

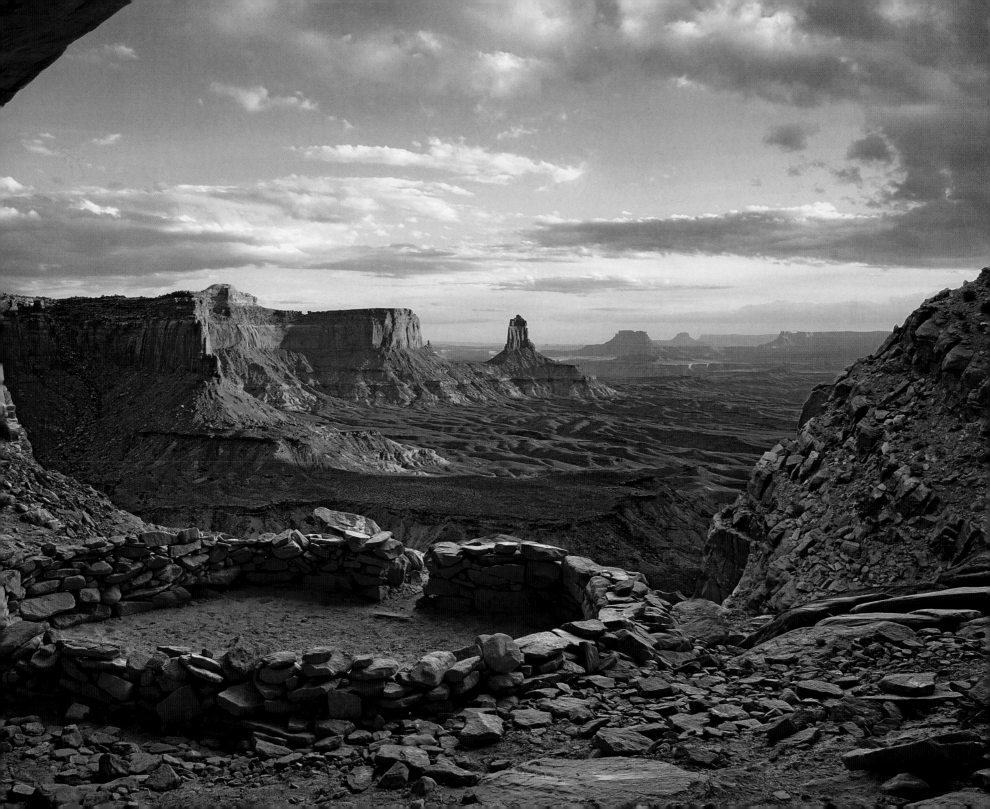

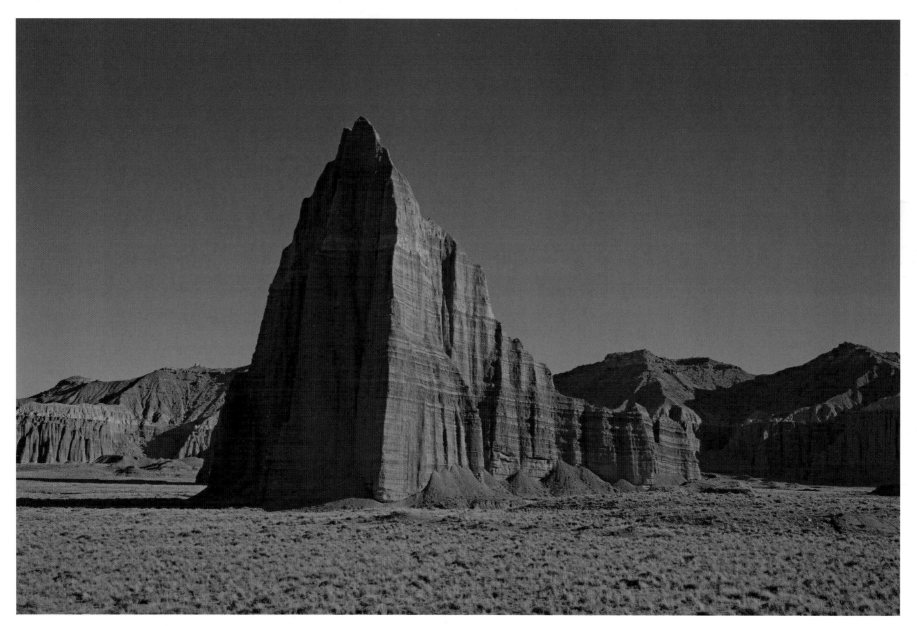

Capitol Reef

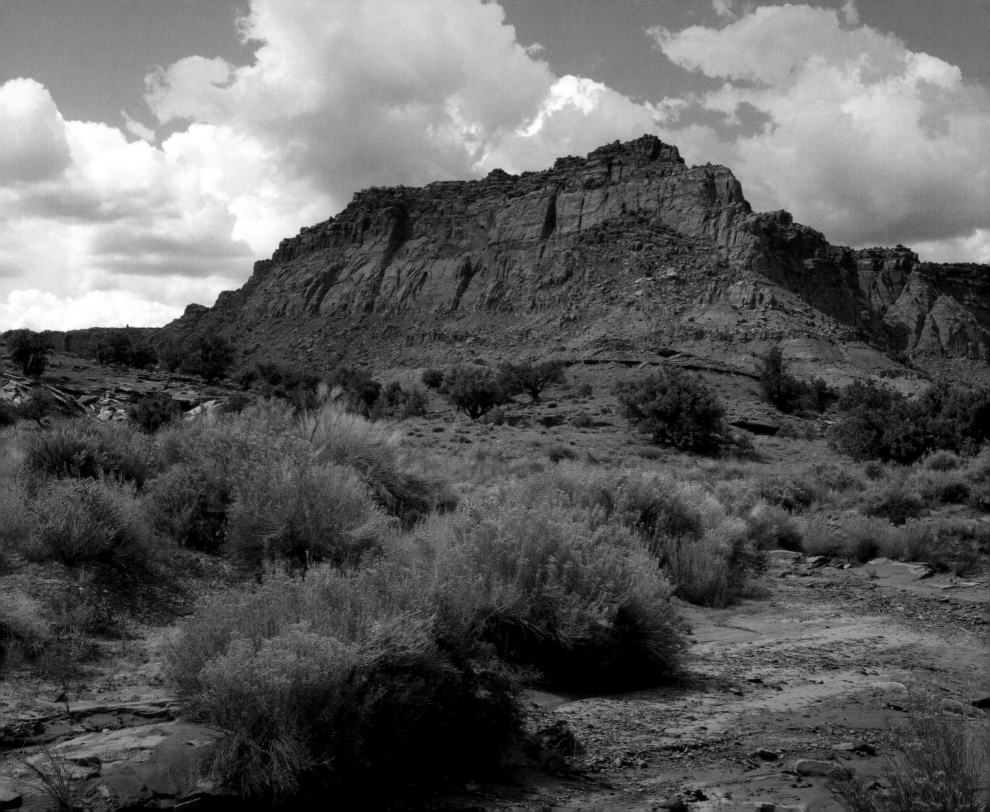

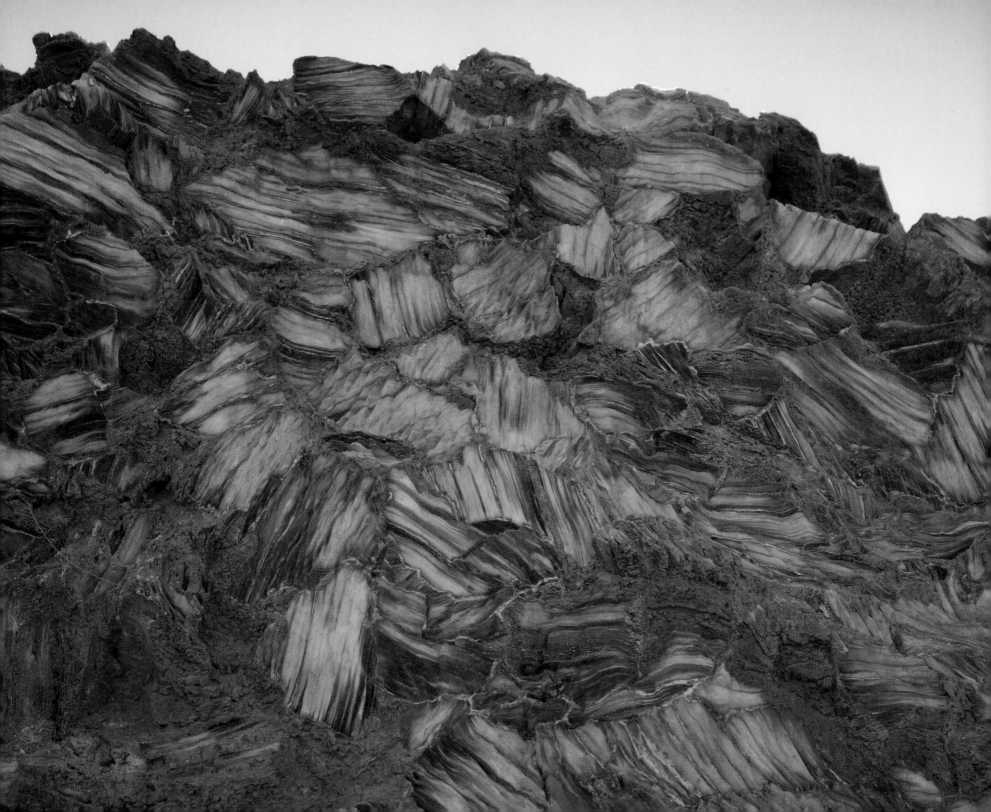

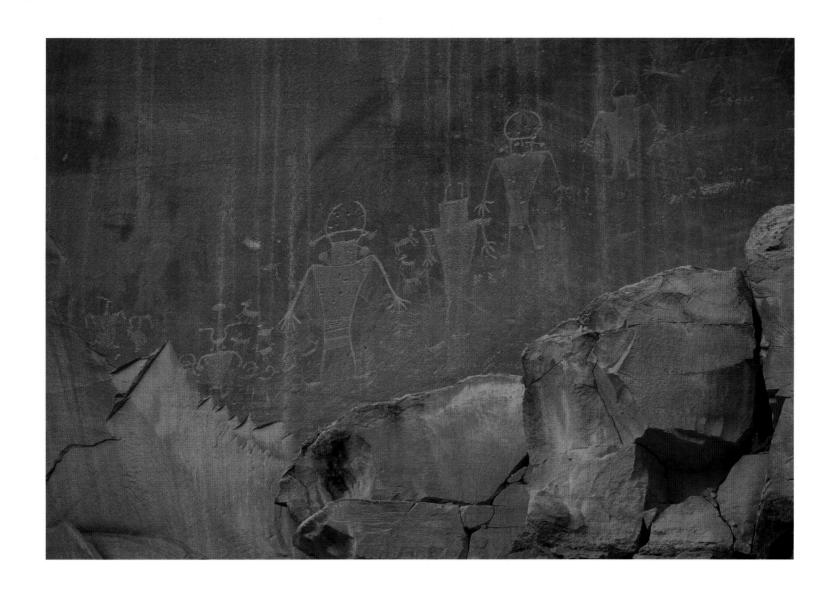

We can have wilderness without
freedom; we can have wilderness
without human life at all, but we
cannot have freedom without
wilderness . . .

–EDWARD ABBEY

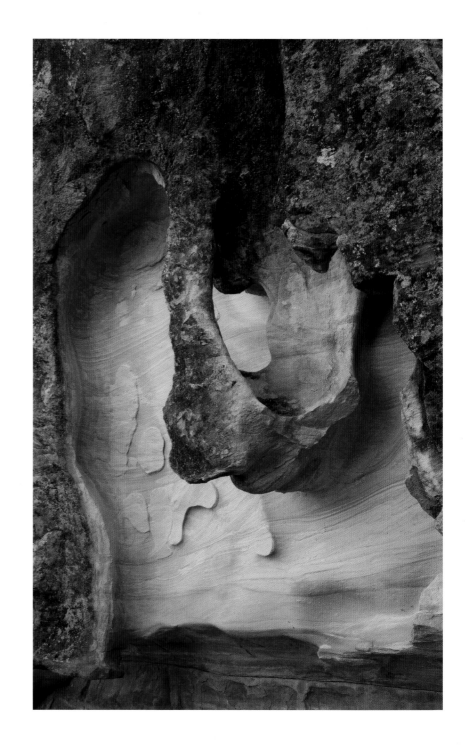

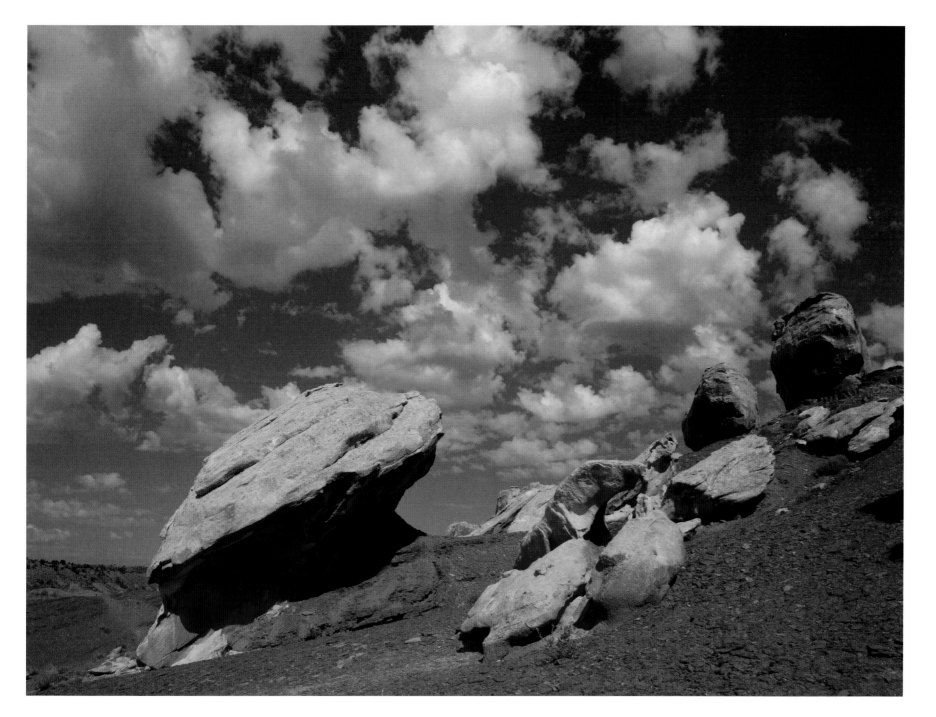

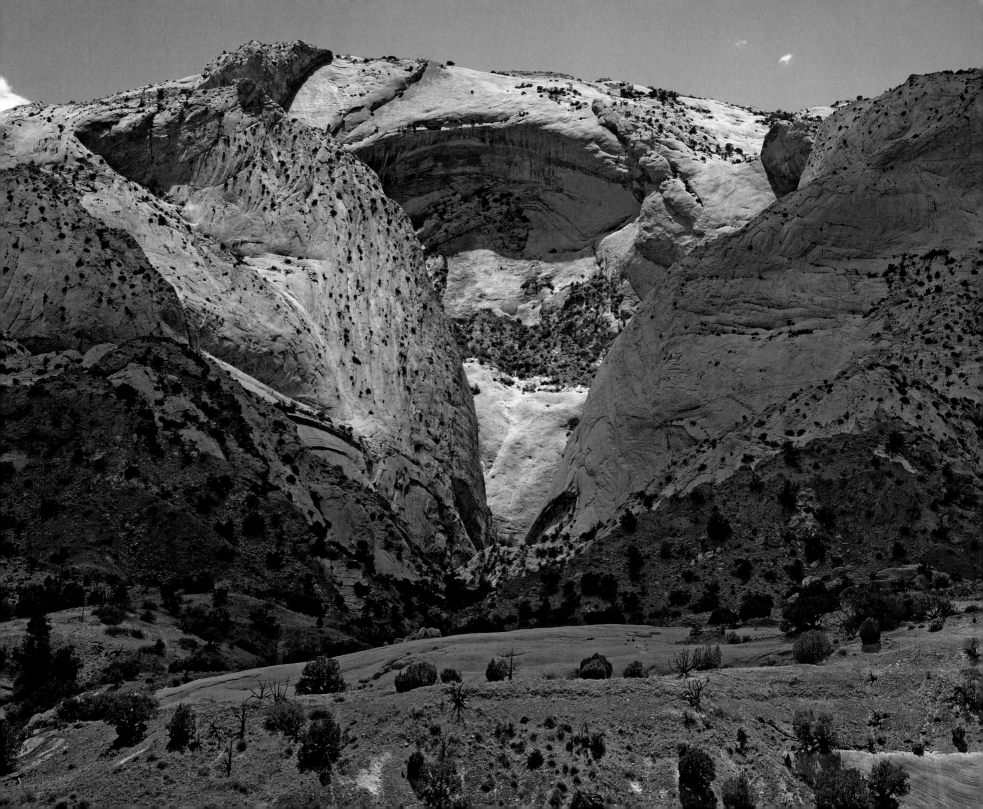

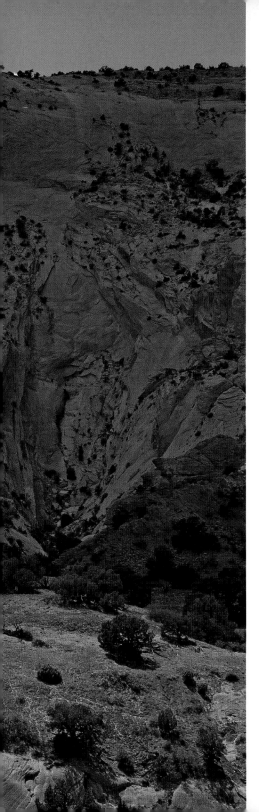

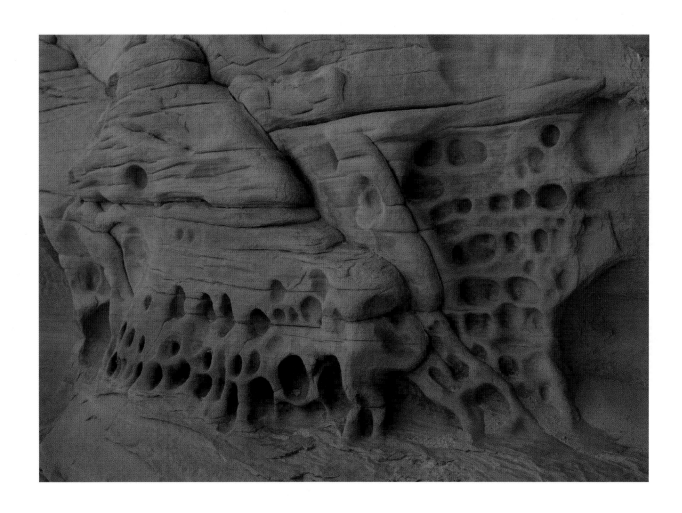

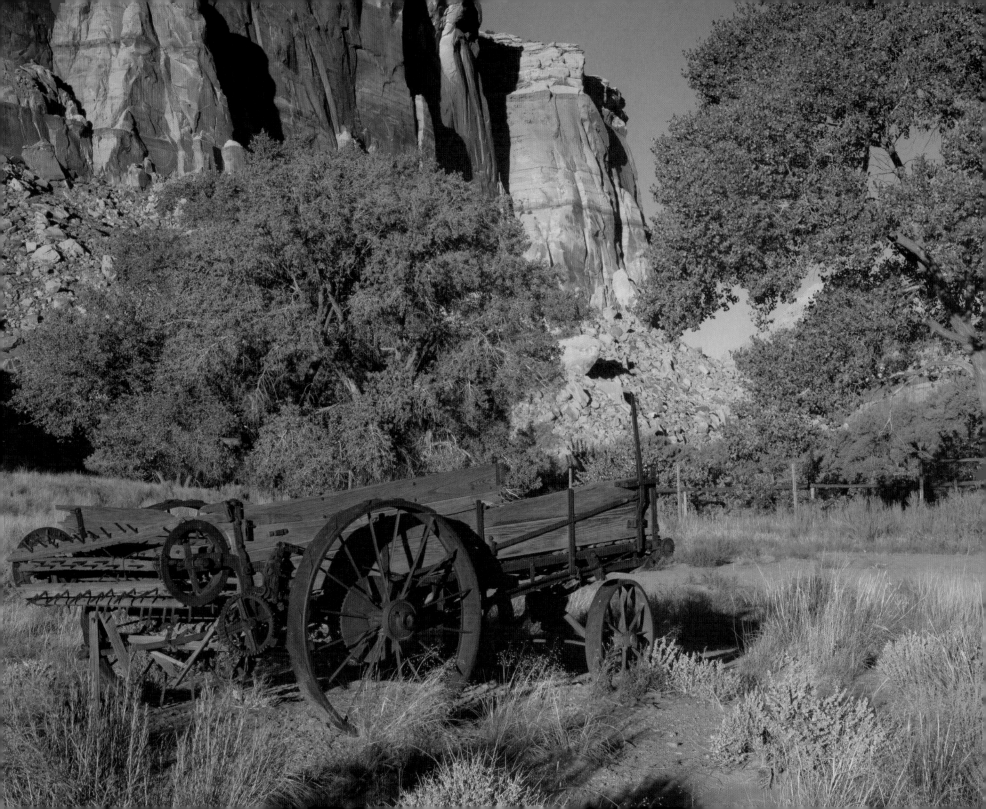

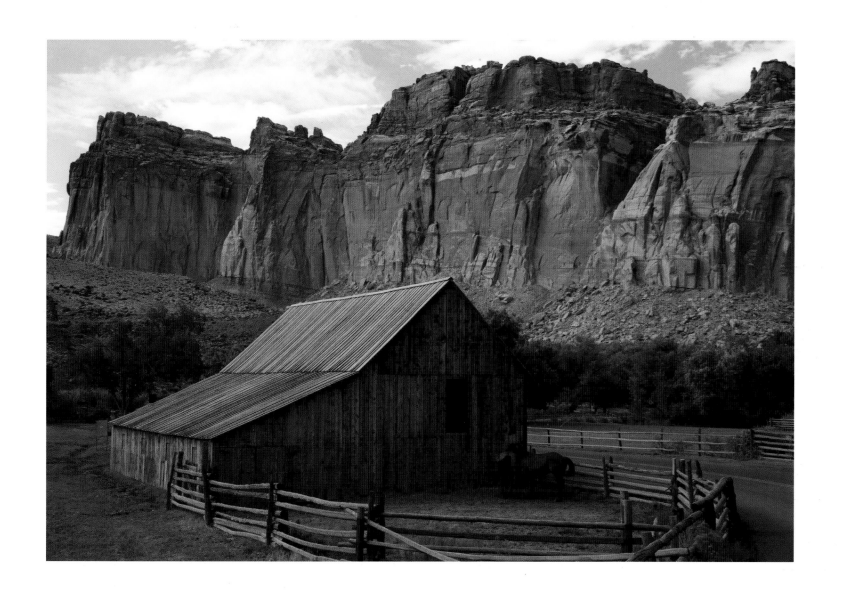

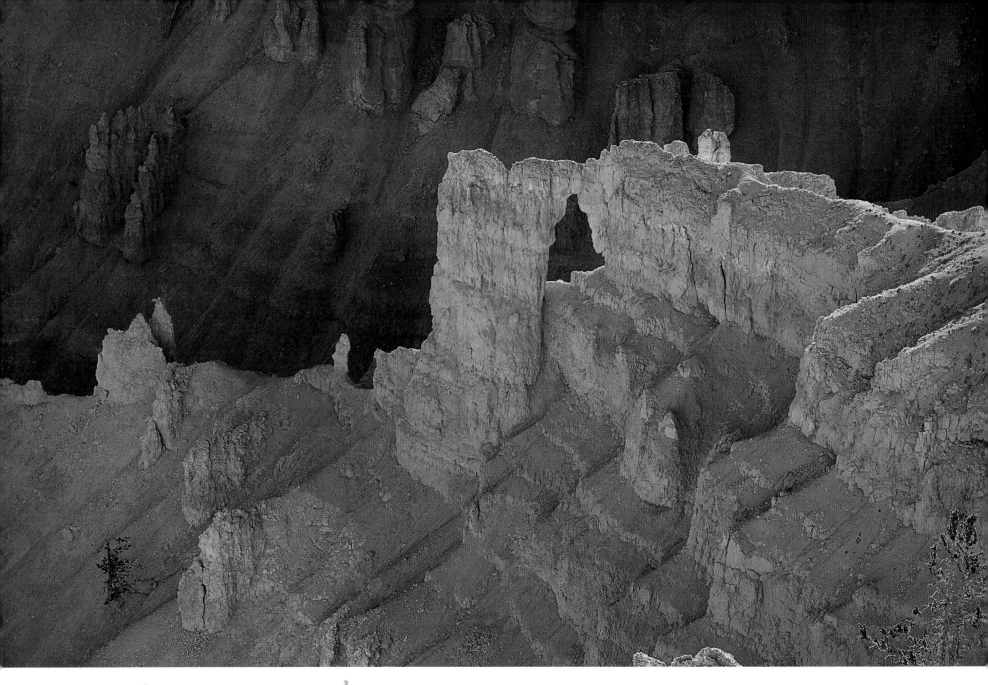

Cedar Breaks

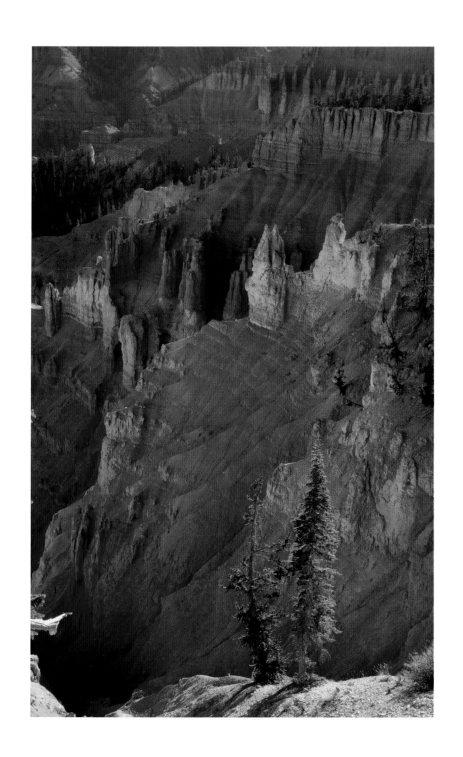

Generally speaking, a howling wilderness does not howl; it is the imagination of the traveler that does the howling.

–HENRY DAVID THOREAU

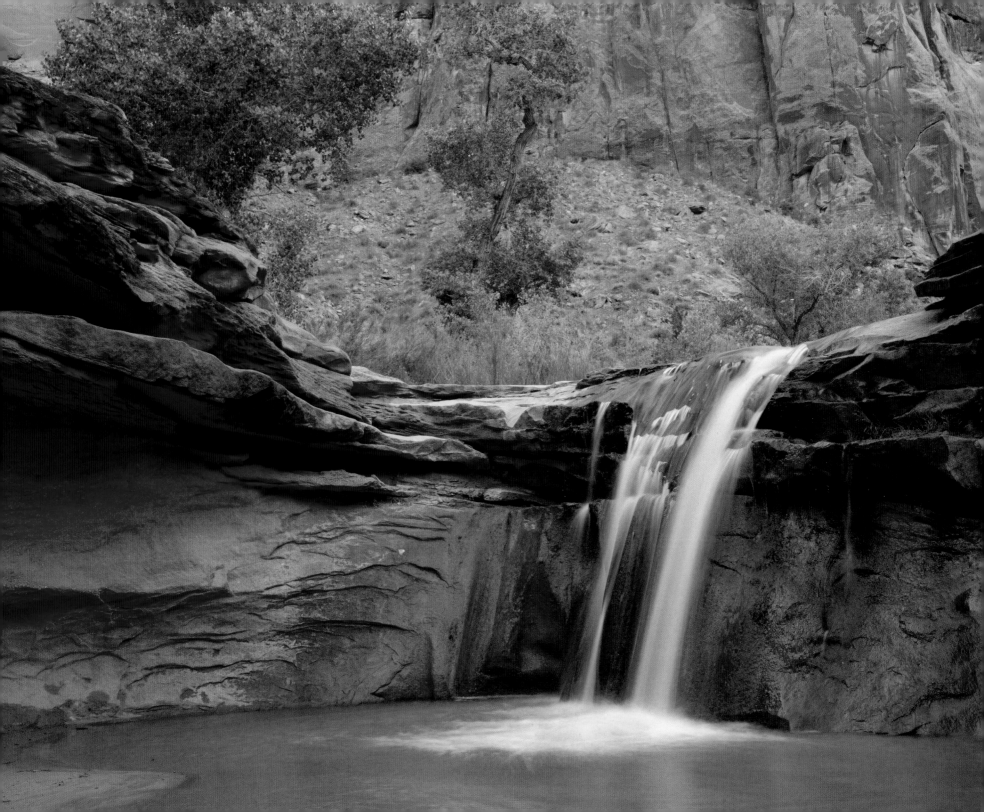

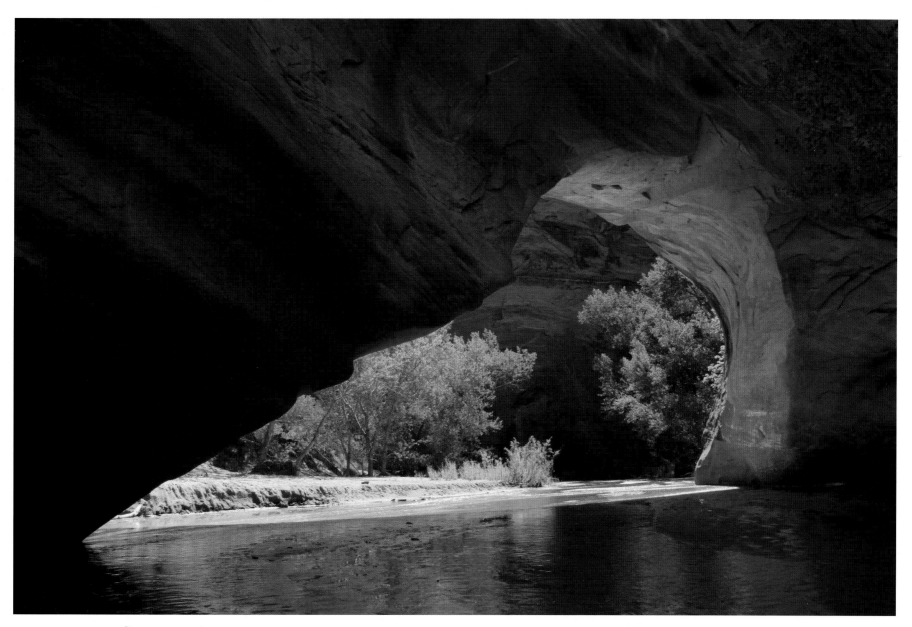

Escalante

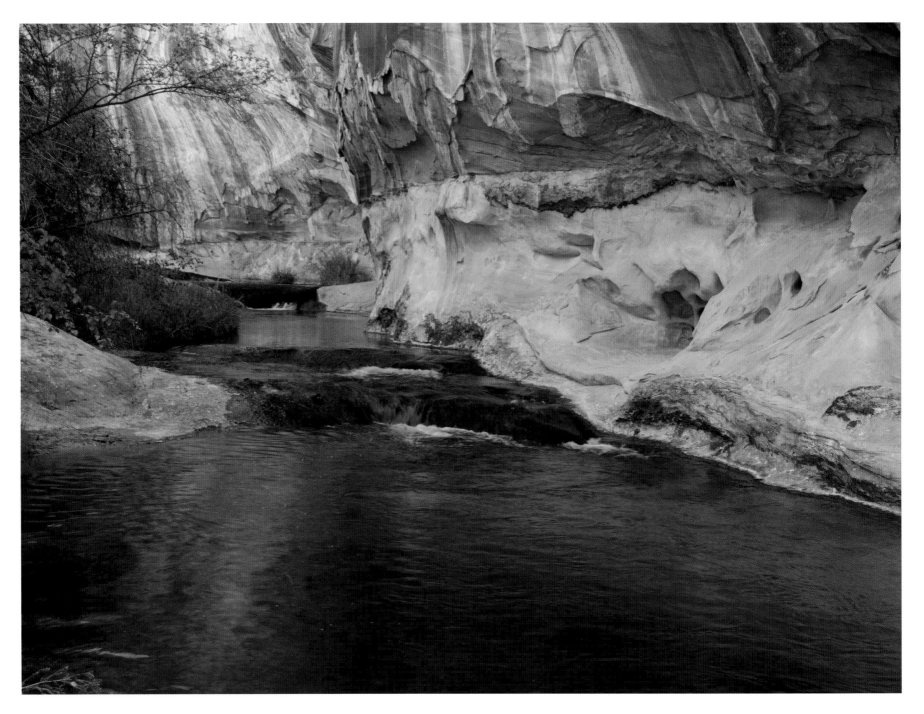

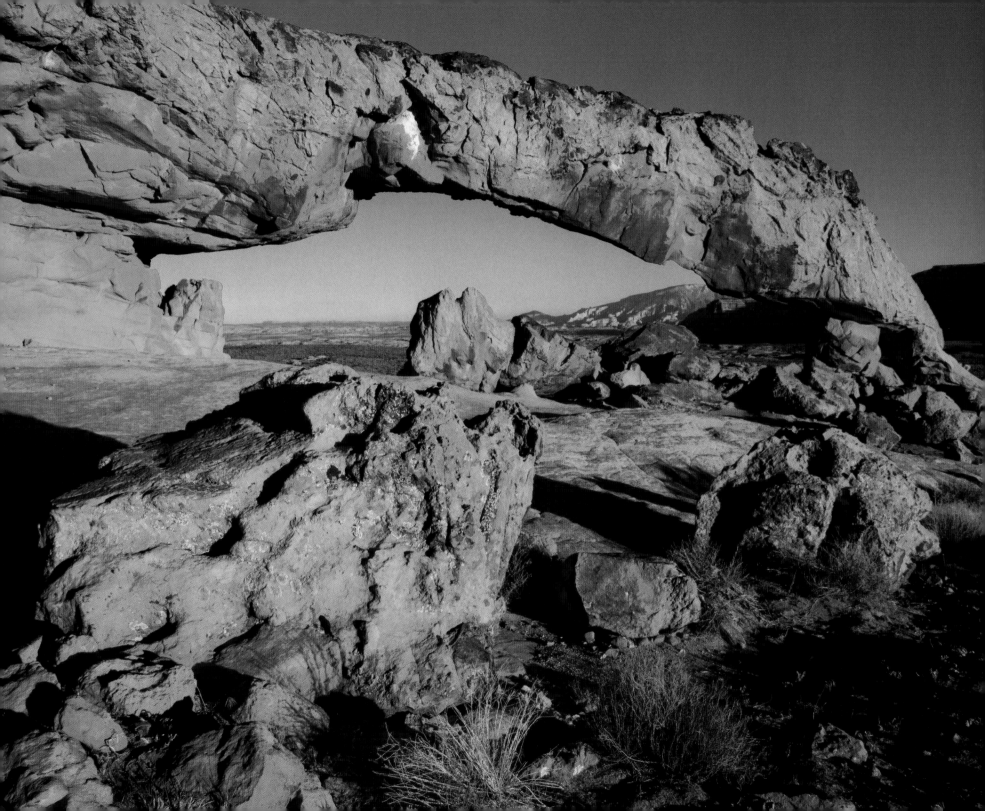

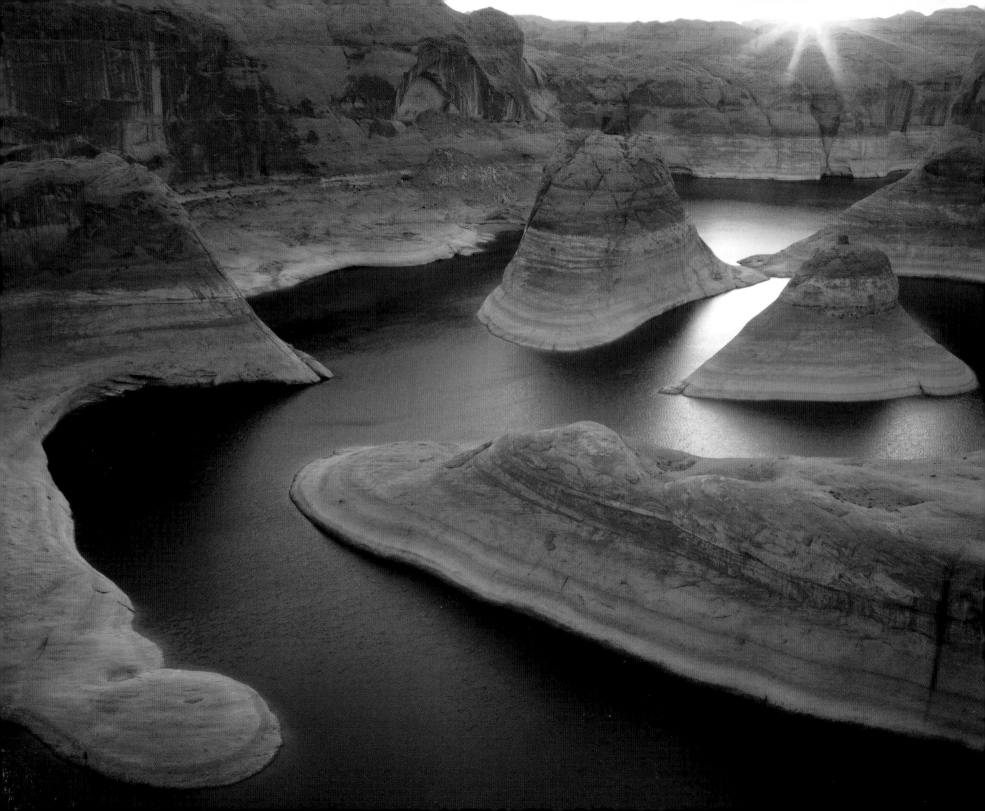

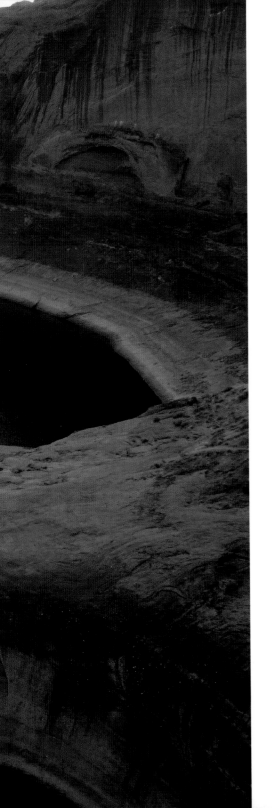

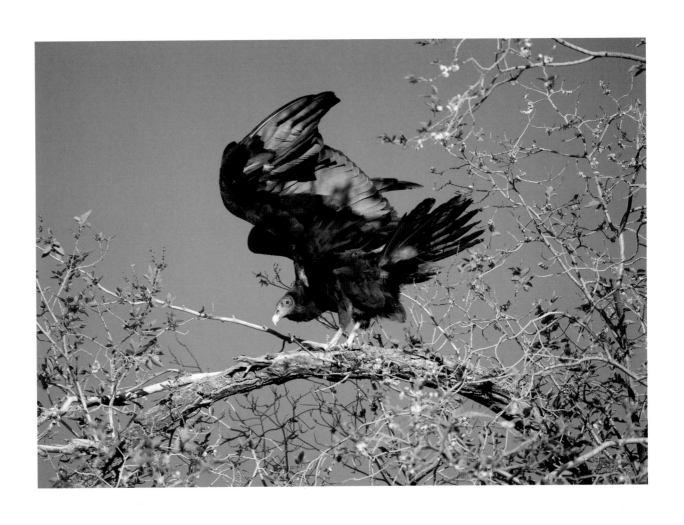

I prefer the saddle to the streetcar and star-sprinkled sky to a roof, the obscure and difficult trail, leading into the unknown, to any paved highway, and the deep peace of the wild to the discontent bred by cities … it is enough that I am surrounded by beauty.

—EVERETT RUESS

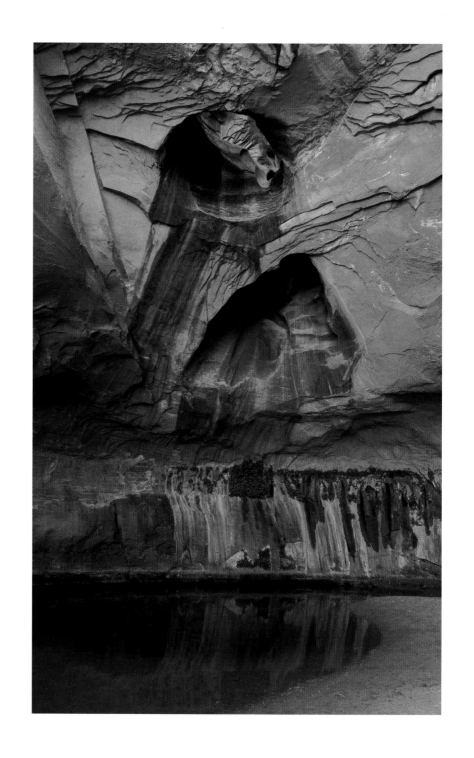

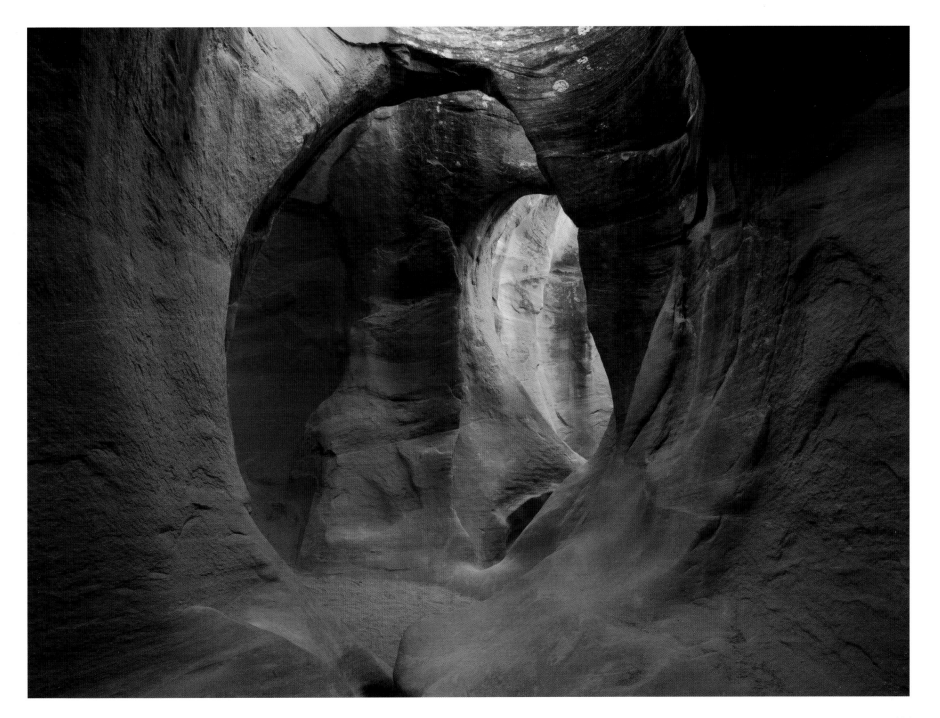

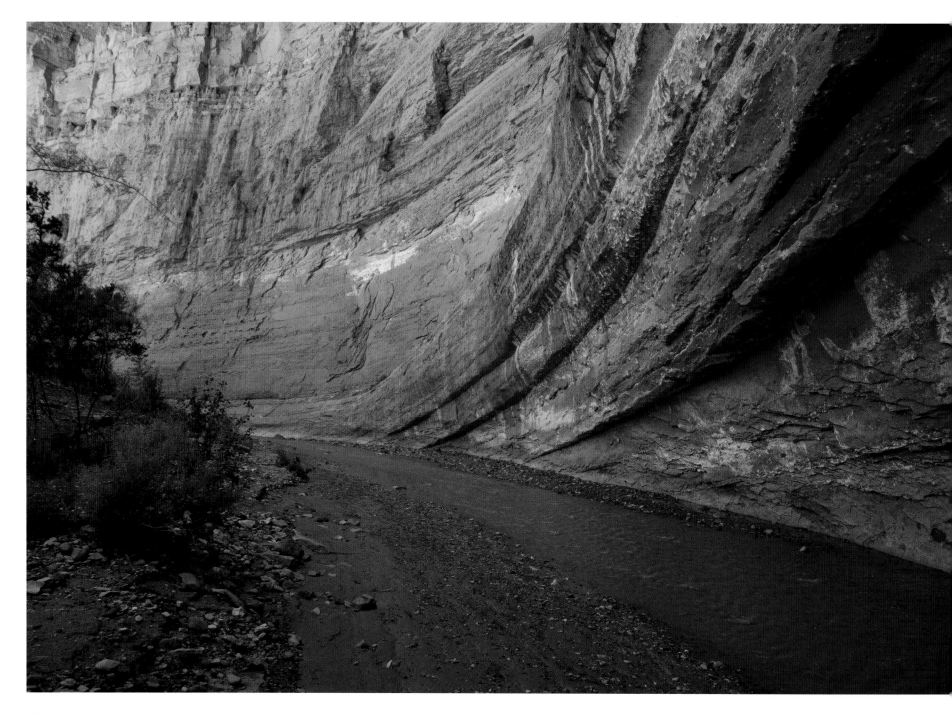

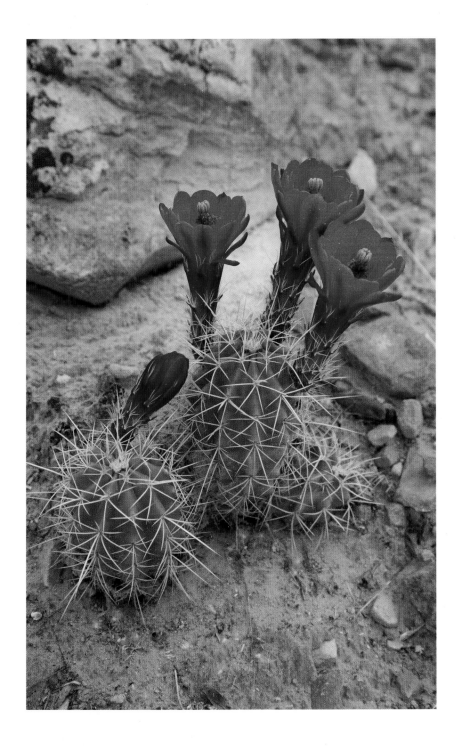

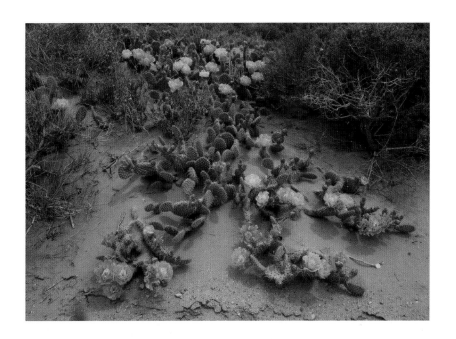

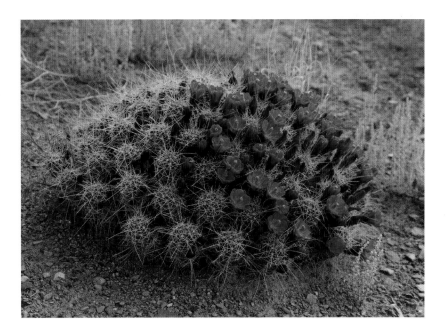

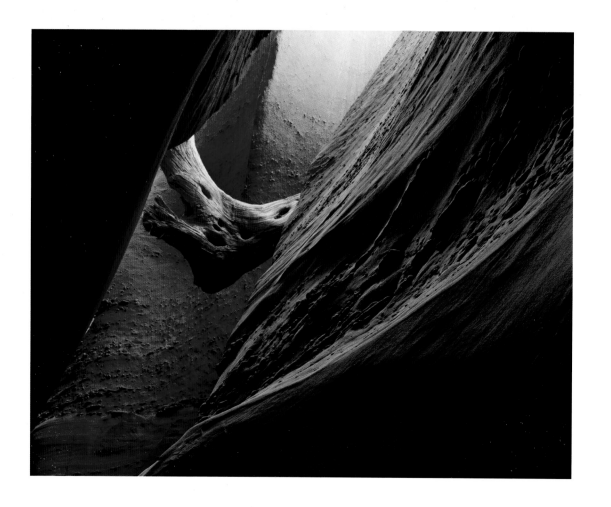

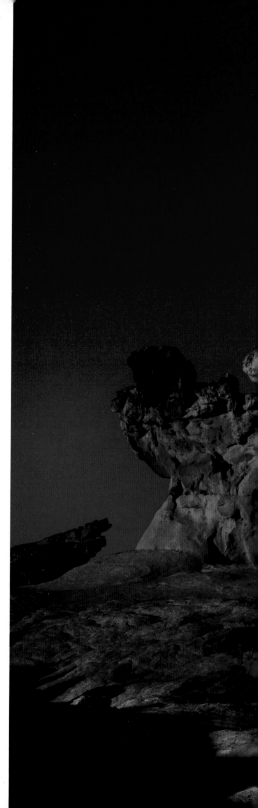

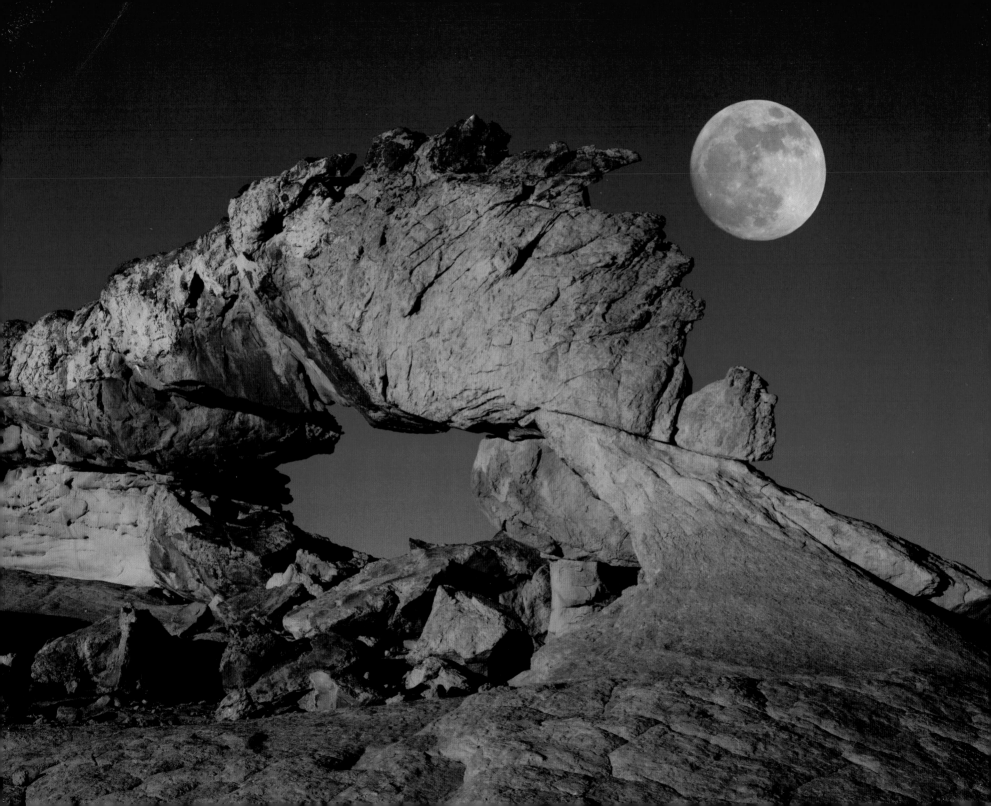

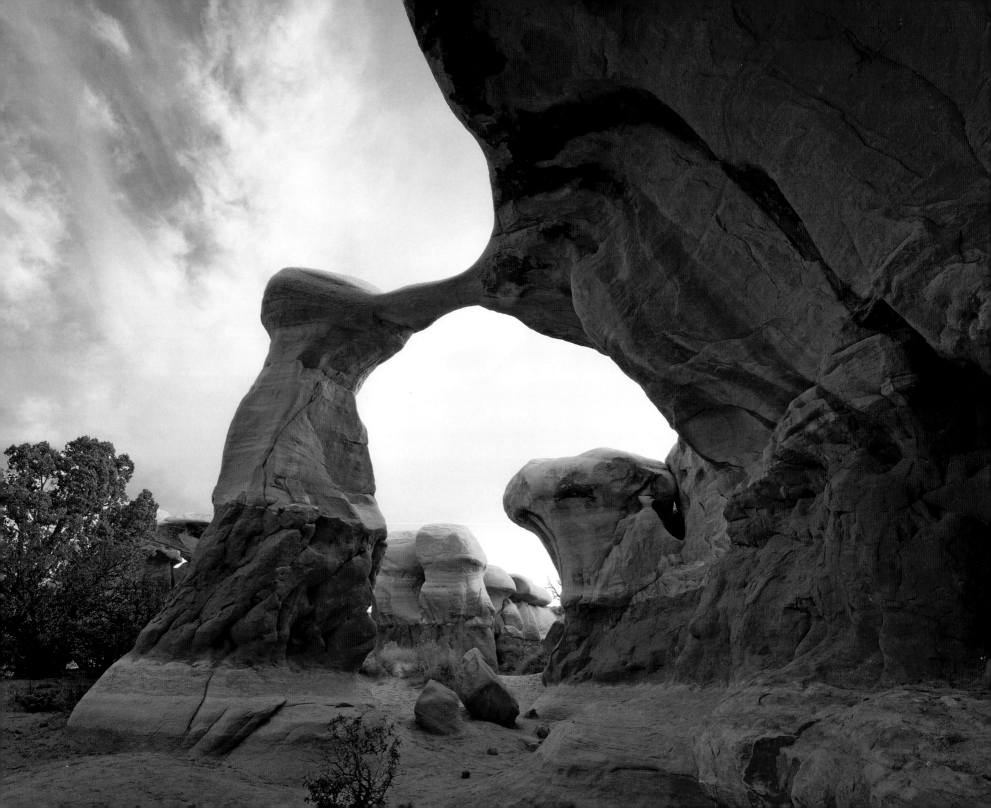

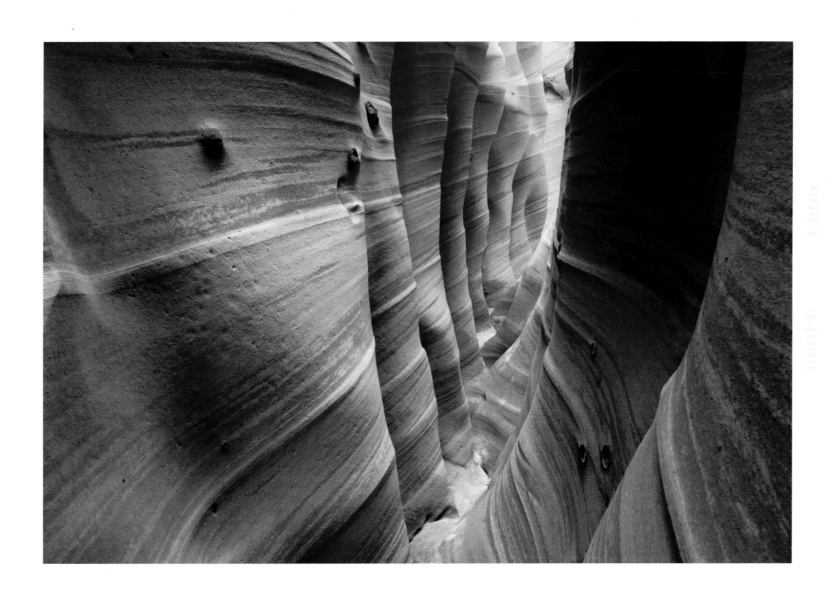

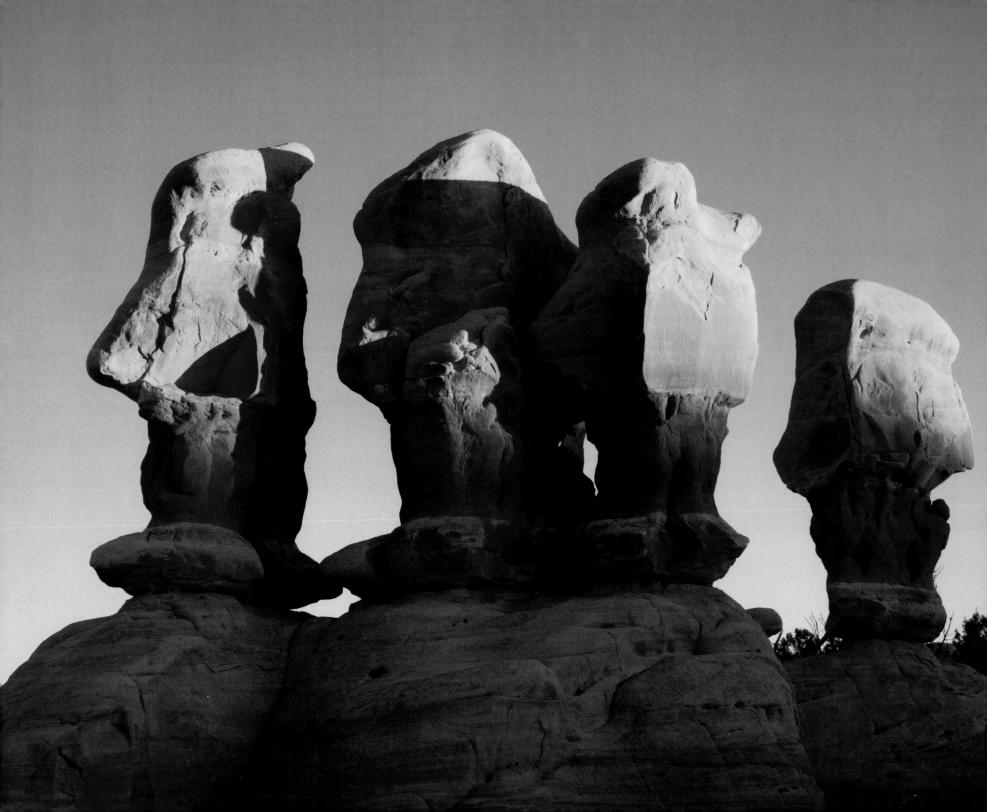

The wilderness is a place that every believer has to experience to be molded for their divine purpose. —E'YEN A. GARDNER

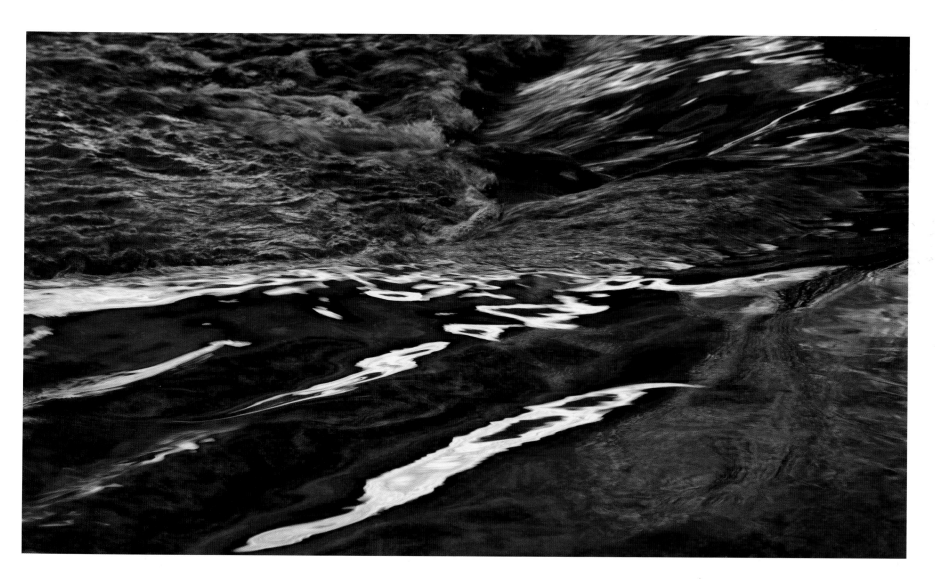

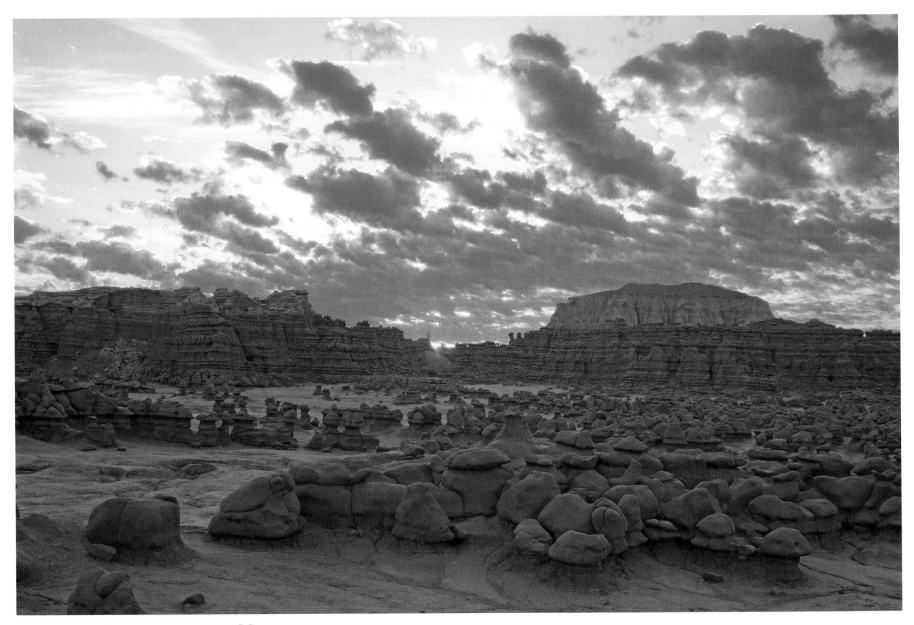

Goblin Valley

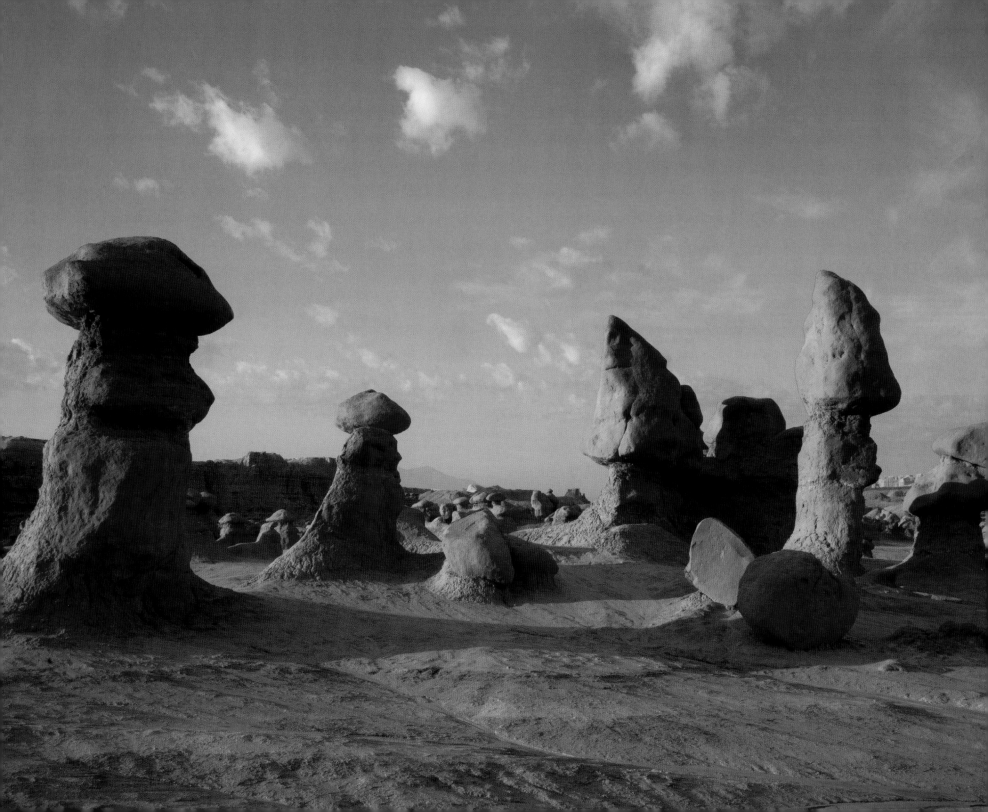

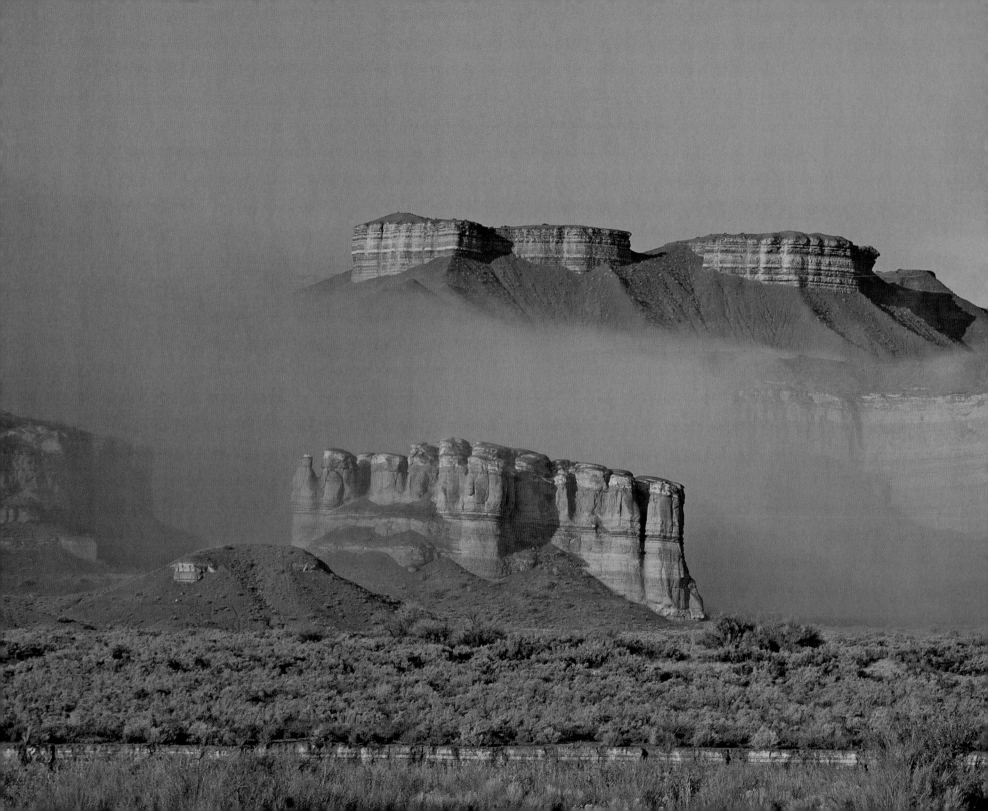

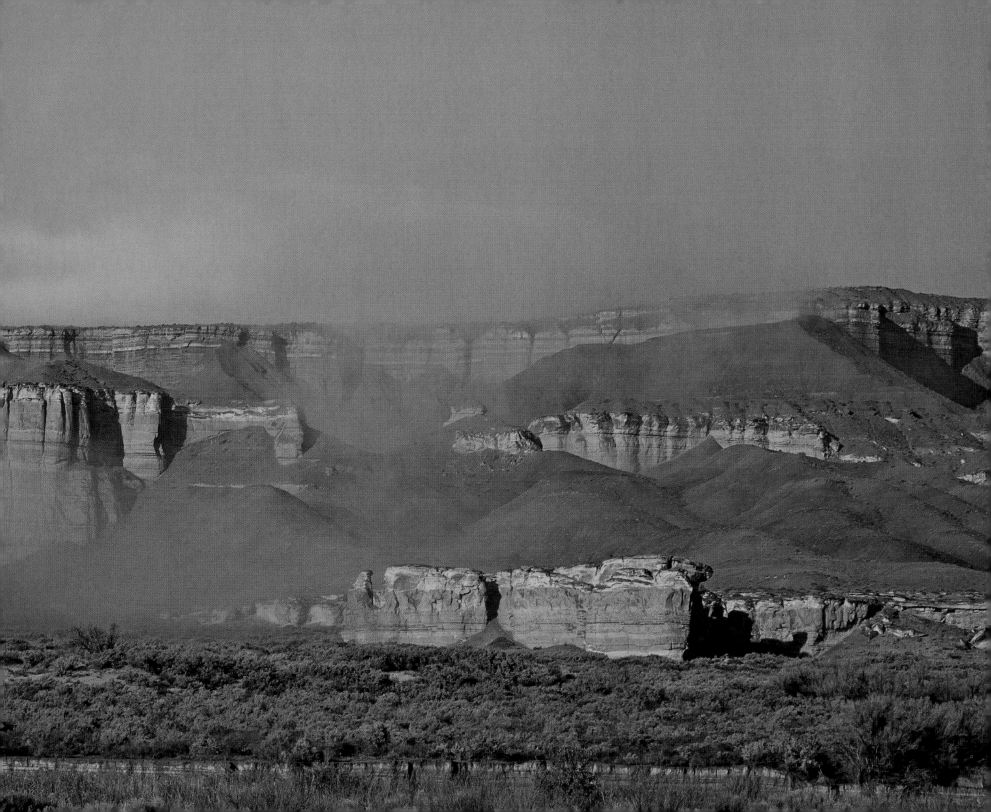

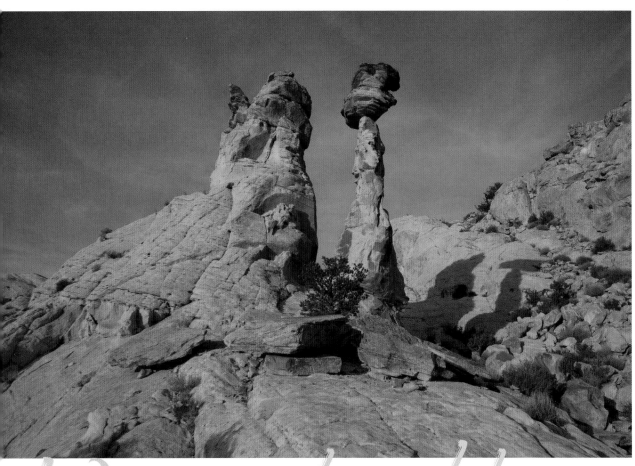

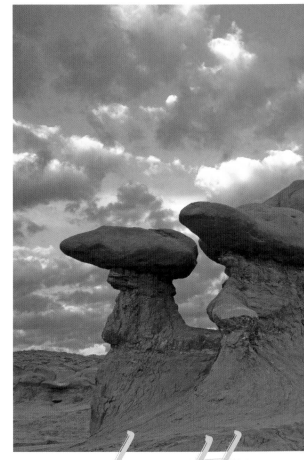

We need wilderness whether

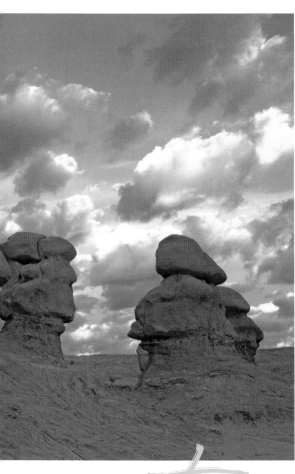

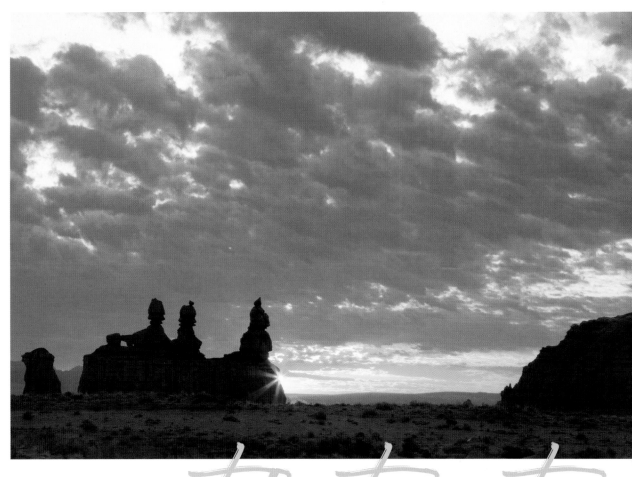

or not we ever set foot in it.

−EDWARD ABBEY

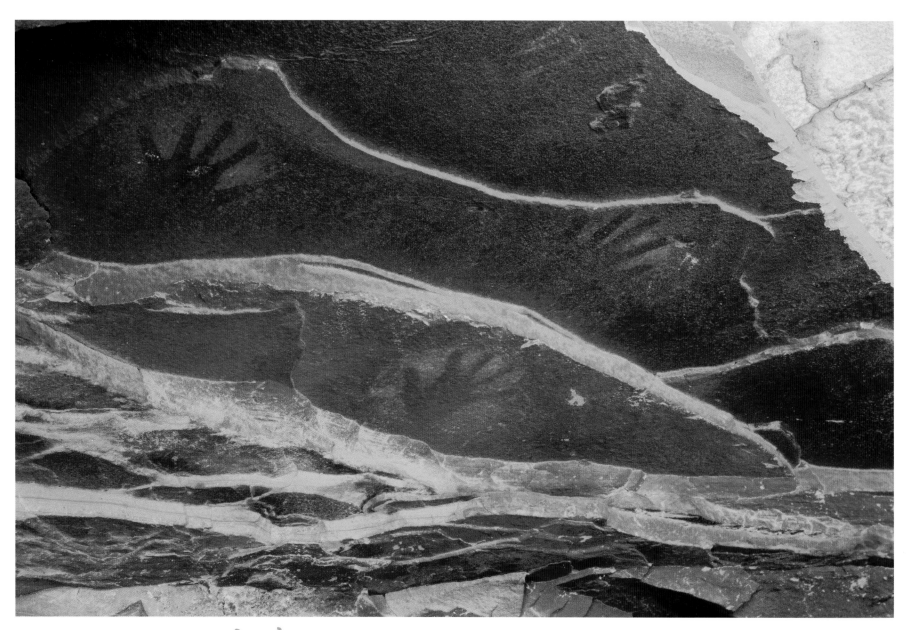

Grand Gulch

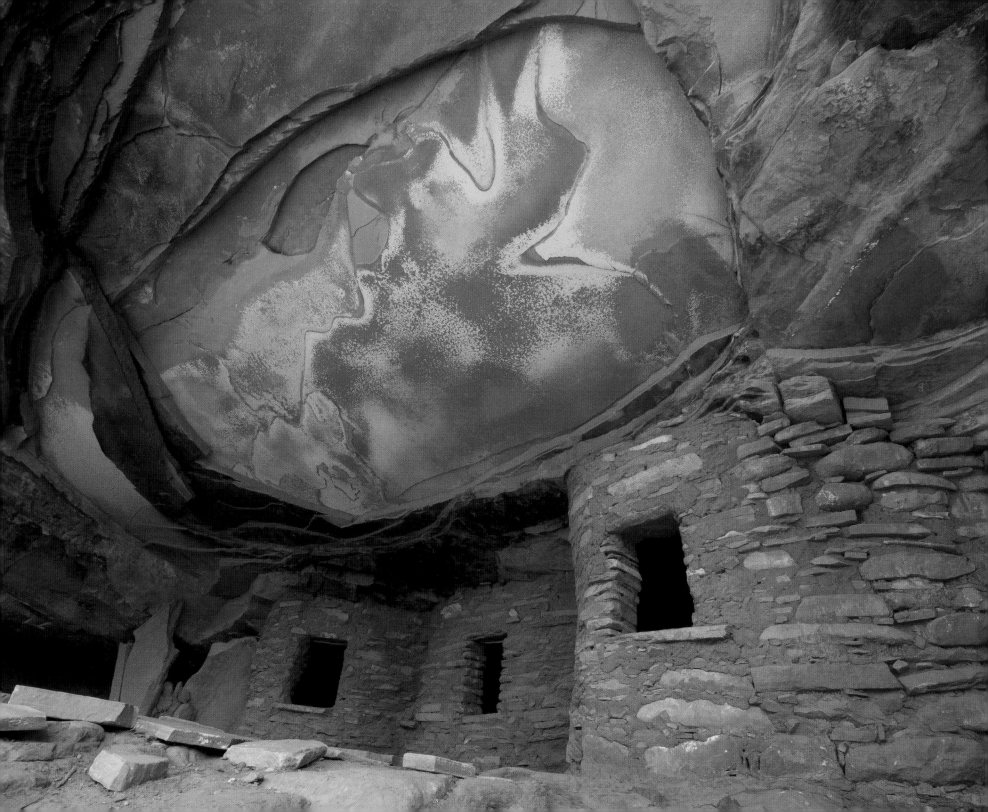

In wilderness I sense the miracle of

life, and behind it our scientific

accomplishments fade to trivia.

– CHARLES A. LINDBERGH

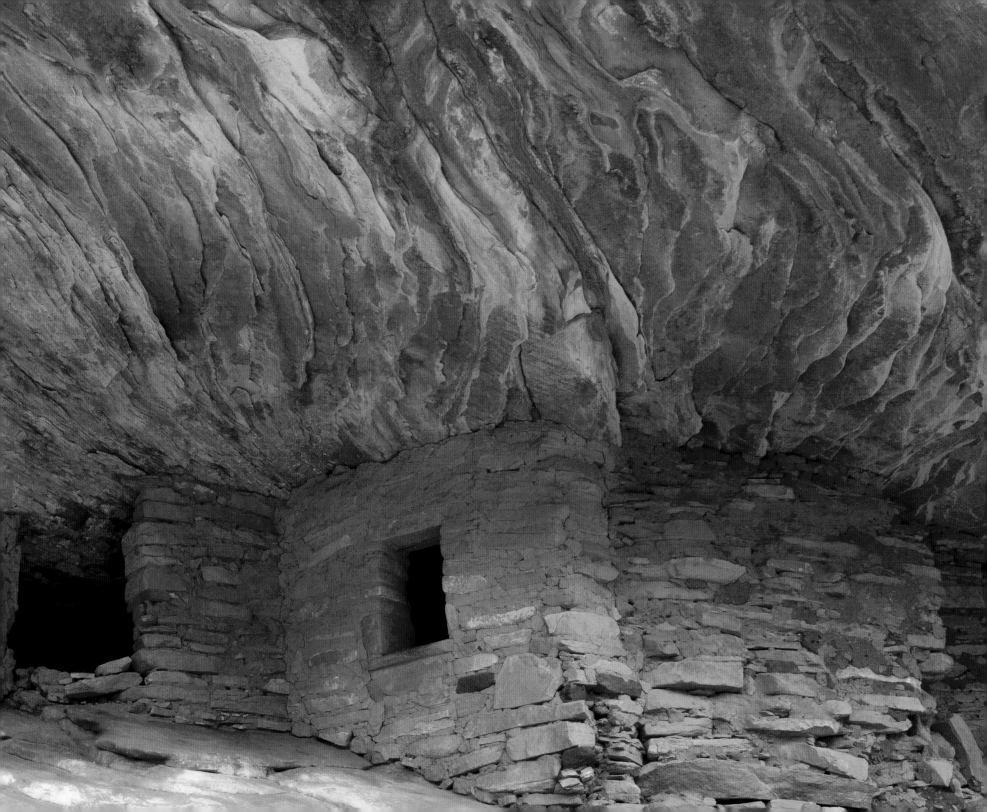

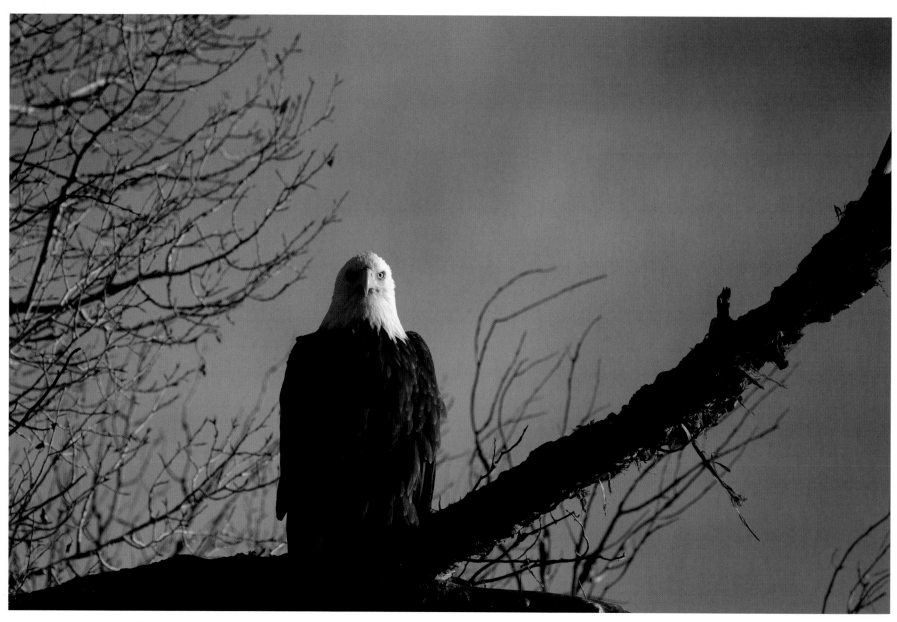

Kanab

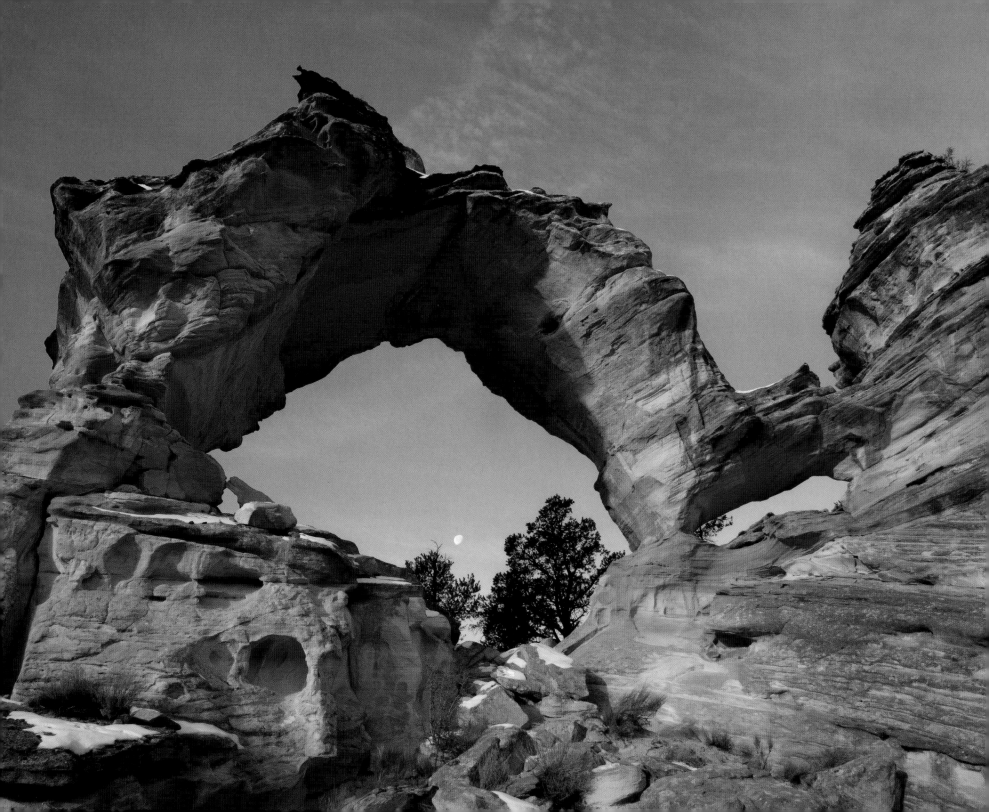

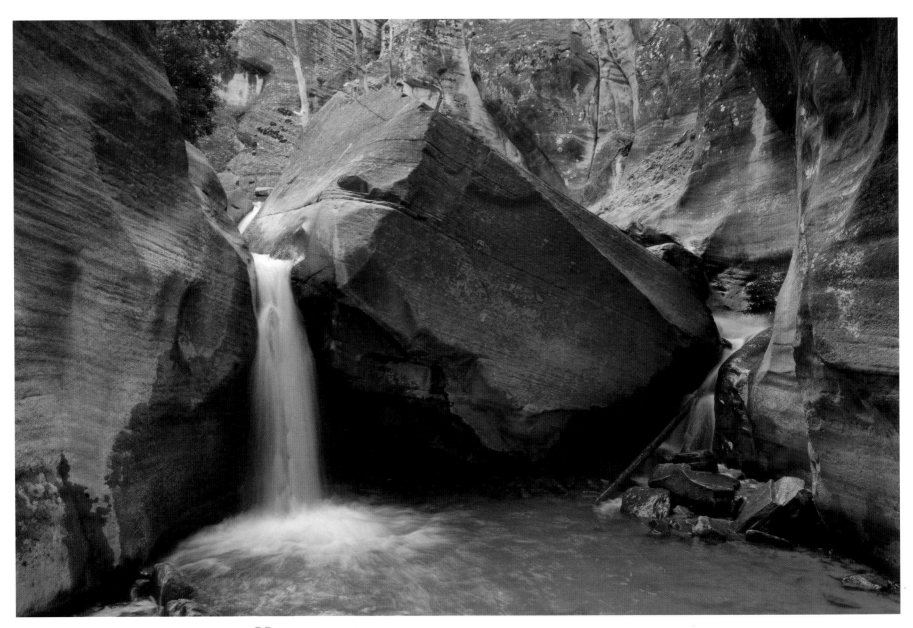

Kanarraville

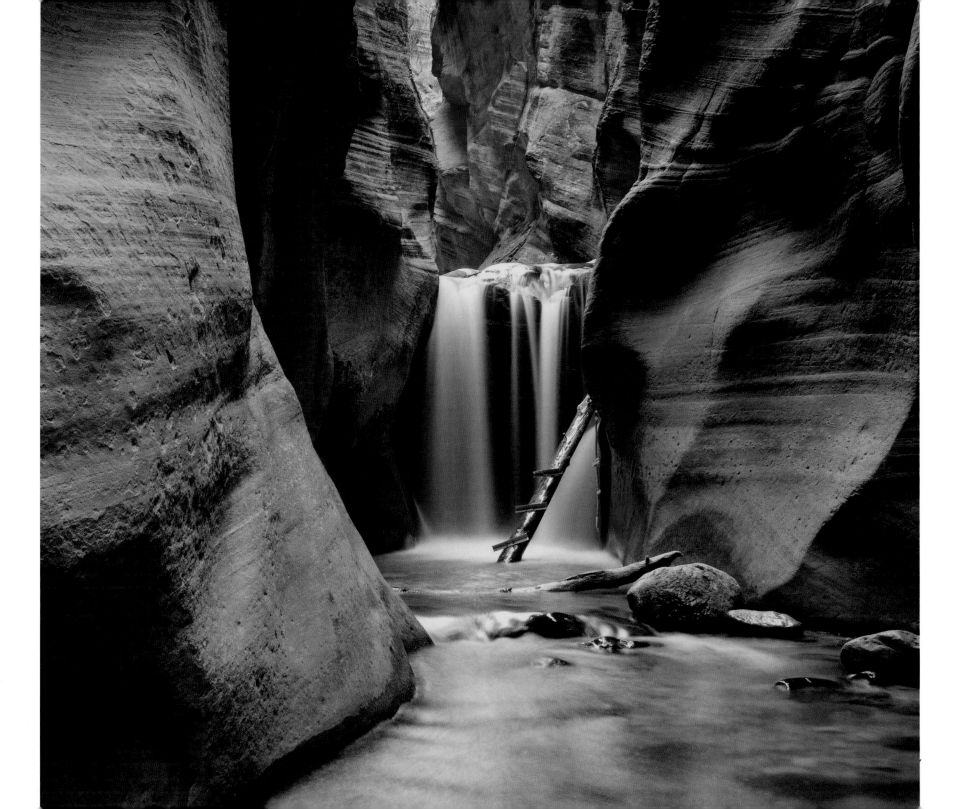

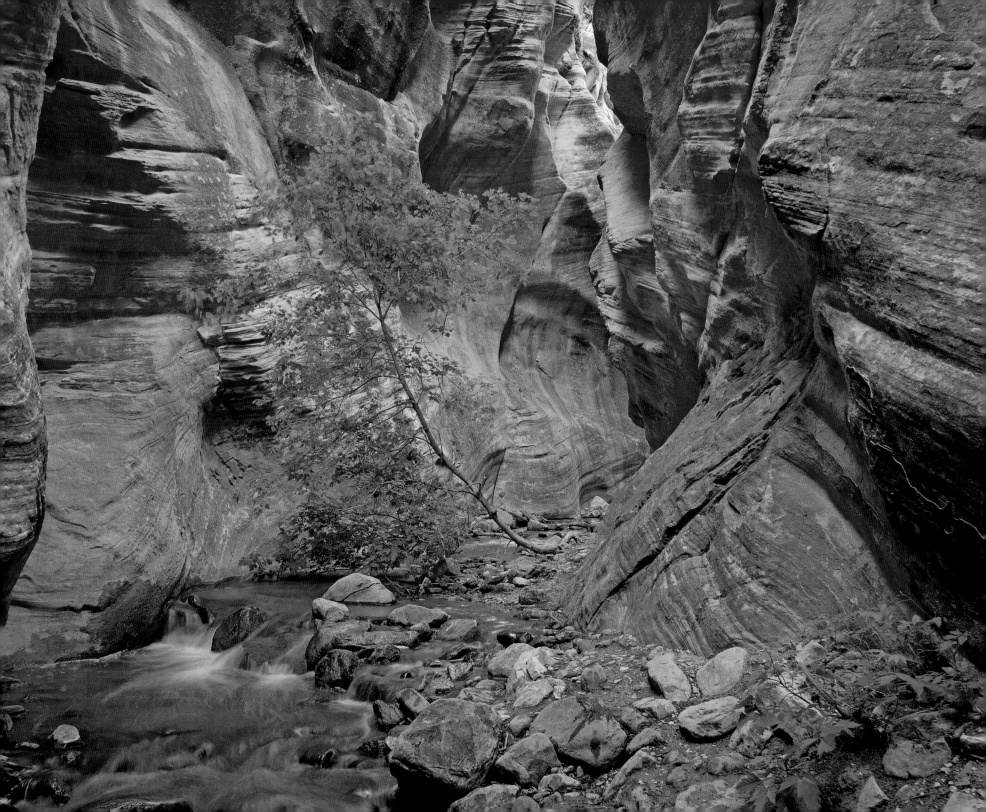

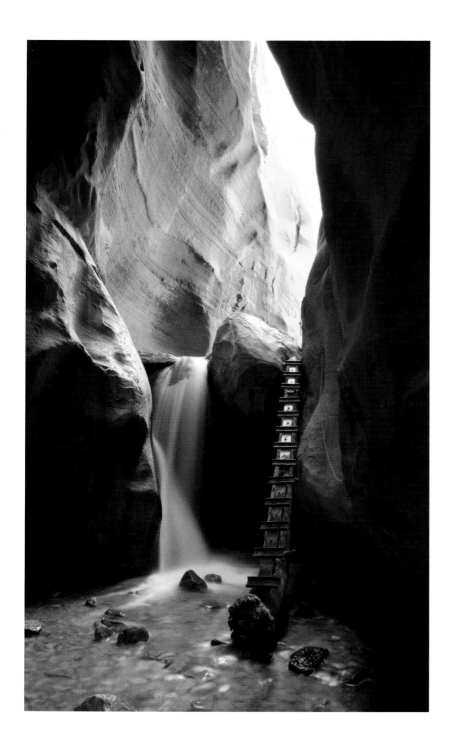

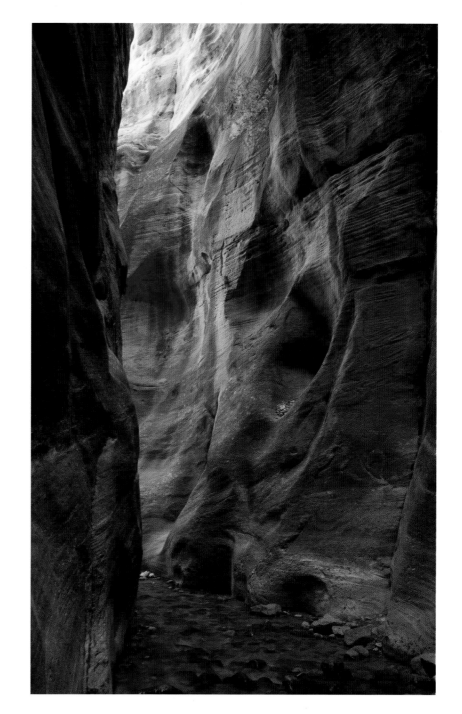

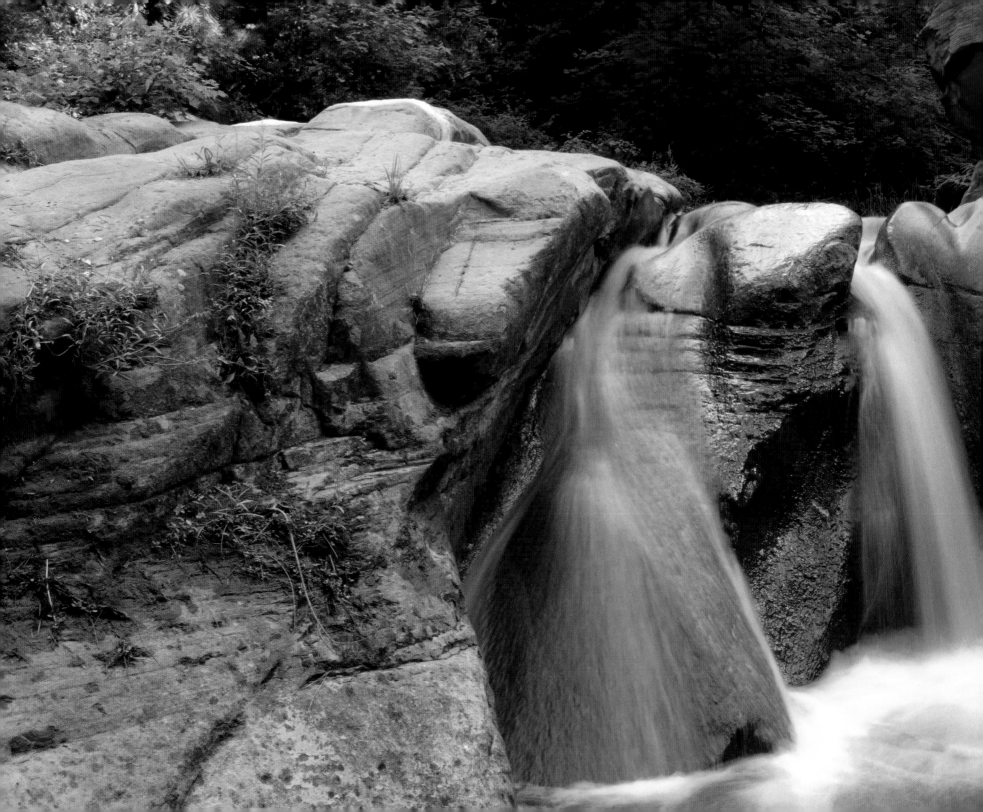

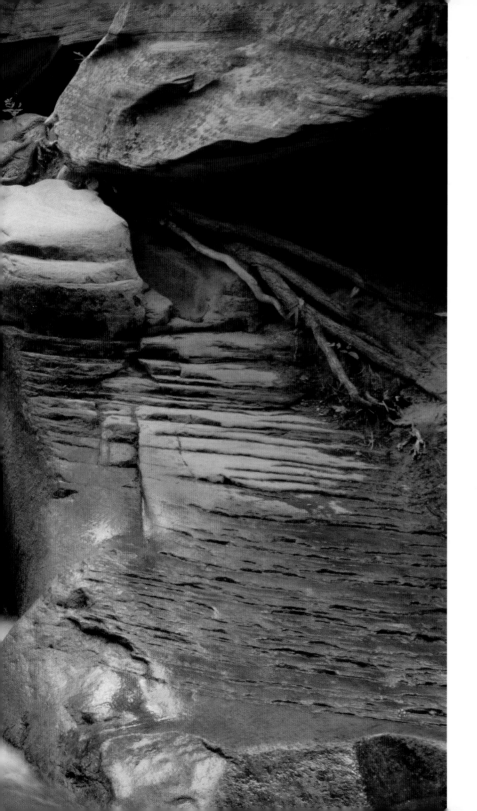

The brook would lose its song if we

removed the rocks.

-WALLACE STEGNER

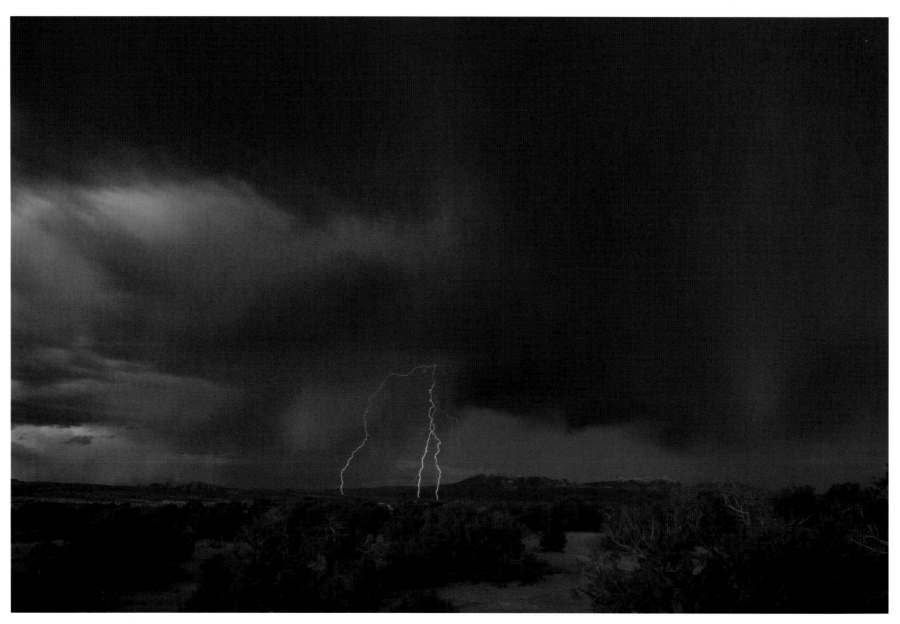

Moab

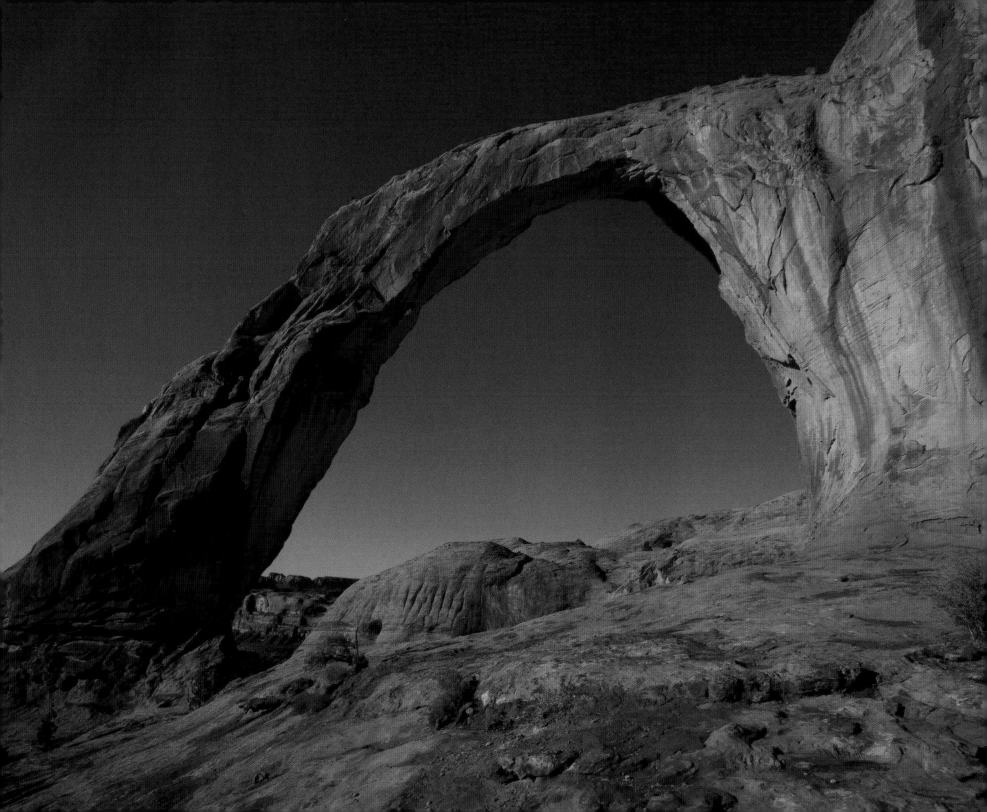

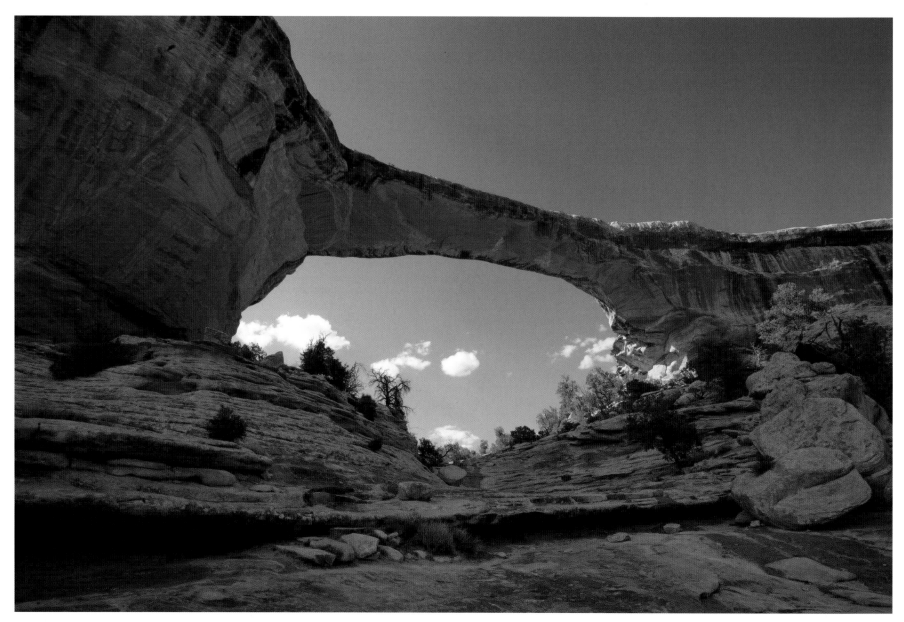

Natural Bridges

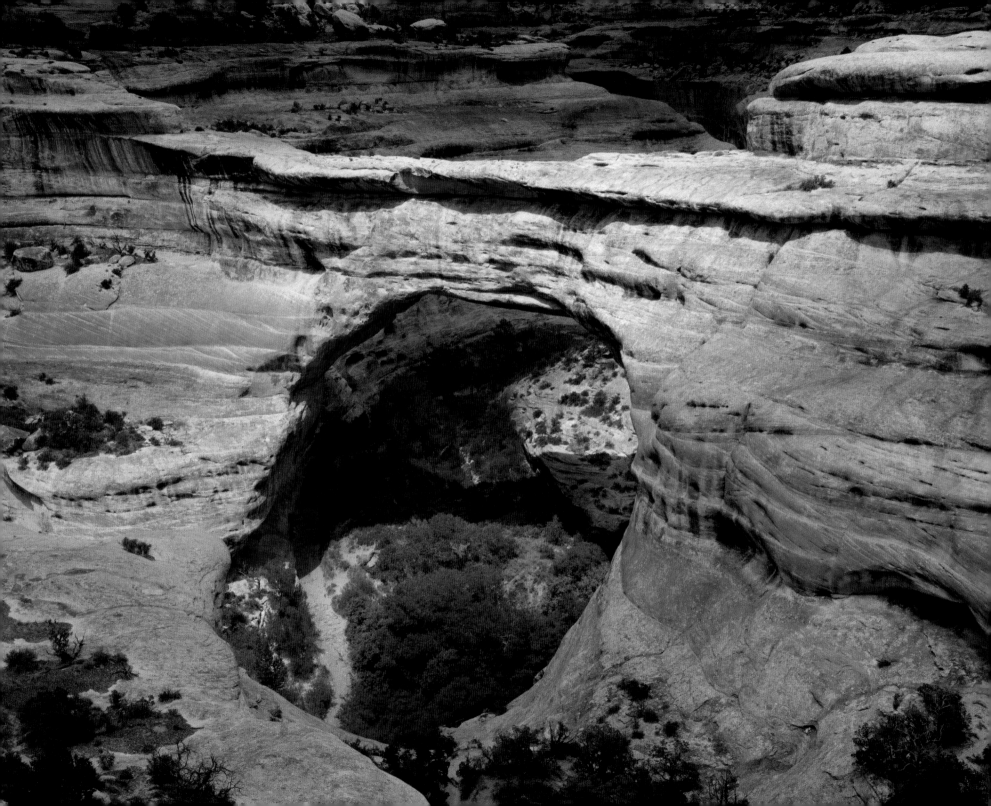

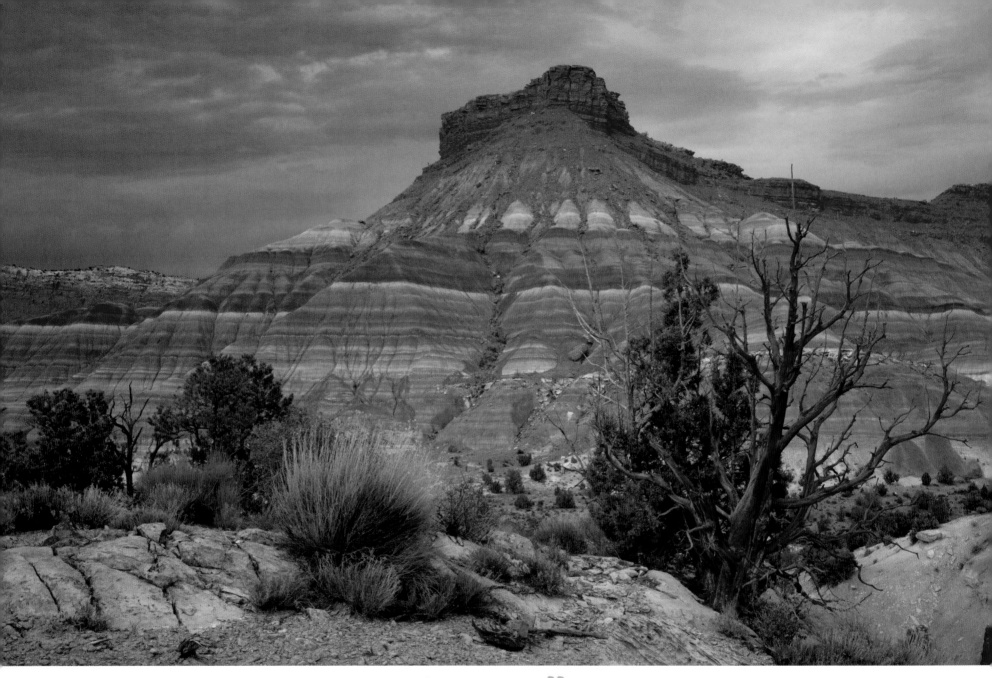

Paria and Coyote Buttes, AZ

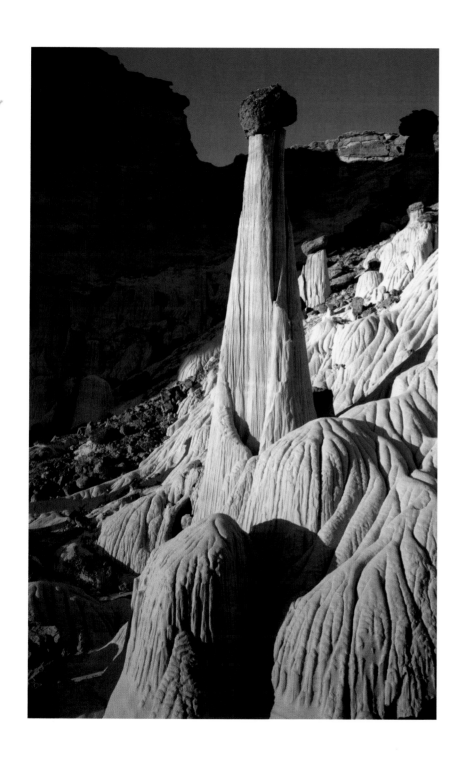

I return to the wilderness to
remember what I have forgotten,
that the world can be wholesome
and beautiful, that the harmony and
integrity of ecosystems at peace is a
mirror to what we have lost.

—TERRY TEMPEST WILLIAMS

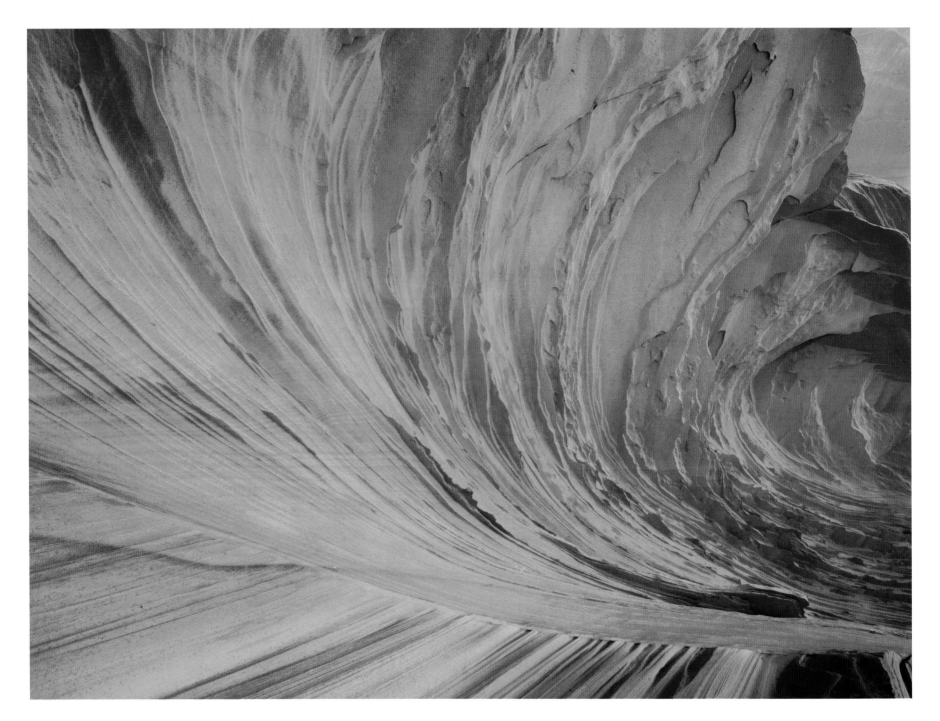

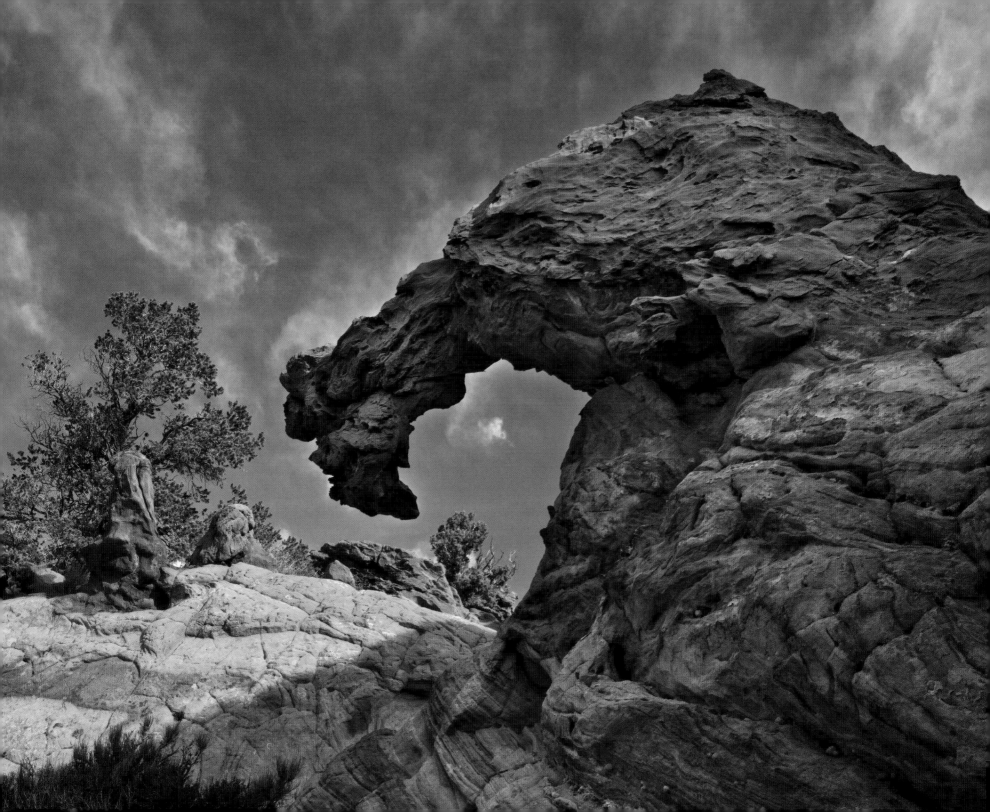

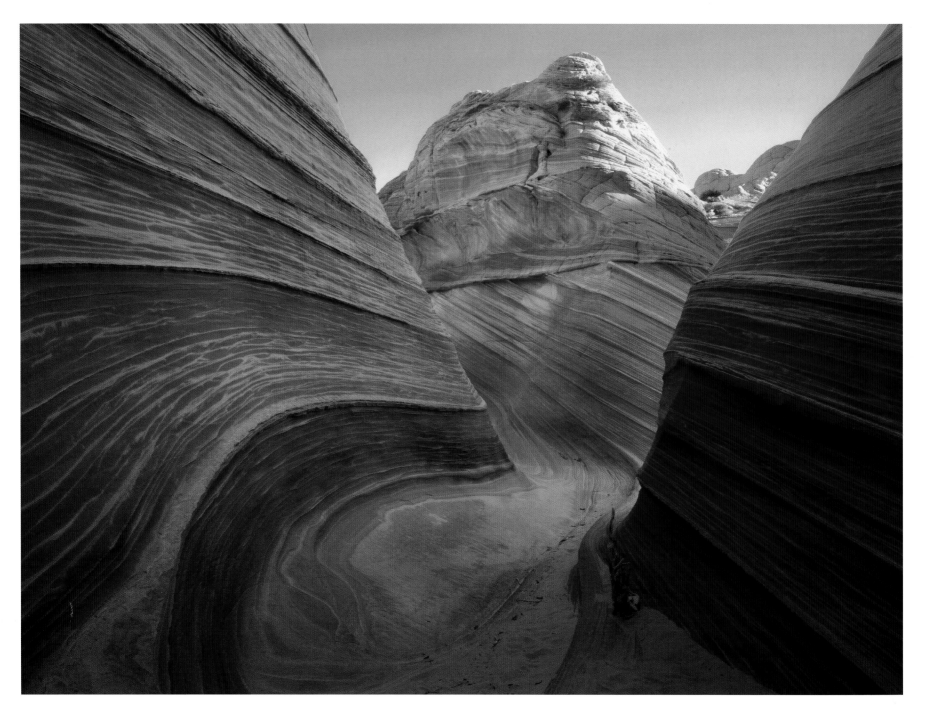

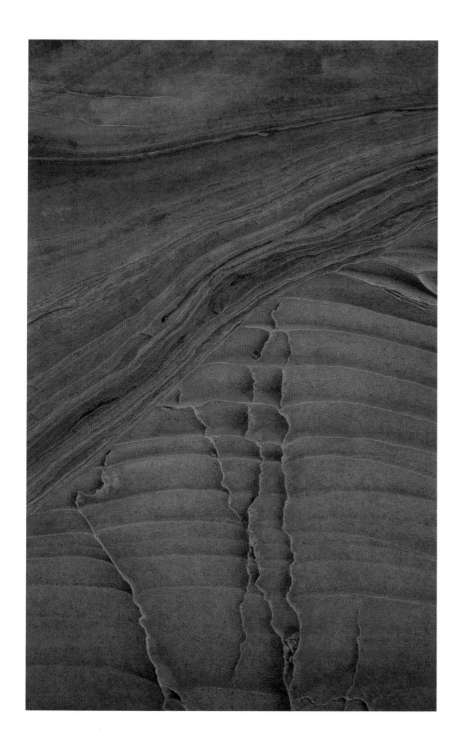
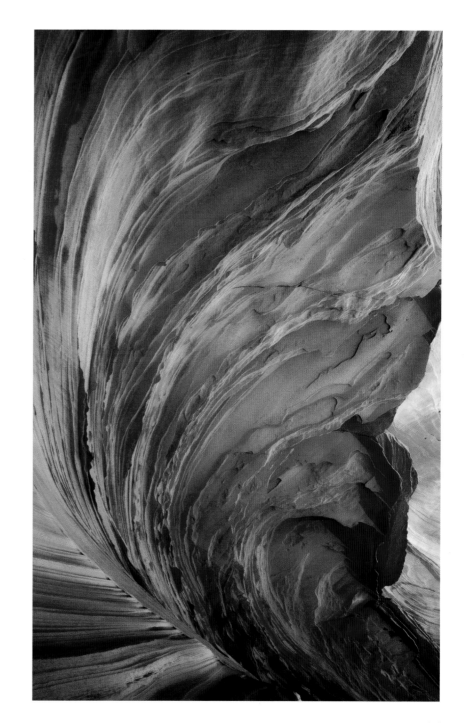

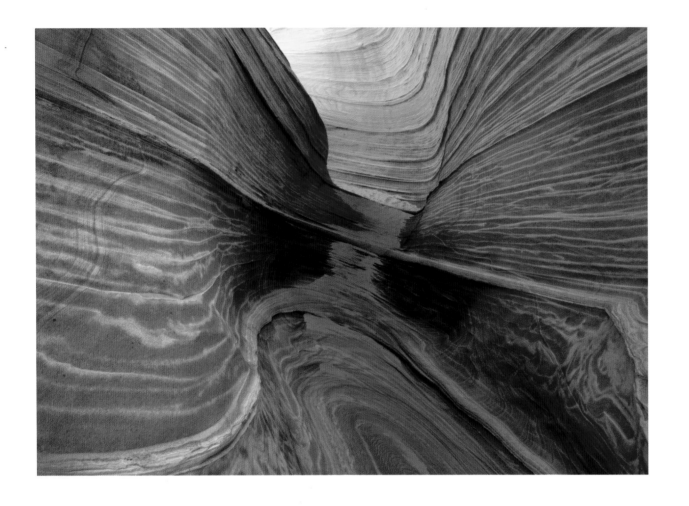

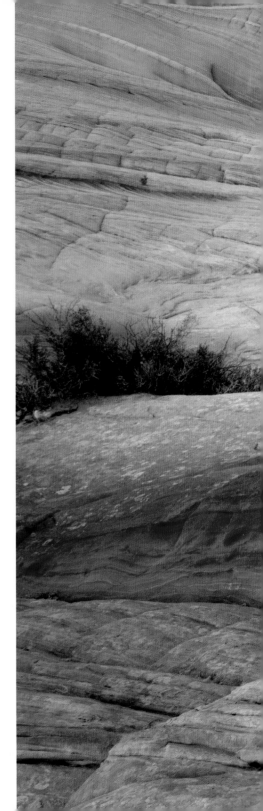

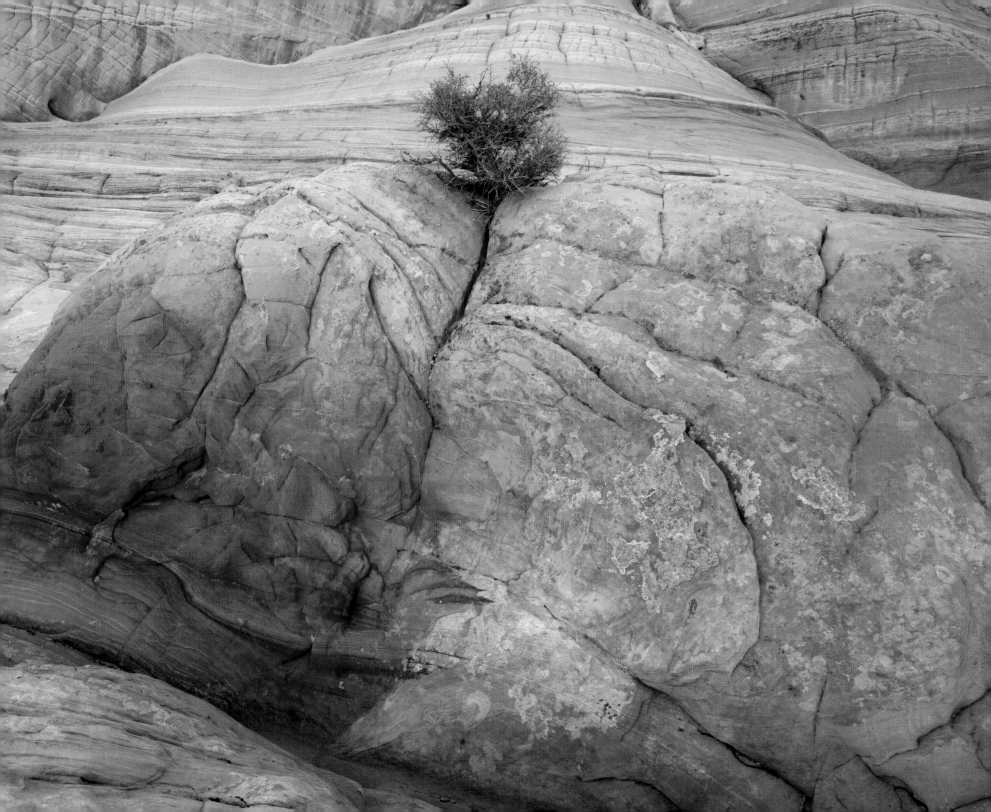

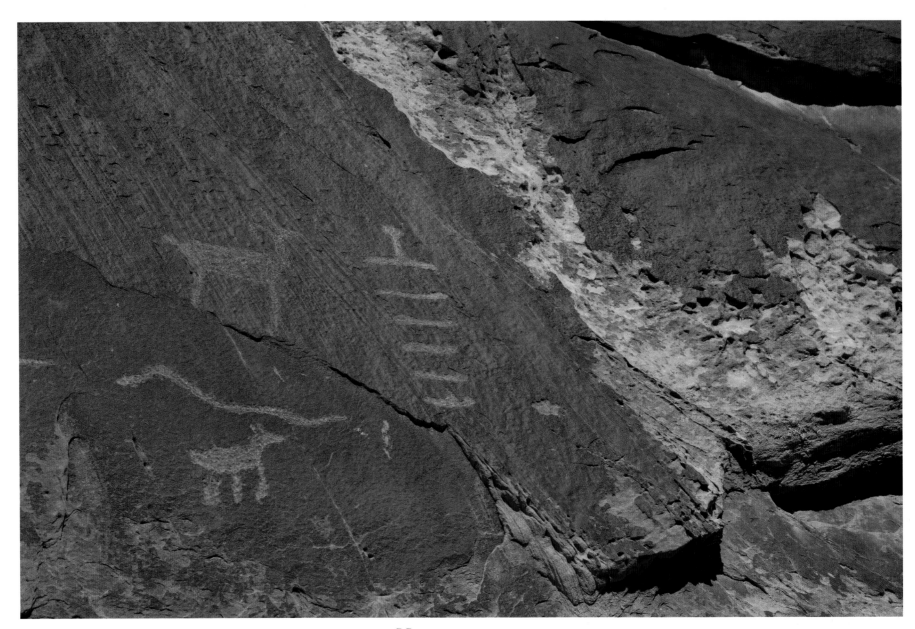

San Rafael Swell

178

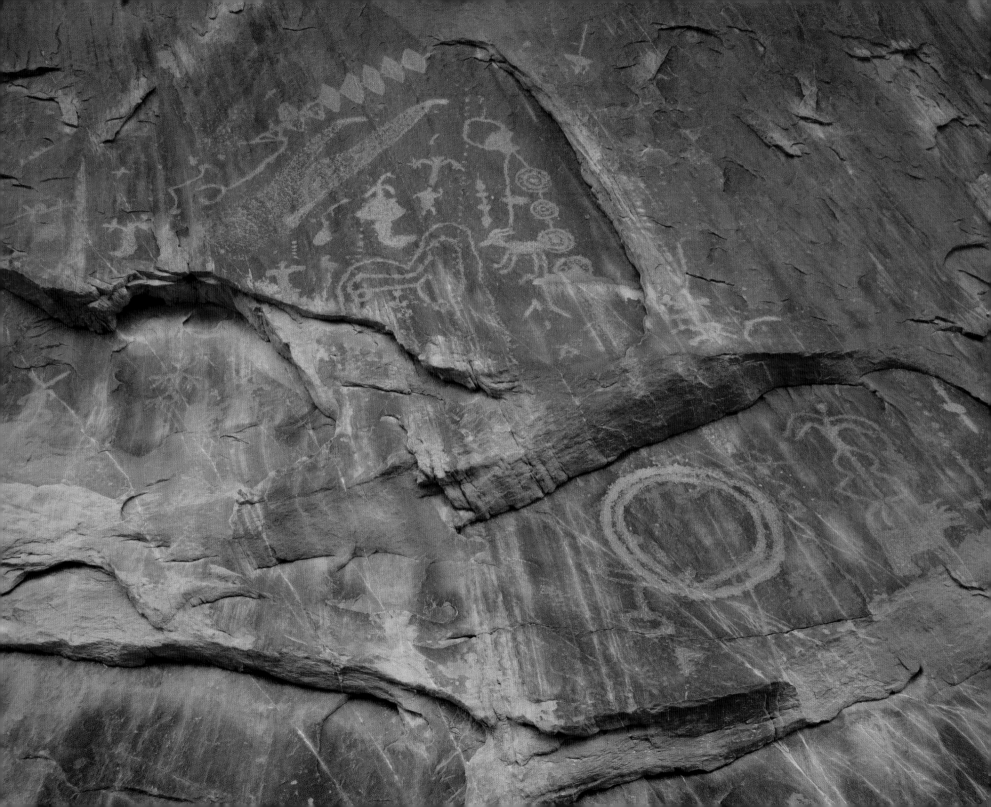

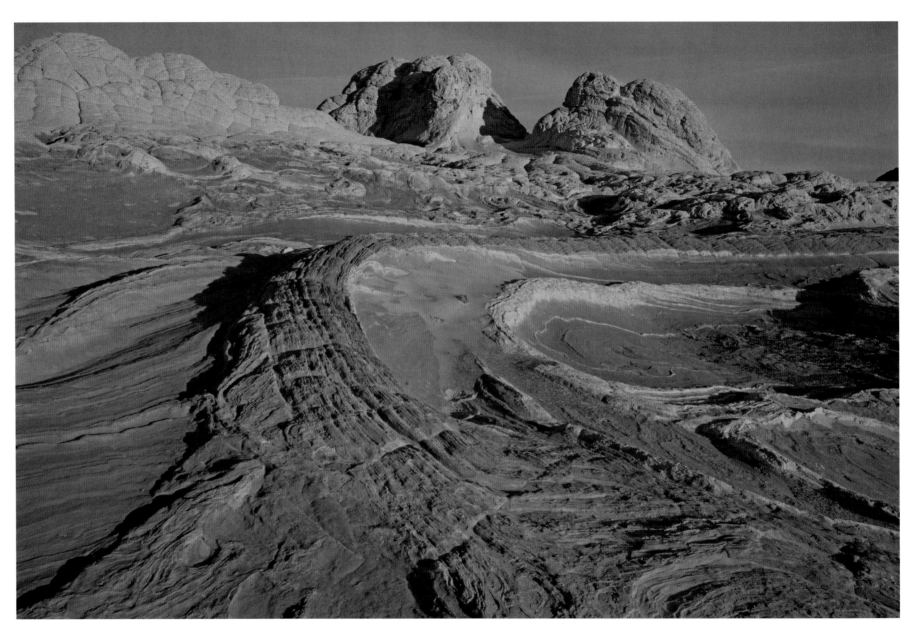

White Pockets, AZ

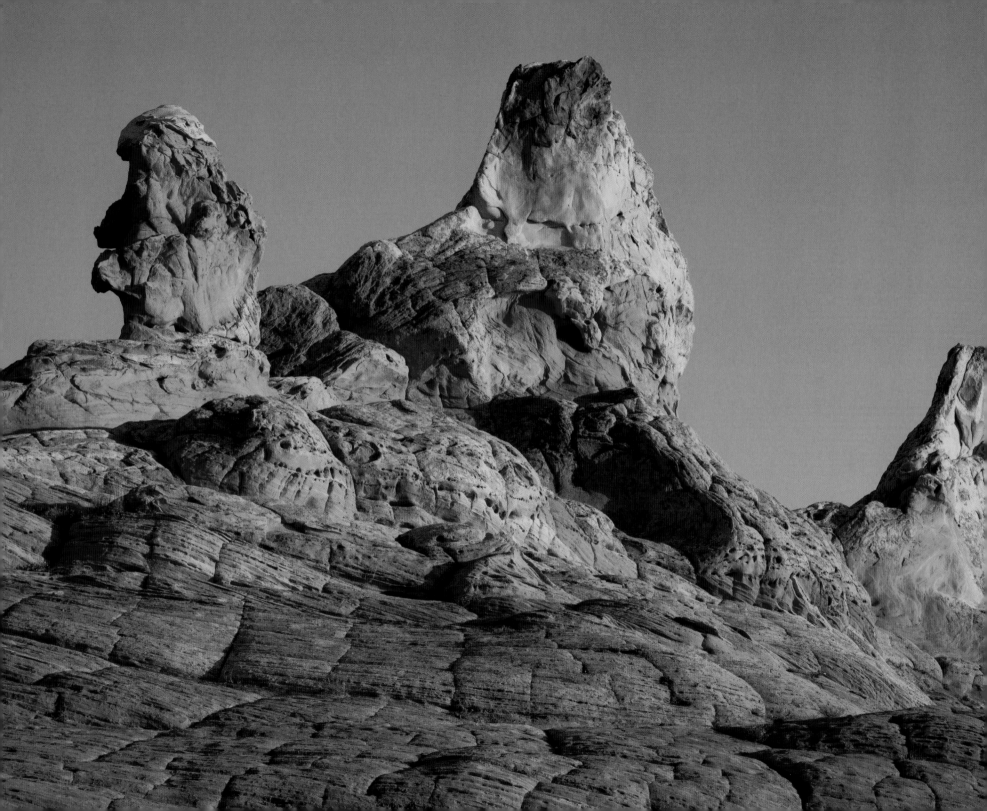

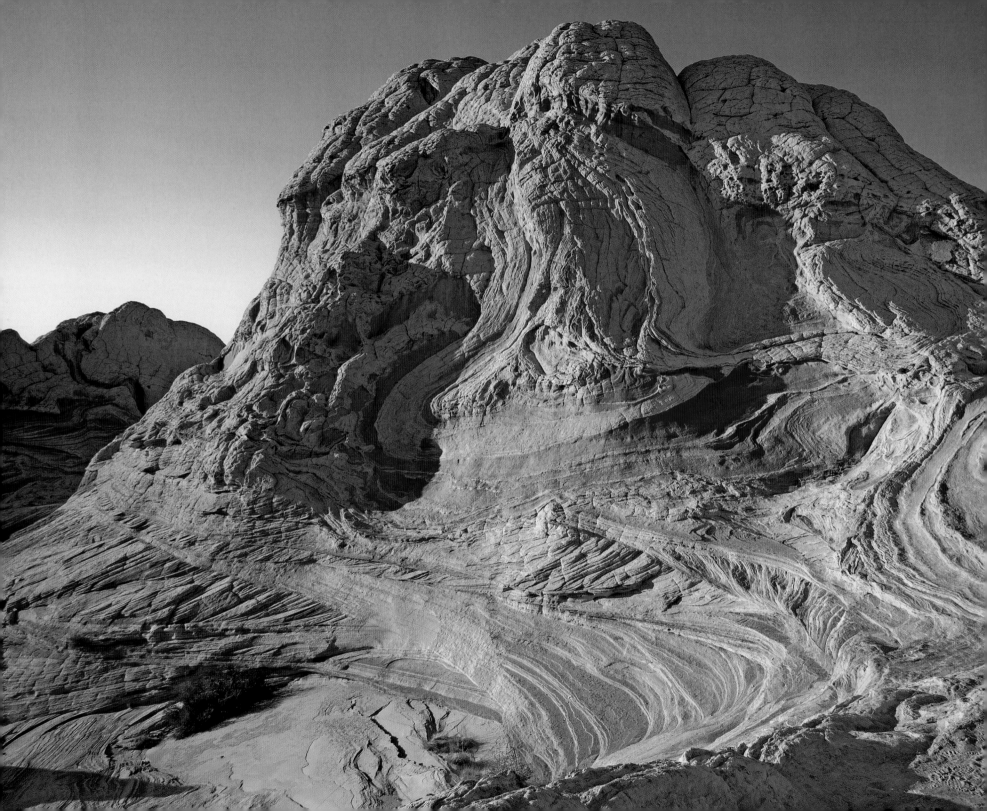

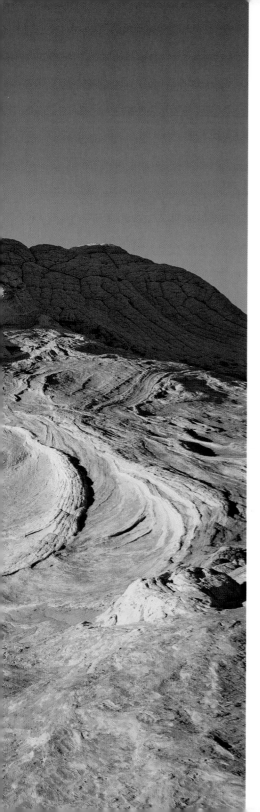

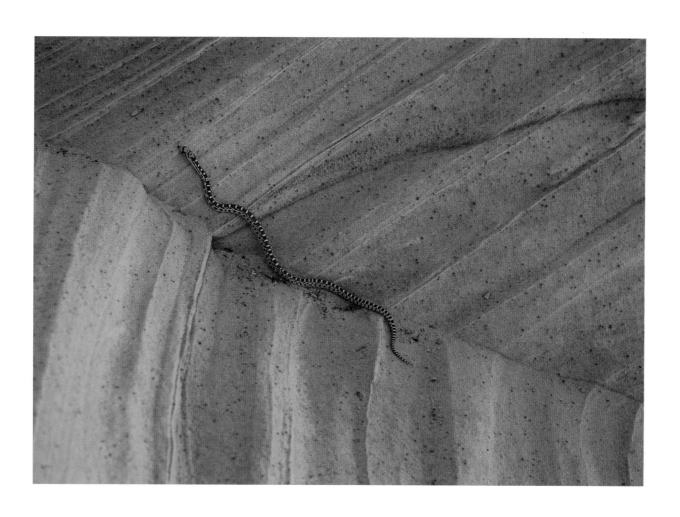

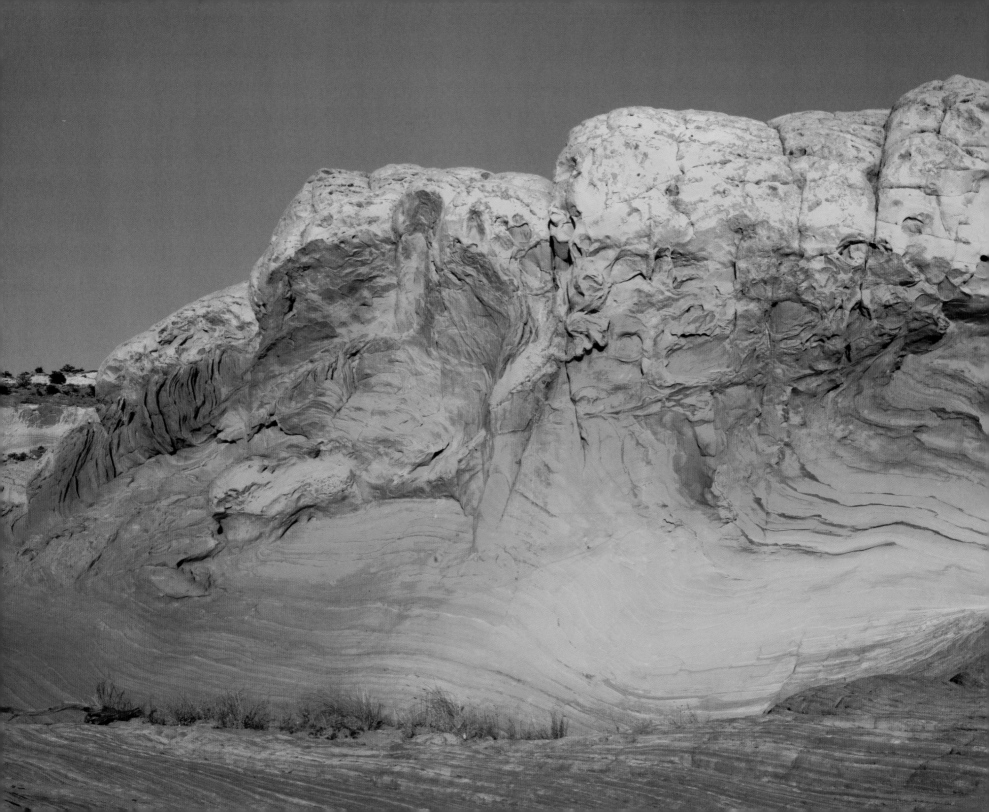

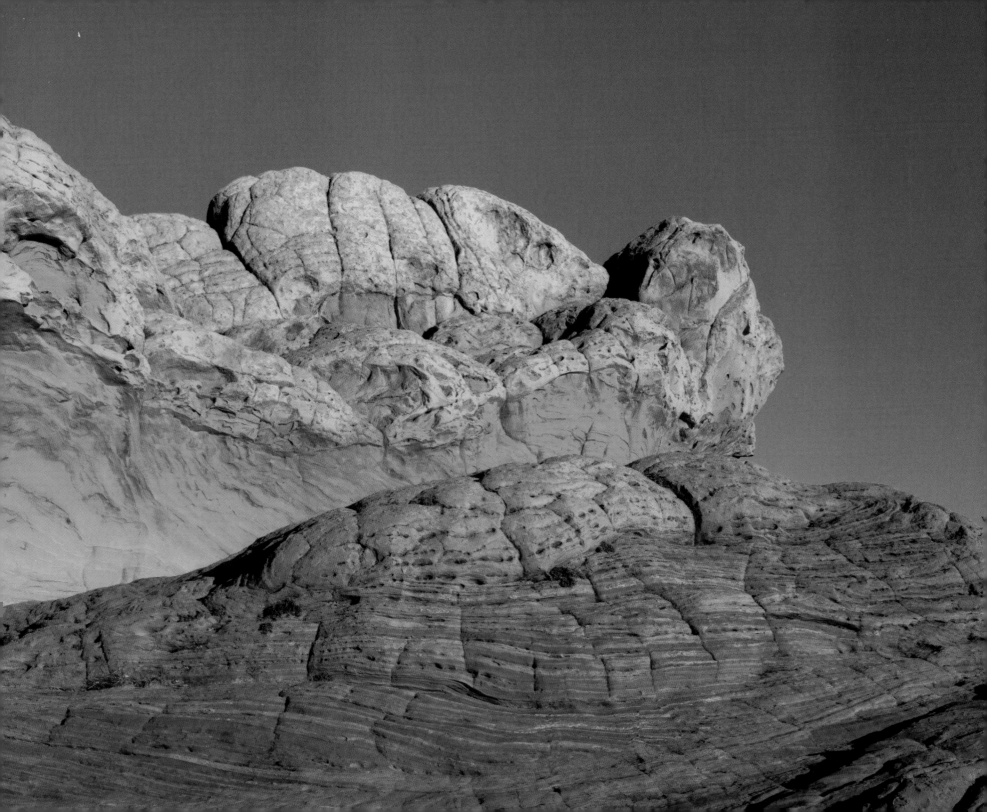

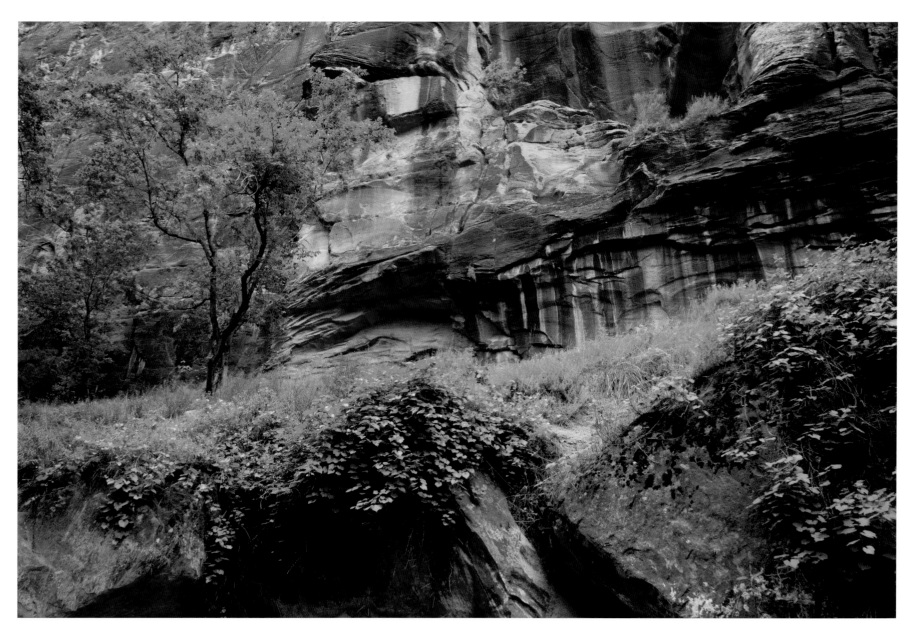

Zion

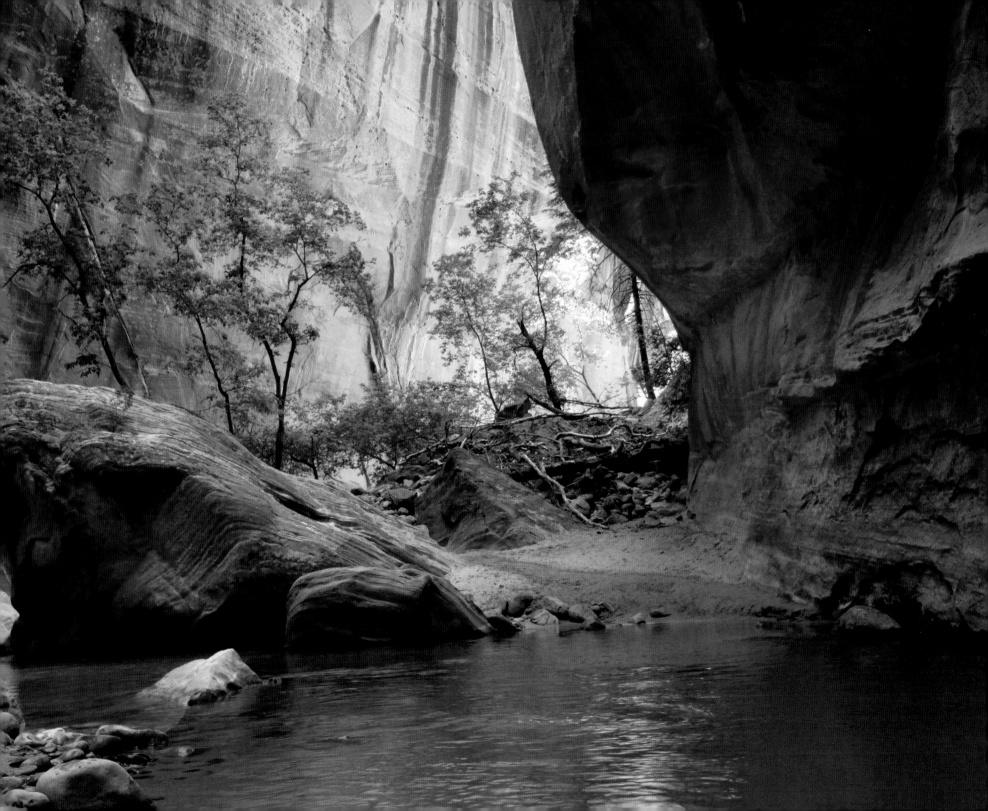

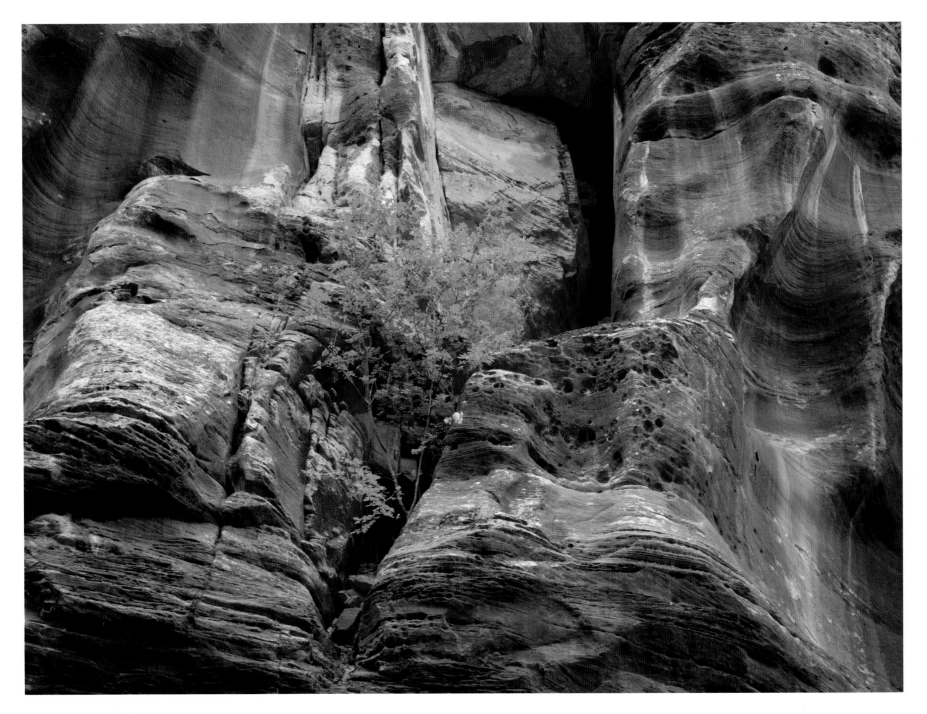

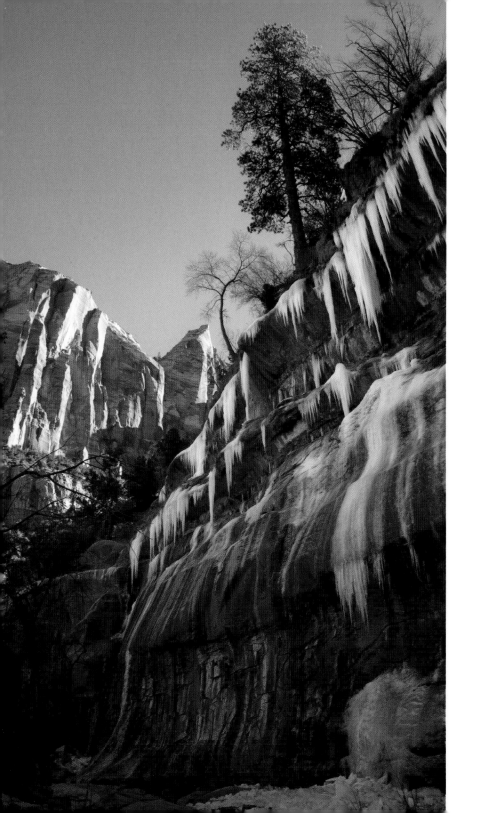
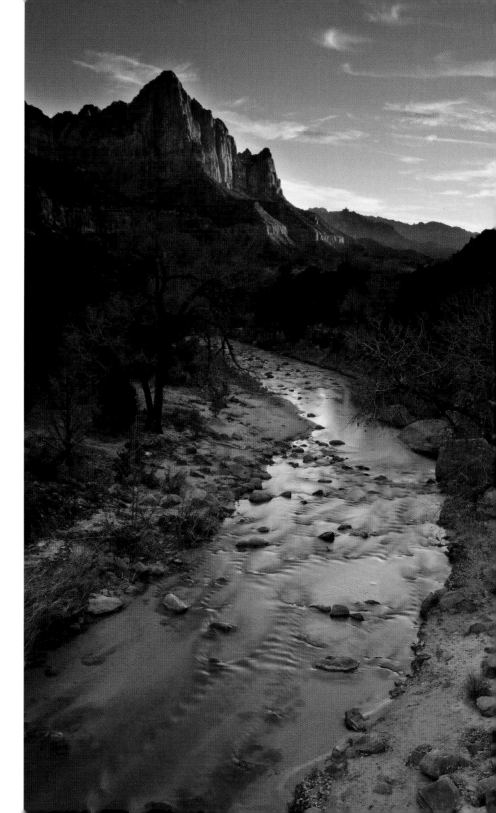

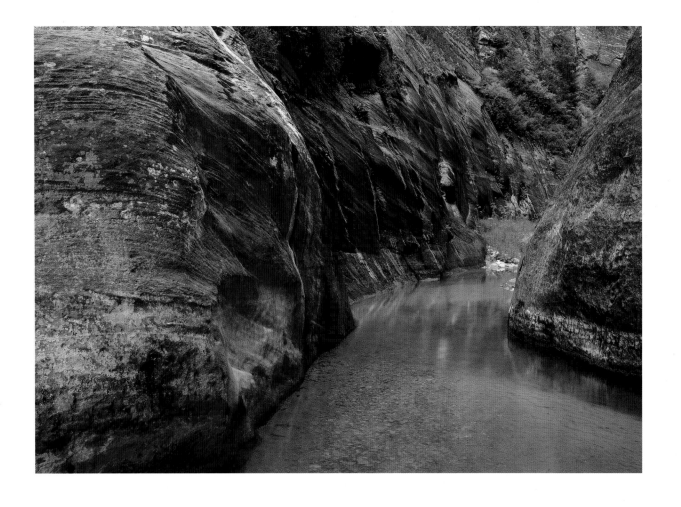

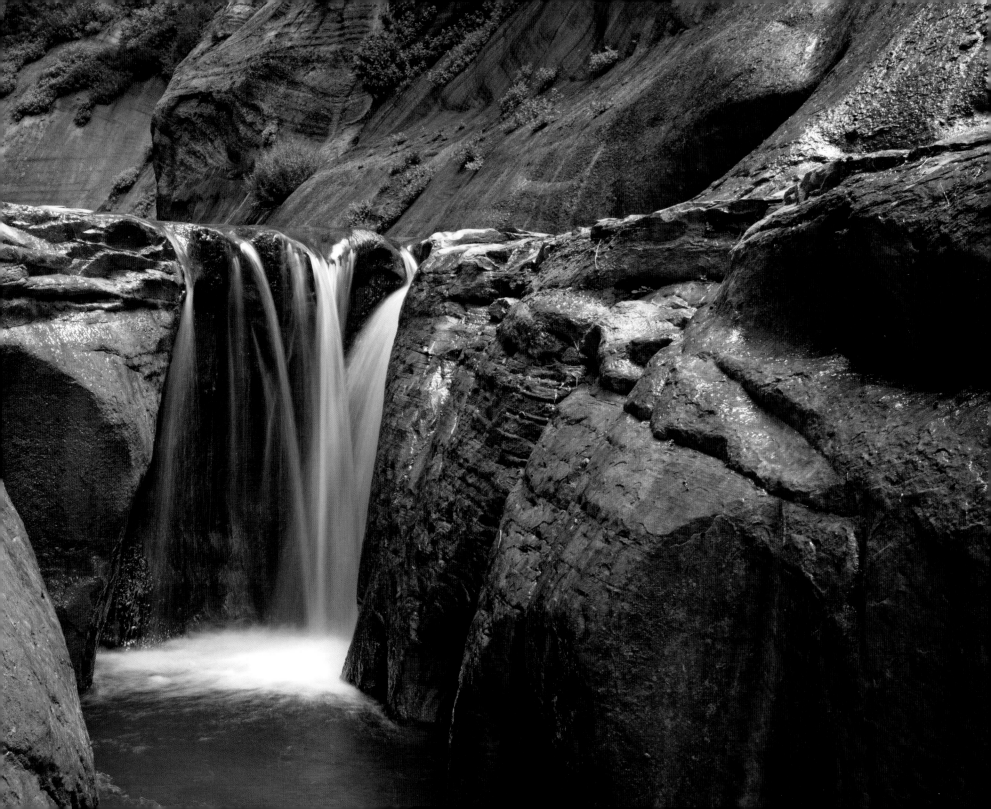

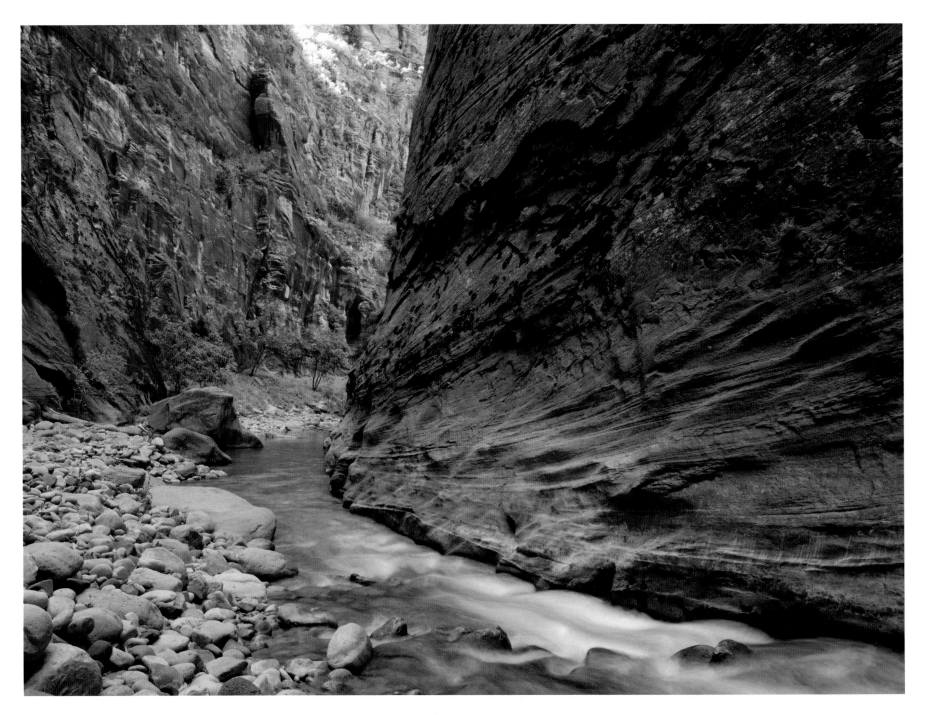